11/82
I

THE
ENCYCLOPEDIA
OF
COLORED
PENCIL
TECHNIQUES

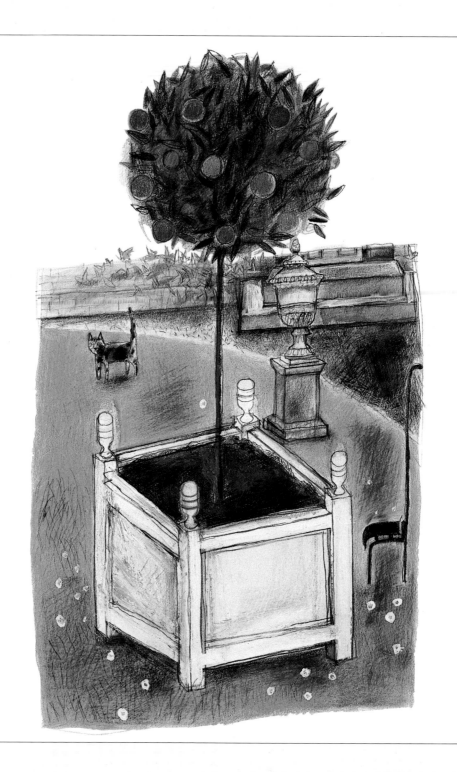

CHLOË CHEESE
"Container Tree"

THE

ENCYCLOPEDIA

OF

COLORED PENCIL TECHNIQUES

JUDY MARTIN

RUNNING PRESS
PHILADELPHIA, PENNSYLVANIA

A QUARTO BOOK

ISBN 1-56138-139-X

Library of Congress Cataloging-in-Publication
Number 92-53693

This book was designed and produced by
Quarto Publishing plc
The Old Brewery
6 Blundell Street
London N7 9BH

Senior Editor Kate Kirby
Art Editor Ashleigh Vinall
Editor Angie Gair
Designer Neville Graham
Photographers John Wyand, Paul Forrester
Picture Researcher Sophie Mortimer
Picture Manager Sarah Risley
Art Director Moira Clinch
Publishing Director Janet Slingsby

The publishers would like to give special thanks to the
following for their assistance in producing this book:
Frisk Products/Royal Talens BV
Daler-Rowney Ltd
Winsor and Newton Ltd

Typeset by En to En, Tunbridge Wells
Manufactured in Hong Kong by Regent Publishing Services Ltd
Printed in Hong Kong by Lee-Fung Asco. Printers Ltd

This book may be ordered by mail from the
publisher. Please include $2.50 for postage
and handling. *But try your bookstore first!*

Running Press Book Publishers
125 South Twenty-second Street
Philadelphia, Pennsylvania 19103

CONTENTS

PART ONE

TECHNIQUES

Where appropriate, text and captions give cross-references to other useful and applicable techniques.

PART TWO

THEMES

Where appropriate, text and captions give cross-references to the techniques previously demonstrated, to enable you to relate the working method to the end result.

FOREWORD

Colored pencils are an excellent medium for the newcomer to drawing and painting. Clean, portable, easy to handle and relatively inexpensive, they can be used any time and in any locution. No supplementary materials or equipment are required, contrasting markedly with paints. All you need to get going are the pencils themselves and some drawing paper or a small sketchbook.

Many different brands of colored pencils are on the market and each have their own special qualities of color and texture. They are very different from the cheap and cheerful crayons of the schoolroom that you may have used for your first ventures in drawing. Artists' pencils with waxy and chalky leads can be stroked onto the page almost like paint - the velvety, malleable textures are a pleasure to handle and the color ranges inspirational.

Mastering only one or two basic techniques can enable you to produce a surprisingly sophisticated result, which is encouraging to the beginner. there is a great deal more to discover in this simple but versatile medium however. This book provides you with the means to explore fully the potential of colored pencils through the examples set by practised artists and through experimentation of your own. Remember too, as with any artist's medium, learning a new skill is a chfallenge but it should not be a chore. There is no absolutely right or wrong way to use colored pencils and the only essential aim is to enjoy both the progress and results of your work.

Judy Martin

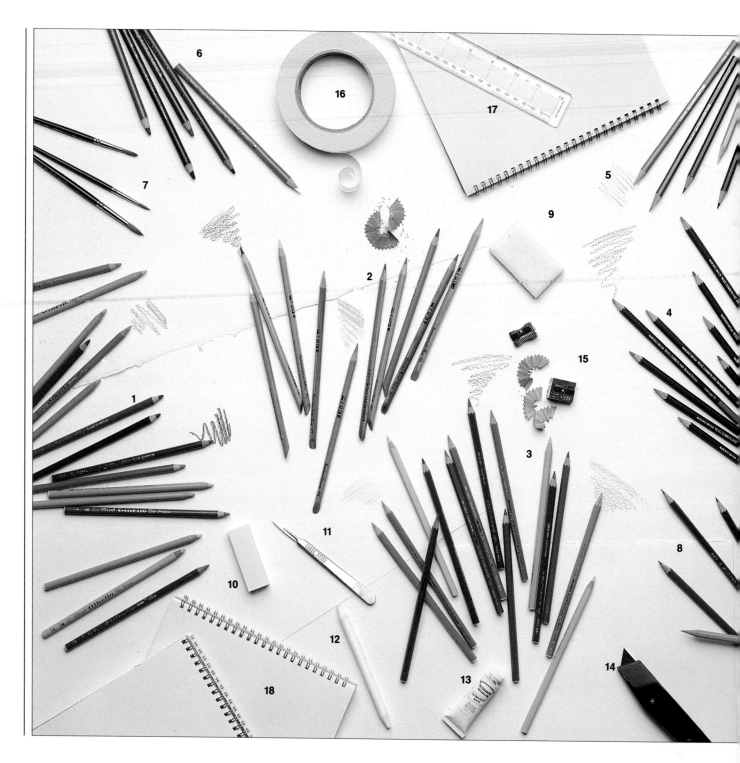

MATERIALS

The artist working with colored pencils now has a wide range of high-quality materials to choose from. Every brand of pencils has its own handling qualities — the pencils are usually sold individually as well as in sets, so it is worth trying out a few different types. There are variations of texture, and the colors available vary between brand-name products, so you should keep in mind the versatility of the palette if you decide to buy an expensive boxed set.

The surface finish of the paper you use also significantly affects the pencil application. Some artists like a grainy paper with a rough tooth that breaks up the color; others prefer a smoothed-out finish that leaves all the textural qualities dependent on the way the marks are made. Ordinary cartridge paper is fine for practicing your skills and is often used for finished work. But if you want to get a special effect making use of the paper grain, check out the variety of papers sold primarily for watercolor and pastel work.

These are essential ingredients; you need few other materials. The items shown here represent your basic studio needs and the different types of pencils available.

1 Chalk pencils have a velvety, pliable texture ideal for blocking in and blending.

2 Wax pencils in the softest grades create subtle effects of shading and color gradation.

3 Water-soluble pencils can be used wet and dry, providing a high degree of textural variation.

4 Wax pencils of a slightly harder consistency are versatile for line work, hatching, and shading.

5 Hard pencils with fine leads are well suited to drawing intricate detail, and to the technique of impressing.

6 Pastel pencils have a grainy texture like that of pastel sticks, but these slender pencils can be sharpened to a point.

7 Watercolor brushes are needed for mixed-media techniques and for wetting water-soluble pencil color.

8 Graphite pencils combine well with colored pencils and are also useful for composing and tracing images.

9 Kneaded eraser is a clean way of lifting out excess color without damaging the paper surface.

10 Plastic or vinyl eraser – this can be used for correction and as a tool for softening pencil colors.

11 Scalpel, used both for sharpening pencils and trimming paper.

12 Torchon, a blending tool for burnishing waxy color and blending chalk.

13 White gouache is completely opaque and can be painted over pencil marks to make corrections.

14 Craft knife is best for cutting papers and boards.

15 Pencil sharpeners are required to sharpen pencils to fine points.

16 Masking tape has a dual purpose – masking off edges on a drawing and also securing paper to a drawing board.

17 Ruler, valuable for drawing lines and guiding pencils on a straight edge; also required for squaring up an image.

18 Sketch pads are handier than paper sheets for outdoor sketching and are useful in the studio for trying out techniques.

TECHNIQUES

When you start to equip yourself with a stock of colored pencils, you will find that their qualities vary considerably from one brand to another, and that some color choices are more extensive than others. Colored pencil "leads" consist of particles of colored pigment mixed with an inert white filler that gives opacity, such as kaolin or talc, a binding medium that holds the materials together and allows the color sticks to be shaped, and waxes, which give the pencils smooth handling properties. It is the varying proportions of these substances that produces the variations in quality, texture and strength of color. Some colored pencils are hard and translucent, some very waxy and giving, others chalky and opaque.

Most pencils are classically shaped with the slender colored lead encased in wood. They can be sharpened to a fine point for detailed line work, or can be used blunt to create broader, smooth strokes. You can also obtain square color sticks that resemble hard pastels, but have a waxy texture like that of colored pencils.

The techniques demonstrated in the following pages are equally effective with all types of colored pencils unless otherwise stated. The only type designed to be handled differently is the water-soluble colored pencil, whose color medium is formulated to dissolve and spread like watercolor paint when brushed over with clean water. However, even this can be used dry in exactly the same ways as other kinds of pencil.

There are various techniques for blending colors effectively. The method you use will depend on whether you want smooth GRADATIONS of color and tone, a layered effect built up by OVERLAYING COLORS, or an optical mixture created by massing linear pencil strokes to produce overall color blends, as with HATCHING or STIPPLING.

Using SOLVENTS, you can obtain effects closer to the fluid color blends typical of paint media, while BURNISHING heightens the effect of graded and overlaid colors. Refer to all these techniques to familiarize yourself with their different surface qualities, so you can choose the method best suited to an individual work.

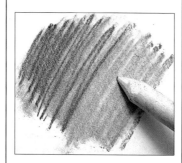

Blending with chalky pencils
1 The texture of chalky pencils allows the colors to be blended by rubbing. You can begin by working one color over another with loose HATCHING.

2 Use a torchon to spread the color, and press it into the paper grain by rubbing gently but firmly over the pencil marks. Alternatively, you can rub with your fingertip or a cotton bud.

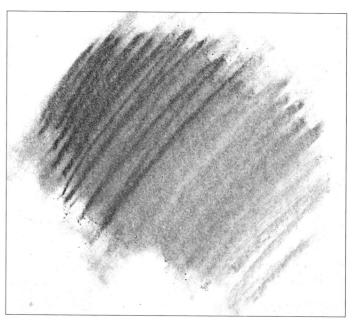

3 In this example, the blended colors still show the direction of the original hatching, creating a soft but active surface effect.

4 To blend flat color areas, begin by laying down areas of solid SHADING. Then, using the torchon, soften the transition from one color to another where the shaded areas come together.

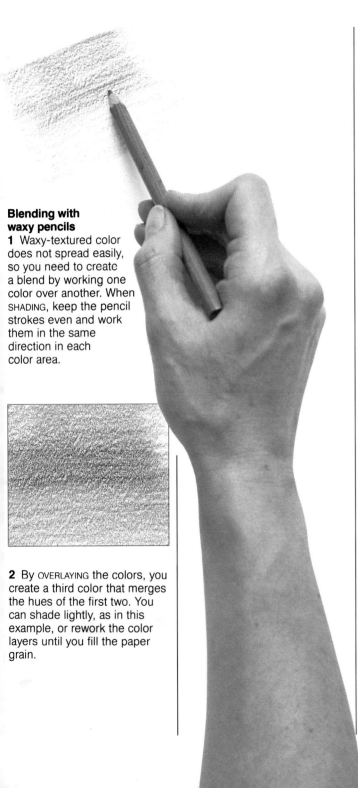

Blending with waxy pencils

1 Waxy-textured color does not spread easily, so you need to create a blend by working one color over another. When SHADING, keep the pencil strokes even and work them in the same direction in each color area.

2 By OVERLAYING the colors, you create a third color that merges the hues of the first two. You can shade lightly, as in this example, or rework the color layers until you fill the paper grain.

3 An alternative method of blending is to use the technique of crosshatching.

Apply a different color each time you change the direction of the sets of hatched lines.

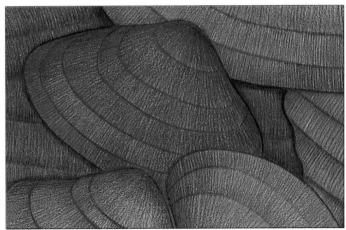

MATHILDE DUFFY
"Shell Tapestry" (Detail)
Subtle blends in the range from red through purple to blue have been achieved here by stroking one color into another with soft SHADING and HATCHING. The pencil lines follow the directions of the shell patterns, constructing form and texture at the same time.

The term "blocking in" refers to the early stages of establishing a composition in any medium. In colored pencil work, depending on the complexity of the image and the drawing style, it may involve sketching the main outlines and laying in blocks of shading and color to indicate form and volume using, for instance, light SHADING or HATCHING.

Generally, it is advisable to get a feel for the whole composition before working any single area in detail. This enables you to check that different elements of the image are in correct scale and proportion, and that the whole image area fits on the paper. However, because colored pencil work often involves delicate surface textures and a gradual build-up of detail, you must take great care not to overload the surface in the early stages, or make deeply impressed marks in the paper that will show through subsequent color layers.

The key is to keep the treatment light and open until you are satisfied with the overall effect; then you can start to develop the detail of form and color more distinctly.

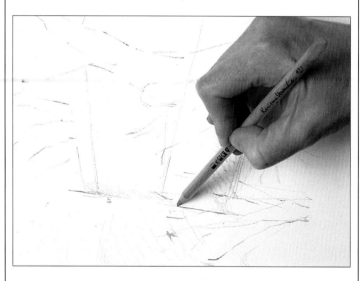

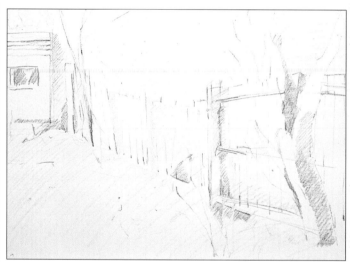

1 The first stage of this piece is the use of lightweight CONTOUR DRAWING to form a basic framework for the composition. The general shapes and patterns of the fence and trees are drawn in line.

2 As the view takes shape, the main lines are given more emphasis, and some soft SHADING is applied to indicate three-dimensional form. Only two browns and two greens have been used to identify different elements of the area.

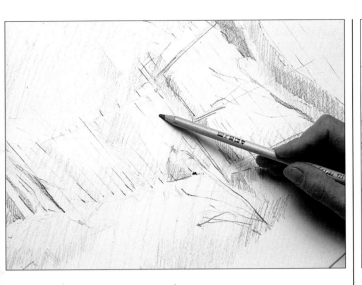

3 The overall impression of shape and color is developed with HATCHING and shading in the same color range, keeping the pencil marks light and open.

4 Gradually the weight of the shaded areas is built up to give solidity to particular shapes.

Additional LINEAR MARKS are applied to sketch further detail of the trees, shed and fence.

5 The process continues in the same way, introducing more colors but keeping the texture of the drawing open and workable. It is important when blocking in not to apply shading and hatching too heavily, or you close down your options for making changes and developing detail.

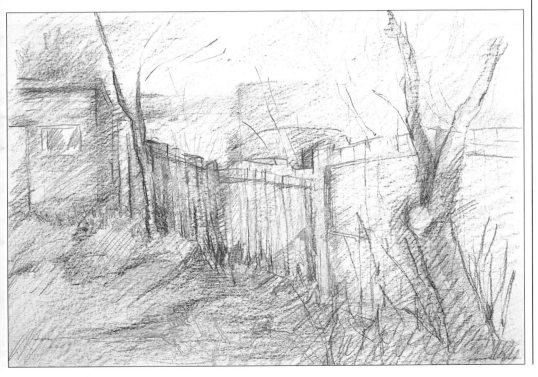

The general definition of burnishing is applying friction and pressure to make a surface smooth or shiny. Burnishing with colored pencils creates a glazed surface effect, compacting the color and ironing out the grain. It can give the impression of colors being more smoothly blended, and increase the brightness and reflectivity of the surface.

A commonly used method of burnishing is close SHADING with a white pencil over colors previously laid. You need to be careful to apply firm pressure, which physically compresses the underlying pigment and paper grain. The white overlay unifies colors and shading, while also heightening the surface effect.

Alternatively, you can use a paler pencil, a neutral gray or one with a distinct hue of its own such as a light, cold blue or warm pale ocher. This may be better suited to the mood or material of your subject, but remember that the color you choose will modify underlying hues, and you will lose any pure white highlights unless you leave them unburnished.

Dense, waxy colored-pencil marks can also be burnished with a torchon (a rolled-paper stump) or a plastic eraser. This avoids the color changes caused by overlaying a pale tint.

Burnishing can be used to give an overall finish to a whole image or employed selectively to imitate shiny materials such as metal, glass or smooth fabric. It can be the final stage of a colored pencil drawing, or you can rework the burnished area after spraying it lightly with fixative. The pressure you apply and the layering of colors may cause a "wax bloom" to build up on the surface, coming from deposits of the wax in the pencil lead. This can be gently wiped away with a paper tissue and the surface fixed to prevent the problem from happening again.

1 The chosen subject has two main colored shapes, a black hat and a green scarf. Burnishing is used to blend the shades and bring up highlights. First, the outlines are sketched in and the hat is shaded lightly with a chalky black pencil.

2 By OVERLAYING areas of SHADING, the shapes of the hat and scarf are modeled in tone. A torchon is used to burnish the colors, blending the shades to create softer gradations.

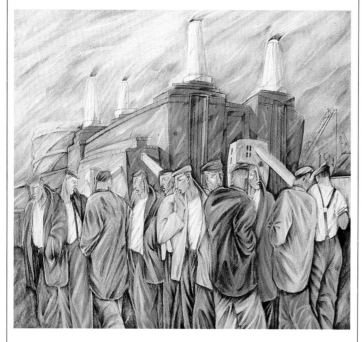

STUART ROBERTSON
"Battersea Power Station"
The artist has used directional burnishing to capture the texture of the workers' clothing. Using this technique and by emphasising the folds in the clothing, provides unity throughout the image.

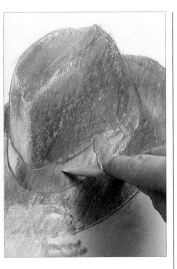

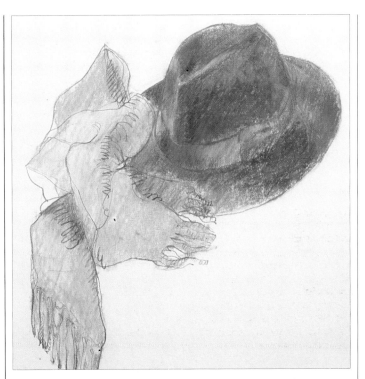

3 The light and shadow on the hat are enhanced by burnishing the highlight areas with a waxy white pencil. This merges the pencil marks, creating solid pale grays.

4 The folds of the scarf are modeled by overlaying color, using a yellow wax pencil over chalky green. You can also see where white has been applied over the green in the same way as on the hat.

5 In the final stage, loose drawing with a graphite pencil creates texture in the folds and fringe of the scarf. Linear detail can be freely applied over burnished color, although its surface is quite compact.

Effects of burnishing
Burnishing with a colored pencil compresses and polishes the first color layer. The color applied in the burnishing naturally affects the original hue. This example shows (left to right) an area of shading in red wax pencil; the same color burnished over with white; with blue-gray; and with light yellow; and the plain red burnished with a torchon.

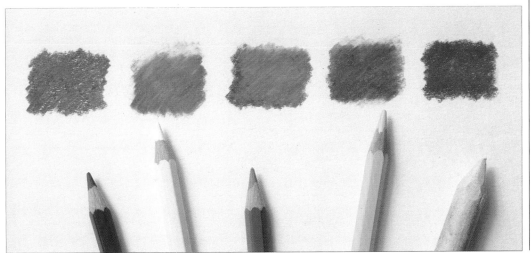

Drawing on a collaged surface extends the principle of working on COLORED PAPERS, allowing you to use different colors and textures of paper within a single image. It applies most effectively to subjects which contain distinctive forms and hard-edged shapes — it is a particularly appropriate technique for still life, architectural views and interiors, and also works well for informal portraits.

You can use papers varying from lightweight tissues to colored cartridge and pastel papers. Tear or cut the papers into the required shapes, assemble them on the base paper and stick them down, then work into the image with colored pencils to develop linear structure and textural detail.

To avoid tearing, especially of fine papers, allow the adhesive to dry before you start to draw. Remember, too, that the thickness of a torn or cut edge will disrupt the path of your pencil slightly, so be careful when working on drawn details that cross between different areas of the collage.

1 The main shapes in the still life are cut out of COLORED PAPERS corresponding to the basic color of each fruit. A brief outline is sketched before cutting, and the first cut shape is used to determine the scale of adjacent shapes, as here with the leafy tuft of the pineapple.

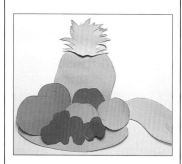

2 When all the main elements are cut out, the pieces are assembled roughly on the backing paper, to get the composition right and check the relationship of shapes.

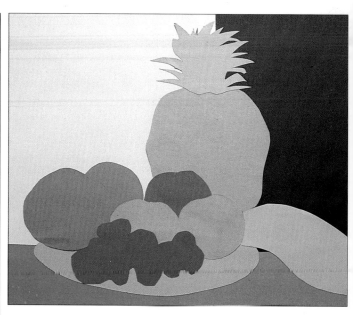

3 To make a dramatic image, the artist decides to use strong, solid colors to form a simple background. These geometric blocks are cut and pasted down, then the fruits are stuck on one by one to complete the still life. If you use a spray or rubber adhesive, you can lift and reposition the shapes when necessary.

4 Allow your adhesive to dry before drawing over collage – if the paper layers are damp, the pencil point may tear the surface. The drawing begins with detail of the pineapple leaves, using line to define the intricate shapes and introducing tonal SHADING and color variations.

5 The faceted texture of the pineapple skin is treated in the same way, using line work and shading to develop form and texture. Notice that you can apply colored pencil over the background if you wish, to refine the contour of the original collaged shape.

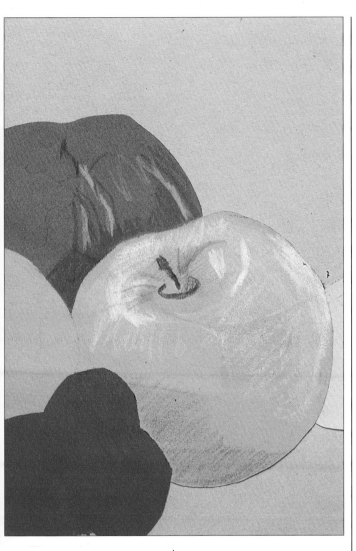

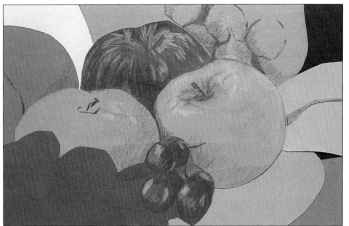

7 The drawing mainly adheres to the outlines of the collaged pieces, but contours and shadow areas drawn with dark pencil colors are used to redefine shapes when required.

In the grapes, this technique is used more extensively to create the smaller shapes of the individual fruits and stems within the overall color area.

6 The paper color for the green apple is a good match for its skin color. Lightweight shading in dark green, white and yellow is applied to model the rounded forms and bring up highlights. The red apple has more complex color variations, which are stroked in with rapid lines.

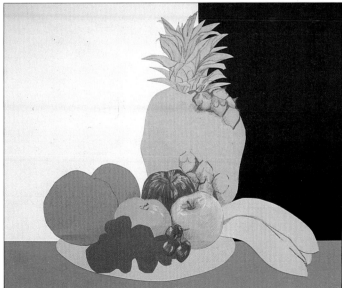

8 The process will continue until all of the fruits are drawn in detail, then any problems with the balance of color and shading can be corrected with final touches to the colored pencil drawing.

COLORED PAPERS

The small area of contact that the pencil tip has with the paper means that it can take a lot of time and effort to build up areas of solid color. Depending on the nature of your subject and the style of your drawing, working on colored paper can have distinct advantages. The color of the ground can be used in two particular ways. First, it can act as a medium shade, which enables you to key the variety of tones and hues in your applied colors. Second, it can form a unifying element of the composition, perhaps standing for a specific element of your subject — for instance, blue for sky and seascape, green or terracotta for a landscape, a warm beige or buff background for an interior or still life.

Colored pencils are often slightly translucent, so the paper color modifies the pencil colors, especially the lighter tints. You may wish to make a tint chart trying out the effect of colored lines and areas of shading on the ground you intend to use. This enables you to predict modifications and make use of the harmonies and contrasts that the paper color can introduce.

It is best to select low-key or neutral shades and colors — very brightly colored papers can make it difficult to handle your range of pencil colors, although on occasions you might need a dramatic color effect to suit the mood of the subject.

If you want to include subtleties such as blended background colors or light textural effects, you can prepare a colored ground by putting a watercolor wash over stretched white paper.

There is little advantage to using a colored ground if you eventually cover it completely, so experiment with pencil techniques that give an open surface texture, allowing the paper color to contribute, such as DASHES AND DOTS or HATCHING.

A selection of colored papers
A colored paper will be closer to the average tone of the picture, making it easier to key the variety of shades in your applied colors.

Drawing on colored paper
1 Select a paper color that harmonizes with the basic colors of your subject, as here, or one that will create a dramatic opposition. If you wish to begin with an outline, sketch it in lightly and begin BLOCKING IN the main color areas.

2 Build up the SHADING gradually at first, introducing as many colors as you need to match the variations in the subject.

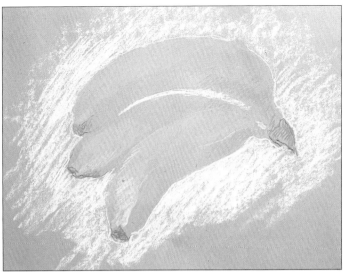

3 As you begin to shade more heavily, you can obliterate the paper color in certain areas, while retaining it in others to help with the modeling of color and shading.

4 The muted paper color here acts as a middle shade against the brighter yellows and white highlighting and background.

Lightweight LINEAR MARKS in brown define the banana stalks and tips.

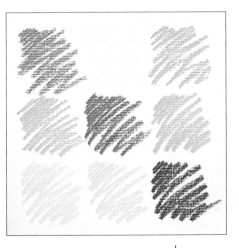

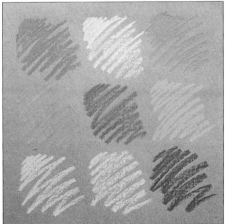

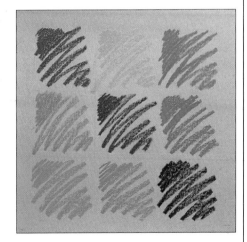

Making color charts
The paper color affects the appearance of your pencil colors, especially those which are light-toned or translucent. You may find it helpful to make quick color charts to check the variations. Notice, for example, how the warm brown ground and cold blue one create a significant difference in the effect of the cool gray and yellow ocher pencils (bottom left and center). The orange (middle right) appears lighter on brown than on blue. The translucent bright yellow (center top) is diminished in intensity by the underlying blue, but the red (top left), which is a naturally dense, strong hue, is less influenced by different background colors.

This technique takes advantage of the linear capabilities of colored pencils as a means of investigating three-dimensional form and volume. The planes and curves of solid forms are described in line only, using both the outline of the subject and the contours within the overall shape to model the image.

A very economical line drawing can be highly expressive of form — the key is to be sensitive to the LINE QUALITIES that best describe different elements of the subject. A variable line that swells and tapers, for instance, is more descriptive of curving contours than a line of even weight. Imagine tracing the

actual surface of an object with your pencil, so that the pencil point travels easily over the form, but with varying pressure relating to surface planes and undulations. The essence of a contour drawing is the same, but you are transferring these impressions to a flat surface.

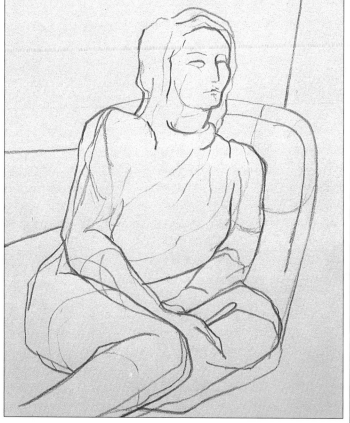

Monochrome drawing
1 In contour drawing, if you are using colored pencil in the same way that you would draw with graphite pencil, it is best to choose a dark-toned color. The effect of, say, indigo blue or burnt umber, is softer in mood than black. This drawing begins with the outline and main features of the seated figure.

2 Although contour drawing is a minimal process, using only the linear cues in your subject, you do not have to get it all right first time. As you trace and retrace the contour lines that you see, the "correct" form will emerge, and you can enhance the effect by strengthening the weight of certain lines.

▼ LESLIE TAYLOR
Untitled
This drawing shows an interesting combination of contour drawing and subtle SHADING. Although the shading contributes a sense of volume through surface modeling, the viewer's "reading" of the image depends strongly on the linear framework created by the contour lines.

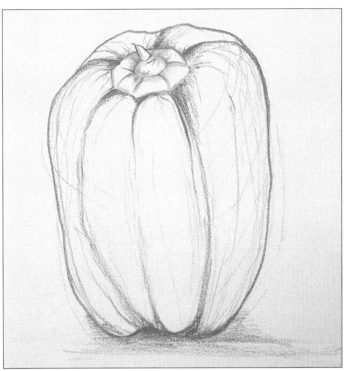

Using local color
1 With some subjects, you can obtain a good effect by choosing a pencil corresponding to the local color of the object; that is, the color that you see under normal light. A rich warm red is chosen to match the skin color of a red pepper.

2 The lines of the contour drawing create the overall shape of the pepper and the swelling curves within the outline. For contrast, touches of green are applied within the red outline of the core.

C O U N T E R P R O O F I N G

This is a simple, quick technique for transferring a graphite pencil drawing from one sheet of paper to another, thus producing a lightweight, reversed image. It is a suitable transfer method for work to be done in WATERCOLOR AND PENCIL, since it involves dampening

the paper, which will have no ill-effect if you are transferring the drawing onto paper stretched for watercolor work.

Spray the original pencil drawing with a light haze of clean water, using a fine plant spray (it is important to moisten, not soak the paper, or it will disintegrate when you apply pressure). Lay it face down on the drawing paper, and apply even pressure to the back to "print off" the image. You can do this by rubbing lightly but firmly with a soft cloth or sponge.

For other methods of laying out the guidelines of a composition, see also SQUARING UP OR DOWN, and TRACING.

2 Lay the drawing face down on a clean sheet of paper. Rub the back and apply pressure evenly to press down the graphite lines. In this demonstration, a torchon is used to press on the back of the paper with a motion like that of shading with a pencil, but you can equally well rub with a soft cloth or the back of a spoon.

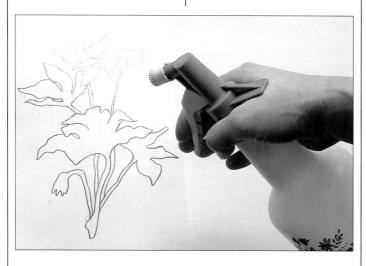

1 The original drawing that you use for counterproofing should be in soft graphite pencil and should not be fixed. Use a fine-spray plant mister to dampen the surface of the drawing.

3 Turn back the original drawing to check that the lines have been transferred to the clean paper. You should obtain a soft, grayed line image that can be covered by the colored pencil marks. Wait for the paper to dry before starting work.

DASHES AND DOTS

Brief marks made rapidly with the point of the pencil by stroking, stabbing and twisting the pencil tip on the paper can be used to build up color masses or to represent surface texture. This is not the same as the dot technique known as STIPPLING, which needs a fairly systematic approach if it is to work as an effective modeling method.

Depending on the quality and motion of the pencil point, you can obtain quite a fine, calligraphic effect or an active, aggressive pattern of marks. You can work over flatly shaded color areas, or build up color masses by repeatedly reworking the dash and dot patterns with different colored pencils. This is a lively, informal technique, and by experiment you will find out how it can relate to particular qualities in your drawing.

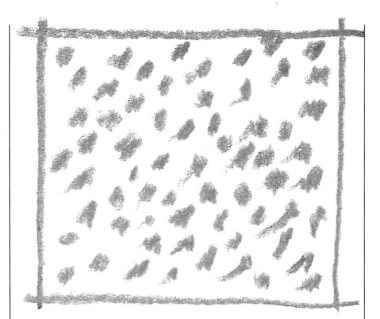

▲ Scribbled dots
Rough-edged, broad dots are created by moving the pencil in a brief scribbling motion, not by stabbing at the paper.

▼ Ticks
Rapid ticks form a loose, open pattern of irregular marks. Some marks are almost straight with a slight hook; others become active zigzags.

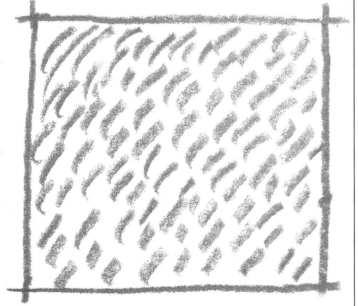

Directional strokes
These loose dashes follow the natural direction of a slanted stroke drawn by a right-handed person. The pencil is used slightly blunted to make a grainy mark.

Feathered strokes
Lightweight vertical dashes merge into a soft directional pattern. The blunted pencil tip and gentle pressure create an atmospheric, grainy texture.

Irregular spacing
While applying these sideways dashes, the spacing and pressure have been varied to suggest an irregular, slightly undulating surface.

Mixing colors
Yellow, dark pink, burnt sienna and burnt umber are overlaid in open patterns to produce a meshed color effect. From a distance it reads as a coherent surface. Some kinds of textures and colors are better represented by an active technique than by a smooth blend.

D R A W I N G I N T O P A I N T

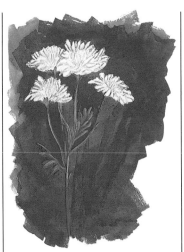

The main purpose of this technique is to combine the fine linear qualities of the relatively hard pencil tip with the fluid or solid textures of brushed color. The effect varies depending on the type of paint. With thick, opaque paints such as gouache or acrylic, you can obtain a three-dimensional texture by creating grooves and ridges in the paint, at the same time depositing color from the pencil within the grooves. If you work into a thinner wash of color, the grainy texture of the line drawing contrasts with the fluid coverage of the paint.

Remember that the pencil tip creates friction on the paper, for this reason when you work into damp paint there is a risk of tearing the underlying surface. If you want to draw into watercolor or gouache washes while they are still wet, use a soft waxy colored pencil or a water-soluble one that will be slightly dissolved by the paint. (See also SOLVENTS, WATERCOLOR AND PENCIL.)

Gouache and colored pencil
This painting began with the background wash of red gouache, leaving the shapes of the flowers roughly silhouetted on the white paper. White gouache was thickly applied to the shapes, and colored pencils were used to draw in the petals, making a three-dimensional "relief" effect. Stems and leaves were drawn with a brush and green gouache, then pencils were used to shade the tones and insert linear detail.

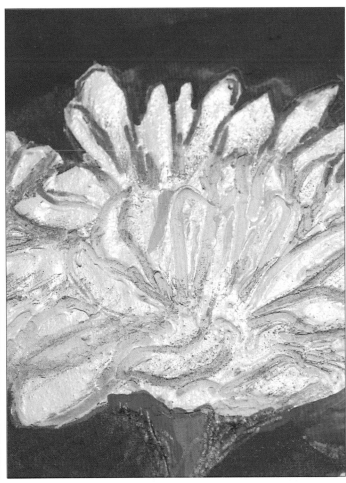

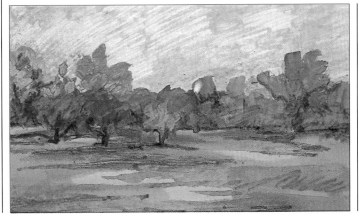

Acrylic and colored pencil
In this example, the acrylic was applied as thin glazes of color, building up the local colors and the effects of light in the foreground. Drawing with colored pencils into a wet glaze moves the paint and creates a vigorous texture (as in the sky and trees). Dark pencils were used as the glazes dried to sharpen the detail of the trees and suggest the darkest shadows, adding black, red-brown and purple to contrast with the greens.

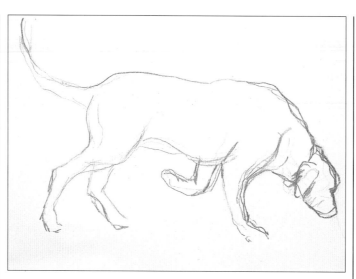

Using an eraser to make corrections is a limited process in colored pencil drawing. Only lightweight strokes can be eradicated completely; a dense application typically leaves a color "stain" on the paper even after quite vigorous rubbing with an eraser, and heavy linear marks will also leave an impression in the paper surface that may show through subsequent reworkings.

The efficiency of erasures also depends on the type of eraser and the texture of the colored pencils you are using. A plastic eraser used on waxy colored pencil marks may spread the color rather than lift it — you can use this effect positively as a means of BLENDING colors or BURNISHING the surface.

An eraser may retrieve the surface enough to allow you to rework the area to modify tones and hues. Where you have a thick build-up of waxy color, use the flat edge of an art-knife blade to scrape away the excess before using the eraser. If you have made a serious error in one part of the drawing at a late stage, it may be possible to insert a PATCH CORRECTION.

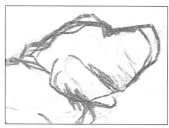

1 Eraser techniques can be used both for correction and as a positive drawing element. The outline of the dog is drawn on smooth paper. The detail (above) shows where corrections have been made to the head.

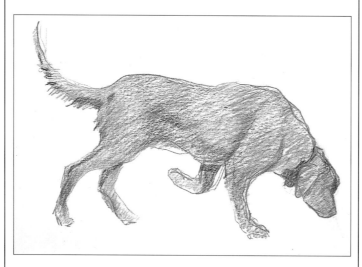

2 The shape of the animal is roughly modeled overall, using light warm brown and dark umber to shade in the basic tones and colors.

3 A plastic eraser is used at the contours of the animal's tail and underside to drag the color outward, making light, feathered marks corresponding to the texture of the longer fur.

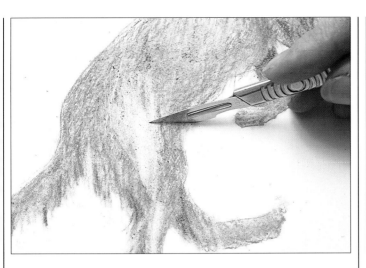

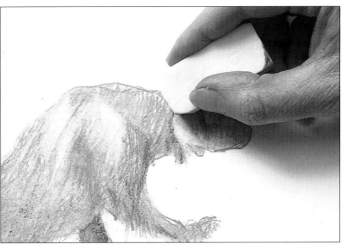

4 To brighten the highlight areas on the flanks and shoulders, the color is scraped back with an art blade. This works best on smooth-surfaced paper, and you must keep the edge of the blade flat to avoid gouging the surface.

5 The plastic eraser is used again, this time for cleaning up the drawing and BURNISHING the highlight areas where the color has already been scraped back.

6 Compare the finished image to stage 2: the work with eraser and blade has enhanced the impression of form and texture as well as allowing amendment of incorrect shapes and over-heavy color. A little more loose pencil work has also been applied to roughen up the furry texture.

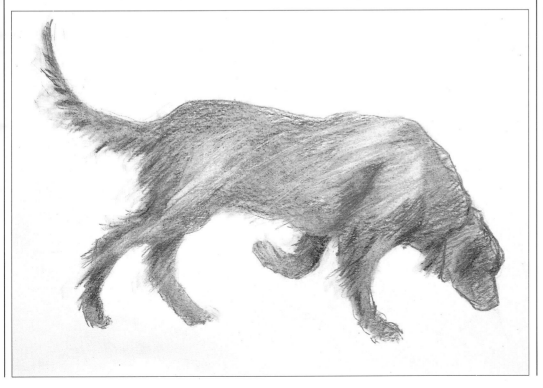

Certain types of color drawing will require you to fill a hard-edged shape quite precisely with solidly shaded color. Controlling the pencil to follow an intricate outline while maintaining consistent pressure and direction in the shading is not easy, but it is a skill that comes with practice.

The method you use to color a filled shape depends on the edge quality you wish to achieve and the complexity of the color effects within the shape. If you have to turn the pencil — or the paper — to gain access to various parts of the contour, bear in mind that a change of direction in heavy shading can show up. To obtain a smooth finish, apply the shading lightly so that the directional strokes are barely perceptible, and build up the color in fine overlays.

A mask or stencil (see also MASKING) is a useful device. You can shade up to or over the edge of the masked shape, so that the direction of the strokes remains consistent. If you like the effect of a hard outline, you can use the technique of IMPRESSING to give a clearly visible contour, either in the same color that you are using for the shape or in a contrasting shade.

Working to an outline
1 Trace your drawing down lightly on the paper to form a faint guideline. To create a clean, hard-edged shape, draw the outline with the color you intend using to fill it.

2 Apply solid shading within the shape, working carefully toward the outline. To fill small curves and angles, you can work the shading in different directions, but keep it dense and even to obtain a flat color area.

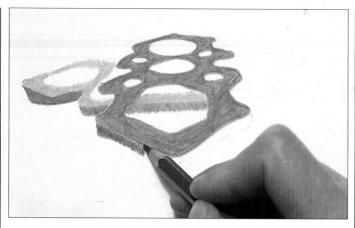

Free shading
Here shapes are freely shaded to provide a soft edge. You may find it easiest to control the color area by angling the shading toward the contour lines, with strokes of even weight and length.

Edge qualities
In the completed vignette, the varied edge qualities give interest to the drawing. The lighter green has been shaded over the brown to bring the colors together. Some loose color work has been applied on top with moistened watercolor pencils in red and purple, and the ground shadow is loosely shaded in gray to bleed off into the white paper.

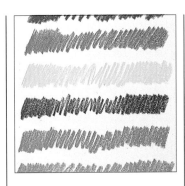

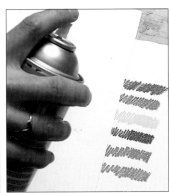

Fixing is by no means essential, although useful in some types of colored pencil work, but in general, the finish of a colored pencil drawing is not fragile, nor is it prone to smudging under normal handling. However, where you have a heavy buildup of soft-textured colored pencil, you may wish to apply a light spray of fixative as a finishing coat to protect the surface.

Fixative can also be applied at intermediate stages of the drawing. This sometimes makes it possible to go on working a surface that has become slightly resistant.

Spray fixatives, available in CFC-free aerosol cans, are colorless in themselves, but they can affect the colors you have laid down, sometimes darkening their shades or dulling their brilliance. You can carry out a simple test by shading blocks of color and then masking off one half while spraying fixative on the other. When it has dried, you can see whether the fixed half of each color block differs from the original hue.

Color testing
1 Select the colors that you intend to use in a drawing and make blocks of shading with each one on white paper. You can use this method to test all your pencils.

2 Place the color chart flat on your work surface, and cover half of it with a clean piece of paper. Apply fixative as described on the left.

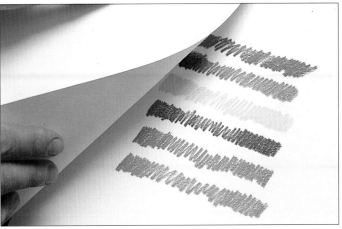

3 Pull back the covering sheet and compare the sprayed and unsprayed halves of the color blocks to see if the fixative has affected the hue or shades. In this example, there is no appreciable difference.

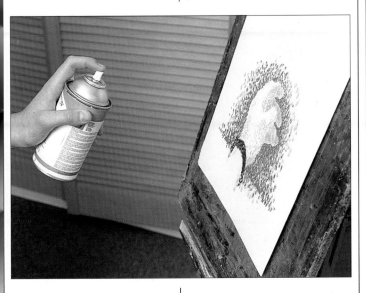

Applying fixative
Hold the can of fixative about 12in. (30cm) away from the surface and spray lightly but evenly to cover the whole of the drawing. If you are using chalky pencils that deposit very loose color, you can apply a second coat, but be careful not to saturate the surface.

This technique consists of SHADING with a pencil on a piece of paper laid over a textured surface; an impression of the underlying texture comes through. Because colored pencil leads are quite fine and responsive, you can obtain detailed effects from all kinds of material – wood, brick or stone; engraved or embossed metal, glass or plastic, or fabrics with a coarse, woven mesh.

The frottage can create an abstract pattern to enliven color areas, or it can be used to simulate the actual material. An even texture such as that of burlap, for instance, forms an effect similar to dense crosshatching (see HATCHING); you can build up its complexity by shifting the paper slightly and reworking with a second color. Wood grain reproduces very effectively – if the subject of your drawing includes a wooden floor or table, you can take an impression of wood texture in a dark shade and then work into the grain pattern with several colors to create a very naturalistic effect.

The rubbing can be made directly on the relevant area of your drawing, or it can be inserted as a collaged element.

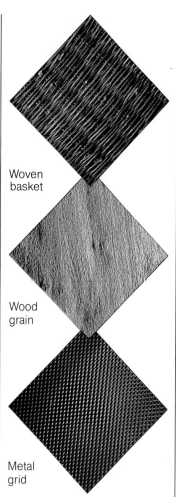

Woven basket

Wood grain

Metal grid

Materials for frottage
It is possible to obtain detailed effects from all kinds of materials.

Textured wallcovering
This rubbing from a section of wood-chip wallpaper found in an ordinary house interior produces a broken, irregular texture that could be used to simulate natural weathered stone or rough concrete.

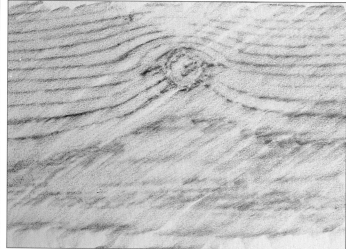

Wood grain
Some types of finished wood, as used for shelving and furniture, for example, are too smooth to provide good surfaces for rubbing. This example comes from an old wooden plank broken off from a fence. The knot and grain come up very clearly.

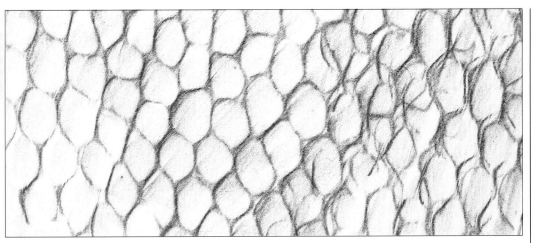

Textured glass

Window glass with a lumpy, "pebble" texture produces an interestingly graphic network of color (left). On the other side of the glass, the swellings and hollows are reversed, and the frottage forms a kind of leopard-spot pattern (center). Two colors overlaid, using the front of the glass to give the texture, create a fluid, rippling pattern of interwoven lines (below) that could form a pictorial equivalent for the surface of flowing water.

Gradation from one hue or shade to another should be smooth and consistent. If you are filling a broad area of sky in a landscape drawing, for example, you do not want to see distinct bands of color, but gentle, subtly varied transitions.

There are various different techniques you can use to create gradations, the one you choose depending on the style and textural qualities of your drawing. Carefully graded SHADING is very effective if you are aiming for a photorealist finish or an atmospheric mood. But you can get very good results using linear techniques such as HATCHING or STIPPLING. To create successful gradations, you need to control very carefully the way you mix and overlay hues and shades to achieve an integrated surface.

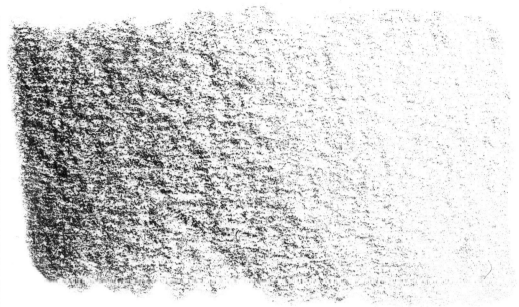

Tonal gradation
1 A very subtle transition through graded tones of one color is achieved by shading carefully with the pencil and gradually decreasing the pressure to lighten the tone. It requires careful handling to avoid abrupt changes that would produce the effect of successive color bands.

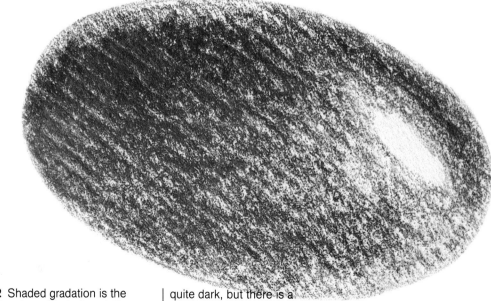

2 Shaded gradation is the classic method of modeling form with pencils. In this example, the overall tone is quite dark, but there is a smaller area of medium tone surrounding the white highlight.

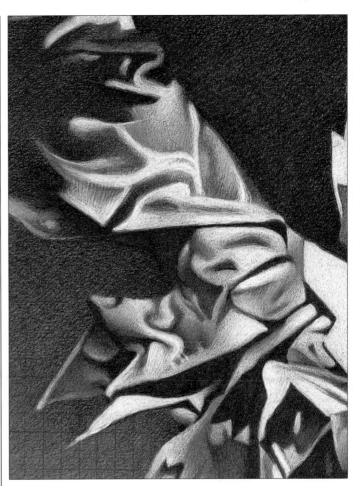

Color gradation
1 The tonal gradation used in the previous demonstration is transformed into a delicate color gradation by laying in a lighter turquoise-blue over the pale tones of the original mid-blue, shading off on a similar scale of density.

2 A gradation through three colors is expertly controlled to avoid the effect of a hard line at the junction of the color areas. This technique is only mastered with practice, during which you learn to lighten up the shading by just the right amount, then work in the next color seamlessly.

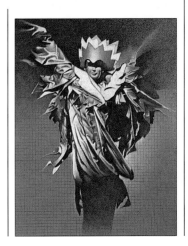

BILL NELSON
"Winged"
Modeling with graded shades and colors produces a remarkable "super-realist" effect in this dramatic image. The complex folds of the garment, the weight and surface sheen of the fabric are all suggested by clever handling of tonal variations and subtle changes of hue. But as the detail picture above shows, the artist employs a relatively free technique, combining SHADING and HATCHING to achieve the gradations.

Graphite pencils and colored pencils are natural partners, since they are drawing tools of exactly the same shape which are handled in the same ways. Every artist finds different values in exploiting mixed-media techniques for particular purposes. A technical advantage of incorporating graphite with colored pencils is the range in quality of graphite leads — you can obtain varied characteristics from the fine silvery grays of H and HB pencils to the increasingly strong, intense blacks of the softer B series. Because graphite is a slightly greasy substance, and more gritty than colored pencil leads, it gives a different kind of line quality, and the dark shades are not the same as those produced by colored pencils containing black pigments.

You can either mix the two kinds of pencils freely or use the graphite to create a monochrome drawing which you then "glaze" over with color by SHADING in colored pencil. Both media are highly responsive to both delicate and vigorous handling, and are easily applied to a wide variety of paper types.

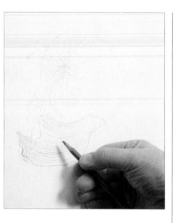

1 When producing a drawing which integrates the graphite and colored pencil textures, begin working with the graphite to set the linear framework and dark shades.

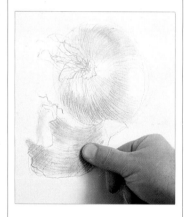

2 Soft graphite spreads easily when rubbed with the fingers. In this example, the shadow areas are softened by rubbing.

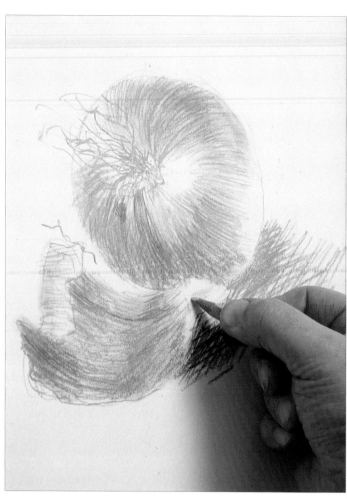

3 The basic colors on the onion are introduced with light SHADING and HATCHING in yellow, yellow ocher and burnt sienna.

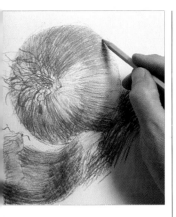

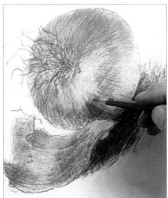

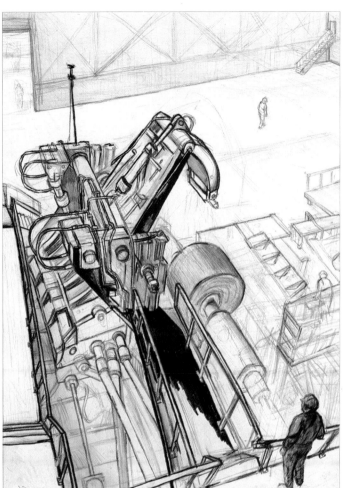

4 As the drawing progresses, further colors are applied to obtain the subtler hues and shadow colors. The textures of the graphite and colored pencils are allowed to mix freely.

5 The color is built up gradually to develop solid form. The graphite pencil is used again to sharpen some of the line detail in the drawing, enhancing the veined effect of the onion skin. Notice that the cast shadow has been strengthened with dark brown and gray shading.

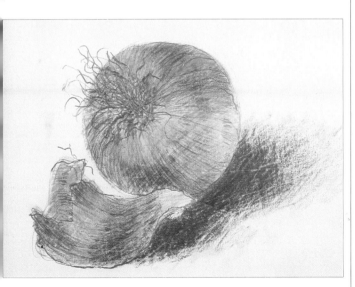

6 In the finished drawing, the graphite lines and shading describe the basic shapes, texture and dark shadow, while the colored pencils contribute local color and highlighting.

PHILIP STANTON
"British Steel"
In this drawing, the artist has used graphite pencil to sketch out the complex framework of the composition and establish the relationship of forms. The tones and linear detail have been strengthened with black pencil, and colors have been introduced where appropriate. When a subject presents a difficult perspective or elaborate structure, as in this example, using graphite pencil enables you to draw freely, and erase and correct before you apply color. Also the graphite lines contribute lively calligraphic styling and textural contrasts.

There is no right or wrong way to hold a colored pencil — any grip that is comfortable and gives you control of the pencil movement is right for you. However, the surface effects you obtain can vary subtly in response to the way you handle this simple drawing tool. They are affected by the pressure and direction of the marks you apply and their range and extent.

The conventional grip in which the shaft of the pencil rests in the curve of the thumb, with the tip guided by your thumb and first two fingers, gives tight control. You can make very delicate marks, firm lines and even shading by small movements of the fingers, wrist and hand. For more open, scribbled or hatched textures, you can use more sweeping movements of your hand and arm.

Alternatively, you can grip the pencil with your hand curled over or under the shaft. These grips give less subtle control, but encourage free gestural movements of the hand and arm. For instance, SHADING with an underhand grip can be very light and quick, while LINEAR MARKS made with the overhand grip can be heavy and vigorous.

If you are experimenting with a change of scale or textural variations in your work, it is always worth trying different ways of physically manipulating your medium.

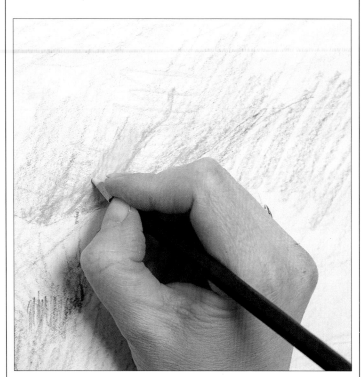

Conventional grip
The common method of holding a pencil, similar to the grip used for writing, gives tight control over line work and shading (above left). Holding

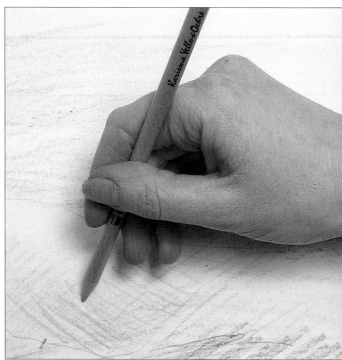

the pencil higher up the shaft (above right) gives you a freer handling method for loose shading and hatching, and you can also approach the drawing from different angles.

Overhand grip
If you hold the pencil with your forefinger over the shaft, rather as if you were stabbing something with a fork, it tends to encourage firmer pressure. It is a good way to develop dense shading (right), or to produce a strong line quality (far right).

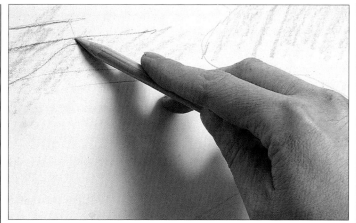

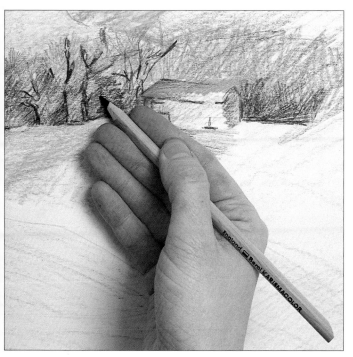

Underhand grip
This method in which you cradle the pencil in the palm of your hand, confines the movement of the pencil tip. Applying pressure with thumb and forefinger (right), you can produce a heavy but sensitive line quality – to make the line your whole hand moves, not just the wrist and fingers. Underhand shading has a lighter touch (above) and you can vary the pressure just by lifting your fingers slightly.

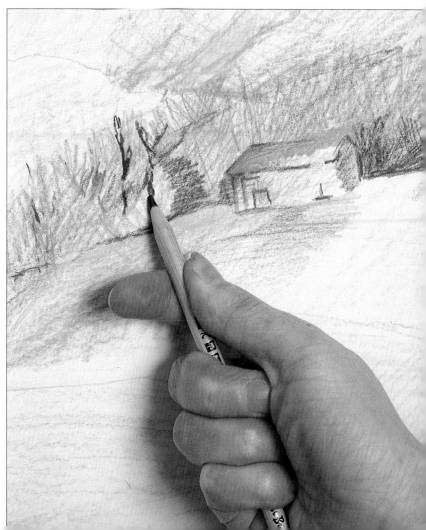

Colored pencil is naturally a line medium, although there are many ways of building up areas of solid and mixed color. Hatching and crosshatching are traditional methods of creating effects of continuous tone using linear marks. With a color medium, they can also be a means of integrating two or more hues and producing color changes within a given area.

Hatching simply consists of roughly parallel lines, which may be spaced closely or widely, and with even or irregular spacing. In monochrome drawing, the black lines and white spaces read from a distance as gray — a dark gray if the lines are thick and closely spaced, a pale shade if the hatching is finer and more open. The effect is similar with colored lines, the overall effect being an interaction between the lines and the paper color showing through.

Crosshatching is an extension of hatching in which sets of lines are hatched one over another in different directions, producing a mesh-like or "basketwork" texture. Again, an area of dense crosshatching can read as a continuous tone or color. However, both techniques bring an additional dimension to the drawing. The direction of the lines can be manipulated to describe form and volume; the textures of hatching and crosshatching produce a more lively surface effect than solid blocks of shading or color, while still constructing coherent shapes and masses.

The effects of these techniques vary according to the character of the lines you draw, their spacing and direction, and the interaction of hues and tones. With practice, you will discover how these elements can be applied to describing specific aspects of form and space, local color, and qualities of light and shadow in a composition.

Free hatching
The lines of hatching do not have to be distinct and separate. Here the second layer of color is hatched over the first with a free scribbling motion (left).

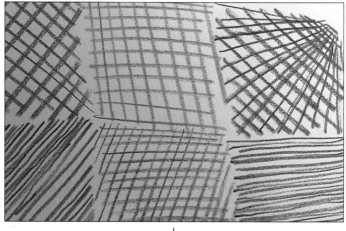

Hatching
The technique of hatching can be clean and systematic, or free and variable. The lines can be of relatively equal weight and spacing (top), or may vary from thick to thin, with gradually increased or decreased spacing (above).

Crosshatching
The denser texture of crosshatching gives you more options for developing shading and color. The same color crosshatched creates an integrated network of lines (above) which can be straight, curved or directional. Using different colors (top) adds tonal and color interest.

Varying the texture
Different qualities of shading and texture are developed by varying line weight and spacing, and by combining colors. Lines that are converging rather than parallel (top right) suggest space.

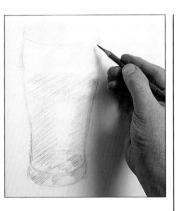
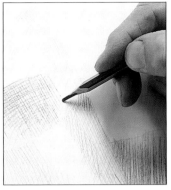
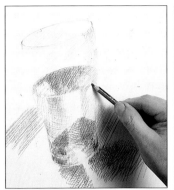
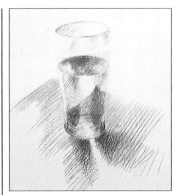

Constructing form
1 To model a form with hatching and crosshatching, you need to begin with a clear impression of the shapes and tones in your subject. This drawing starts with a pencil outline and lightly hatched indication of light and shade.

2 The medium and dark shades are developed with black and blue pencils. When you are working on fine hatching, the pencil needs to be kept quite sharp to maintain an even line quality.

3 With the introduction of a lighter blue and the gradual build-up of the darkly crosshatched areas, the drawing takes on a definite impression of three-dimensional form.

4 The tonal structure is continually intensified, keeping to the basic monochromatic palette. The different densities of the hatching and crosshatching divide the overall shapes into distinct areas of light and shadow, describing the glass, the flat table-top and the effects of transmitted and reflected light.

JOHN CHAMBERLAIN
"Gymnast"
A very free use of these linear techniques is cleverly controlled to model the gymnast's body quite precisely. The heavily grained paper enhances the patterned effect of hatching and crosshatching, but the arrangement of line and color makes a solidly descriptive image.

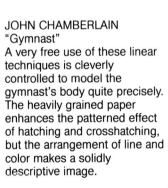
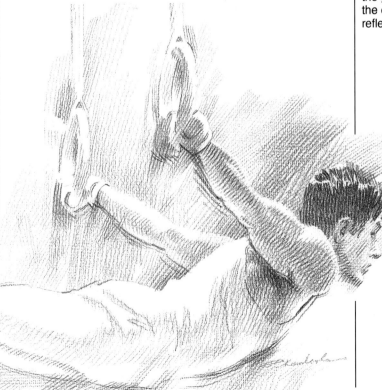

A highlight is the brightest point of reflected light in an image, typically represented in drawing and painting as a flash, spot or patch of pure white. Because of the translucency of colored pencil leads, it is difficult to obtain a clean effect by applying white highlights as finishing touches, as you can with an opaque medium such as pastel, gouache or oil paint.

There are methods of creating highlights that rely on allowing the white of the paper to show through the color — leaving the paper bare so that the highlight is a distinct white shape, or erasing the color to retrieve the paper surface. Erasure only works well if the color application is light and the paper surface quite resilient. The technique of IMPRESSING can be effectively applied to creating fine linear or dot highlights.

If you are working on COLORED PAPER, you can apply bright highlights with a white pencil directly on the paper surface — if the pencil is fairly soft-textured and the paper color not too intense, you should obtain a clean white. If you do need to impose highlighting over a densely worked colored pencil drawing, you can add opaque color in the final stage using pastel or paint, being careful to create marks of suitable scale and texture to integrate with the colored pencil strokes.

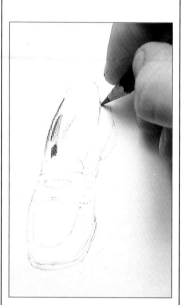

1 When you are planning to create highlights by leaving the white of the paper bare, you must achieve a clear "map" of your subject before you start shading. Make a light outline drawing that locates the important shapes.

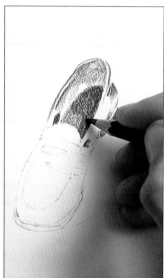

2 Shade in the color slowly, working up to and around the highlight areas. Take special care when dealing with fine detail, such as the linear highlights on the heel of this shoe.

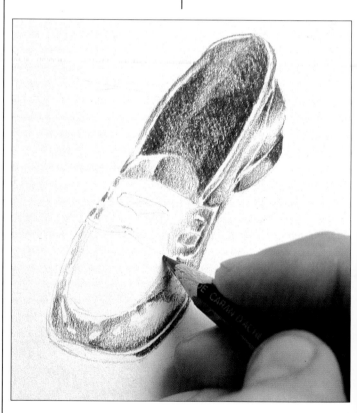

3 Build the tones gradually, keeping the contrast of lights and darks. Try to hold your hand clear of the drawing, to avoid smudging color into the white areas. When you are working on a broader composition, use a clean sheet of paper to protect the area beneath your hand.

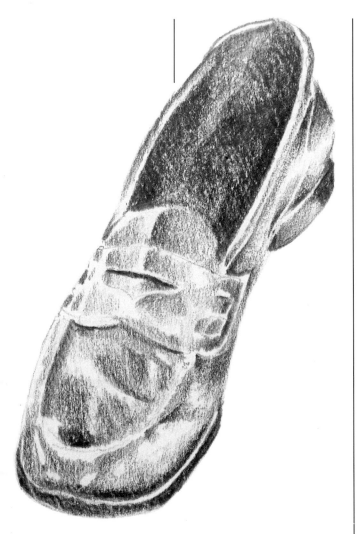

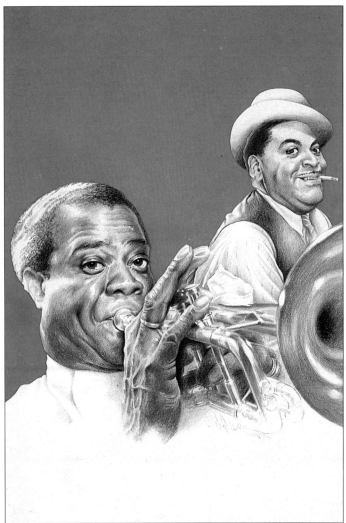

4 The finished drawing gives an effective impression of the shiny leather, by forming an appropriate contrast of the lightest and darkest shades, and leaving soft but clean edges to the highlights.

JO DENNIS
"Louis Armstrong and
Fats Waller"
Very strong highlights give a heightened sense of realism to a naturalistic rendering and make the image sparkle. To obtain clean whites, make sure the paper surface remains untouched in highlight areas, or paint them in at the last stage with opaque white gouache.

IMPRESSING

The basic principle of impressing is that of making a mark that actually indents or grooves the surface of the paper. You can then work over it with gentle pencil SHADING which glides across the impressed mark, so that it remains visible through the color overlay. For a clean effect, the impressed line should be pushed well down below the paper surface, so place a newspaper beneath the drawing paper to allow some "give" when you apply the pressure.

The impression can be colorless, made with a hard pointed instrument that marks the paper firmly, but is not sharp enough to tear it. A blunted stylus or the wooden end of a paintbrush could be used, for instance (and artists have been known to improvise using keys, their own fingernails or any suitable hard object). This means that the impression shows itself as the paper color (white or tinted) after you have shaded over it.

Alternatively, you can make the same sort of "blind"

impression by working on tracing paper laid over the drawing paper, using a stylus, hard pencil or ballpoint pen to apply heavy pressure. The process of constructing a complex image in this way is demonstrated under WHITE LINE.

If you want the impressed marks to appear in color, you can either form them with the sharpened lead of a colored pencil or you can put down an initial area of solid color and make a blind impression on it as described above, before overlaying a second color.

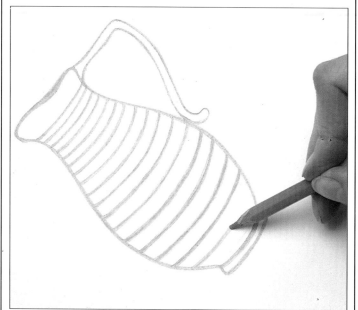

Impressed colored line
1 Make a drawing of your subject with firm, even contour lines, pressing the tip of the pencil hard into the paper.

Layers of newspaper placed underneath help to create the necessary "give" in the paper surface.

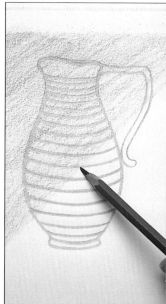

2 Shade lightly over the drawing, allowing the pencil tip to skip over the impressed lines. You will see that the original lines read clearly through the overlaid color. You can use more than one color for both the outline drawing and the shading, to form a more complex image.

 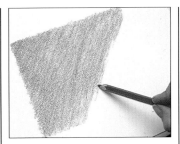 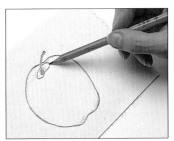

Blind impressing

1 Make your initial drawing on tracing or thin layout paper. Place a clean sheet of drawing paper on newspaper and lay the tracing over it. Retrace the outlines very firmly with a sharp pencil point or ballpoint pen.

2 Lift the tracing paper from one corner to check that the line is distinctly impressed on the drawing paper. Be careful to keep one edge of the tracing in place, so it goes back in precisely the same position.

Blind impressing over color

1 The basic method used here is exactly the same as blind impressing, but you work onto color instead of on white paper. First, create an area of even shading in one color.

2 Use a trace drawing, as before, as the guideline for your impressing. Make sure you locate the image in the right position over the shaded color.

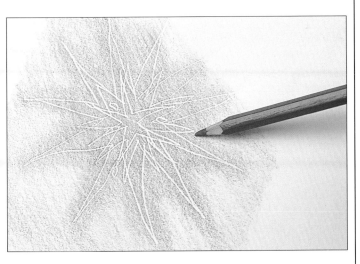

3 When the impressing is complete, remove the tracing and put the paper on a drawing board or other suitable work surface. Shade color over the impressed lines, using a light but even motion. You can blend or overlay colors in different areas of the drawing. Be careful not to apply so much pressure that the pencil tip is pushed into the white lines.

3 Shade over the impression with a second color, so that the first color appears as line only. The overlay creates a subtle effect, but to read the line clearly, you need to choose colors with a good degree of contrast.

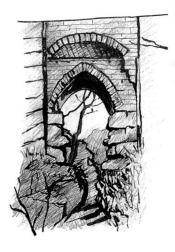

Black ink line has a fluidity and clarity that marries well with the bright colors and soft textures of colored pencil. It provides a clean, graphic framework that supports the color work. You can combine the different LINE QUALITIES of the media and integrate them using tonal techniques such as HATCHING, SHADING and STIPPLING.

Like colored pencils, pens and inks provide a wide range of visual properties, from the fine, uniform line of technical pens and rapid, flowing action of fiber-tip pens to the sensitive variability of dip pens with pointed or squared nibs. Black drawing inks are dense and velvety, while writing inks often have subtle blue or sepia tints. You can also combine colored pencils with the extensive palette provided by colored drawing inks in similar ways.

1 A simple outline drawing of the view is constructed using black waterproof ink and a dip pen with two different types of nibs. The intention is to create a strong graphic framework for the image, and then to add color and texture with the pencils.

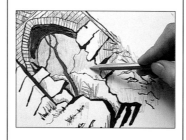

2 To begin with, a basic impression of local colors is blocked in with light shading, identifying brickwork, stone, trees and grass.

3 Each area is given more textural interest, overlaying hatching, shading and linear marks and gradually increasing the color range.

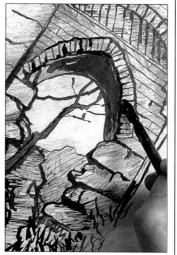

4 The waxy texture of the pencils has softened the blacks where color has been freely worked into the drawing. More drawing is done with pen and ink to sharpen and strengthen the linear textures.

5 With the increasing density of both media, the drawing has a more cohesive effect, with a livelier interplay between the black line and pencil color. None of the detail is "realistic" (see below), but the drawing has a descriptive character.

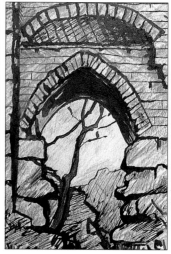

LINE AND WASH

Traditionally a technique associated with pen and ink drawing, line and wash is a method of adding shading and color to an image with a strong linear framework. The lines create the structure of the composition; modeling and color detail are then introduced with washes of diluted ink or watercolor.

Lines made with ink or graphite pencil are typically black or very dark in color, standing out quite strongly against the fluid, paler areas of wash. If you use colored pencils for the line element, they contribute a new dimension in which you can use color to enhance the impressions of space and form created in the initial drawing, or to emphasize a mood. You can flood the washes into and over the colored pencil lines; and when they have dried, you can use the pencils again to rework basic structures and develop the detail. Remember that working over color washes will somewhat modify the intensity of the pencil hues.

A very direct way of exploiting this technique is to use water-soluble pencils, used dry for drawing, then brushed over with clean water. In this way the texture of the line and wash elements are more closely integrated (see also SOLVENTS).

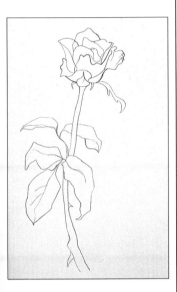

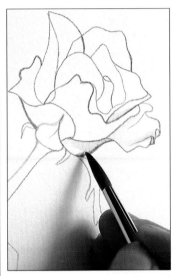

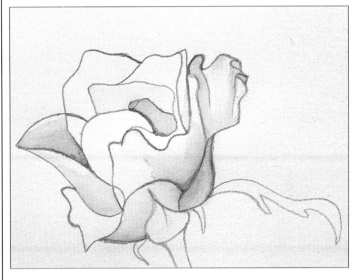

Using water-soluble pencils
1 Make an outline drawing of your subject with firm lines and strong colors. The line needs to be quite heavy, as you will be using the pencil pigment to create the wash.

2 Moisten a fine sable or synthetic, soft-haired brush with clean water. Brush just inside the pencil line, picking up and spreading the color into the shape.

3 Continue in the same way, gradually shading and blending the colors to produce a range of hue and tone. If you do not have enough intensity in one area, go over the pencil line again and dissolve more of its color with the brush tip.

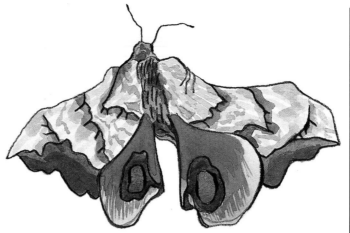

Pencil and watercolor
If you use nonsoluble colored pencils, the washes can be applied with watercolor paint. This drawing of a moth was first worked in outline with waxy colored pencils; then the watercolor was washed in to build color and texture. Some pencil lines were redrawn to strengthen the graphic qualities of the image after the paint had dried.

4 At each stage of the drawing, you can choose whether to strengthen the line work or deepen the washed color. Be careful when working in water-soluble pencil over a wash, because the moisture softens the pencil tip and spreads the line.

5 This approach to line and wash drawing produces a delicate color effect, as the washed color is relatively lightweight. To produce a denser, more graphic image, use paint washes.

DAVID HOLMES
"Landscape"
This free abstract interpretation of landscape in line and wash shows the different, very striking effect of strong color areas overlaid with calligraphic, grainy pencil strokes. The watercolor wash appears more solid and opaque because of the intensity of the hues.

Playful freehand curves

Calligraphic sequence

Because pencil is a point medium, the kind of marks you make with it are basically linear in character. Standard techniques of pencil drawing employ this characteristic — for instance, HATCHING — but the tool is capable of making many different kinds of marks, which are less easily defined. These vary according to the way you push or pull the pencil across the paper as well as to whether the pencil tip is sharp or blunt, chisel-edged or rounded. You can produce finely "spattered" slashes and trails, decisive hooks and ticks, curling flourishes or angry scribbles, linear patterns that are loose and randomly formed or neat and regimented.

Through experiment you can build a repertoire of linear marks that may stand for different elements of your subjects — such as man-made or natural patterns and textures or atmospheric effects — and also enliven the surface qualities of your drawing. In this way you can introduce discreet variety even in areas that from normal viewing distance read as continuous flat color or tone.

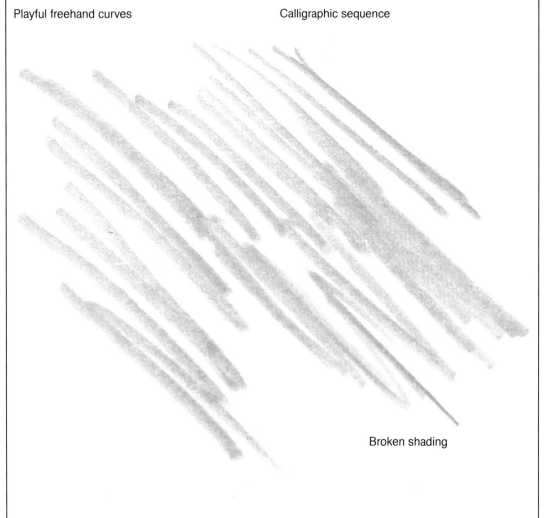

Broken shading

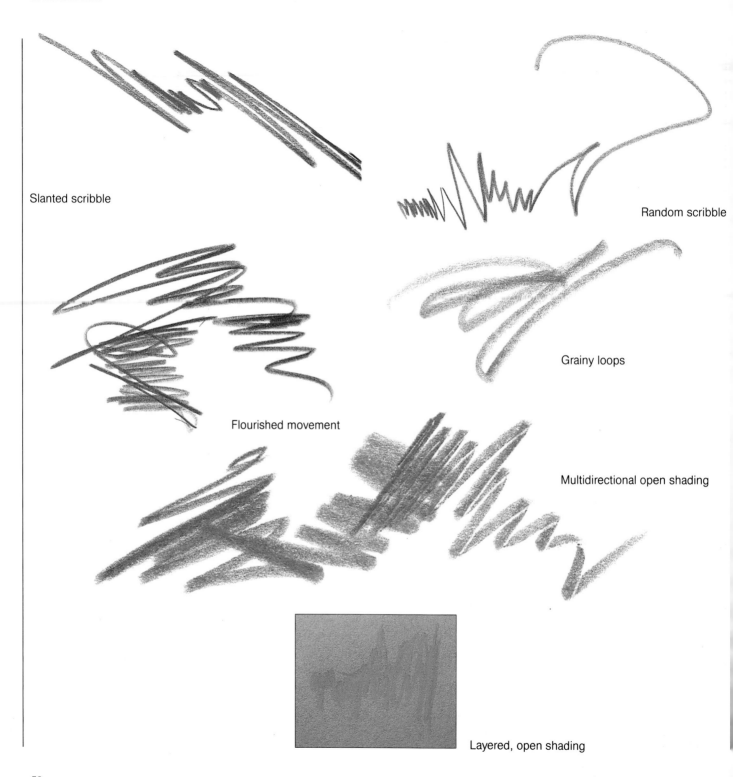

Slanted scribble

Random scribble

Flourished movement

Grainy loops

Multidirectional open shading

Layered, open shading

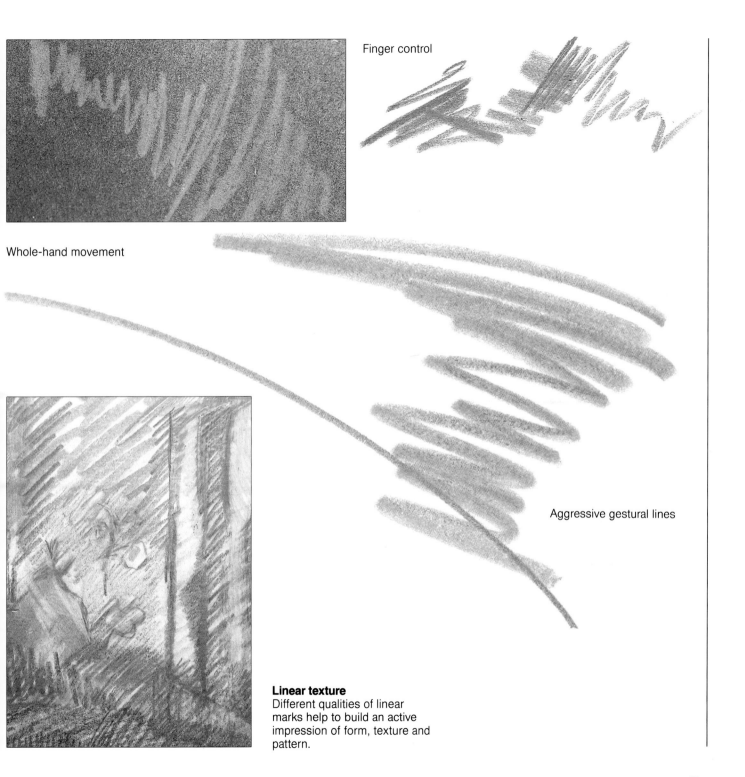

Finger control

Whole-hand movement

Aggressive gestural lines

Linear texture
Different qualities of linear
marks help to build an active
impression of form, texture and
pattern.

L I N E Q U A L I T I E S

The quality of line refers not to the gestural energy that you give to the pencil strokes, as with LINEAR MARKS, but to the innate character of an individual line.

Four basic qualities are usually recognized: a sharp, clean line of unvarying width implying firm contour or geometric precision; calligraphic line, tapering and swelling with a directional rhythm to show movement and energy; broken line, appearing variable and hesitant, sometimes actually fractured; and repetitive line — quickly formed, parallel or overlapping strokes eventually tracing a continuous contour.

The linear bias of colored pencil drawing makes these qualities an important factor in determining the expressive character of an image, especially crucial when exploited in techniques such as CONTOUR DRAWING and HATCHING.

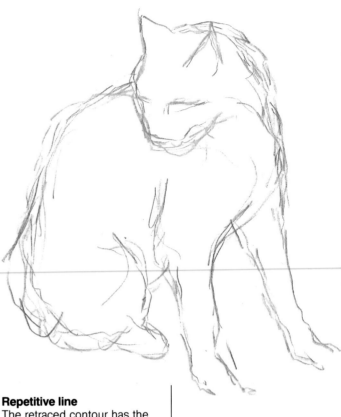

Repetitive line
The retraced contour has the practical advantage of enabling you to modify the shapes you are drawing and suggests the quality of movement in the subject.

Firm, unvariable line
Because of the "giving" texture of colored pencil, a line of even weight and density has a sympathetic quality, but provides a strong graphic contour.

Calligraphic, directional line
Variations in weight and emphasis help to model form in CONTOUR DRAWING.

MARKERS

This combination of media has been widely used in design and illustration for preparing presentation visuals and images for print. Its drawback for artwork intended to have long-term display potential is that some markers are not color-fast, and colors may fade or even disappear altogether when exposed to normal lighting conditions over a period of time.

However, markers and colored pencils make an attractive and versatile partnership. Broad markers are often used to block in areas of solid and blended color, with colored pencil employed to impose a linear structure and fine detail work. But as both can be used to create either line or mass, you can investigate different ways of putting them together to suit your drawing style.

There is a choice of marker types, from very fine fiber-tips to thick, rounded or wedge-shaped felt-tips, and colors range from subtly varied neutrals to brilliant, strong hues. The least expensive brands tend to contain a limited range of bright colors, while the more costly ones used by professional designers provide an extensive palette of graded hues and shades.

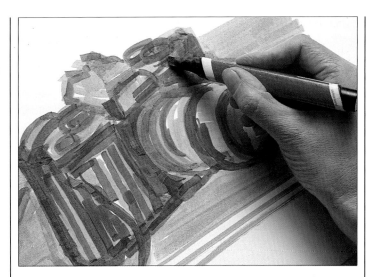

2 The marker drawing is reworked to increase the sense of solidity and suggest the shapes and textures of individual parts of the camera.

3 The colored pencil work begins with contour drawing in dark indigo blue, to correct the outline shapes and give a firmer structure to the drawing.

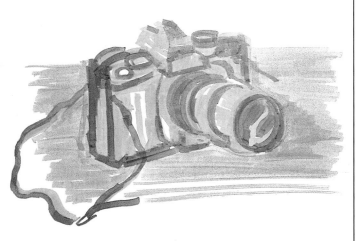

1 An advantage of using broad markers is that it is easy to block in an impression of three-dimensional form very quickly. In this case, non-realistic colors are chosen, but the particular hues are selected to provide light, medium and dark shades for modeling the camera body.

4 A black pencil is used to shade solid tonal blocks over the marker color and to indicate surface textures and more precise contours.

5 White gouache is painted on to block out the shape of the camera against the background, covering stray touches of marker and pencil color that were incorrectly applied. This is a useful way of amending a drawing in either medium. The gouache is not as clean and smooth as the white of the paper; but from a short distance, the corrections are not too obvious.

6 Where the color has been built up densely on the camera lens, an art blade is used to scrape back the surface, to bring back white highlights on the glass and outer rim.

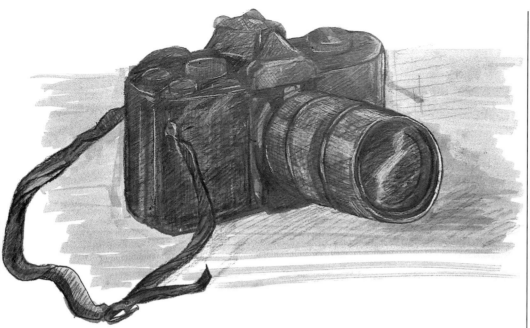

7 The finished image shows how the pencil work has been built up over the marker color to define detail and enhance the weight and texture of the object. Notice how the varied colors of both markers and pencils are drawn together by the black shading and hatching worked across the color areas (detail above).

Fine-tipped markers
Fiber-tip pens and fine-tipped markers can also be used with colored pencils, naturally forming a more delicate image, which is more suitable for small-scale subjects, than broad markers.

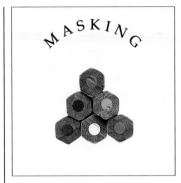

A mask is anything that protects the surface of your drawing and prevents color from being applied to a specific area. The simplest form of mask is a piece of paper laid on your drawing paper; the pencil can travel up to or over the edge of the paper, and when you lift the mask, the color area has a clean, straight edge. You can obtain hard edges using cut paper; torn paper makes a softer edge quality. You can also use thin cardboard, or pre-cut plastic templates such as stencils and French curves.

If it is important to mask off a specific shape or outline, which may be irregular or intricate, you can use a low-tack transparent masking film which adheres to the paper while you work, but lifts cleanly afterward without tearing the surface. You lay a sheet of masking film over the whole image area and cut out the required shape with a craft knife. Carefully handled, the blade does not mark the paper beneath. Low-tack masking tape can also be used to outline shapes; is is available in a choice of widths, and the narrower ones are very flexible for masking curves.

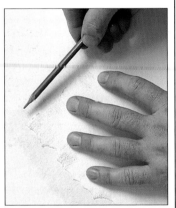

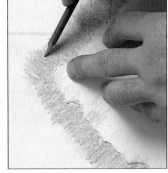

Loose masking
1 Place the paper mask on the drawing paper and hold it down firmly. Begin by shading lightly over the edges of the mask.

2 Build up the shaded color to the required density, keeping the direction of the pencil marks consistent at each side of the mask.

3 Lift the top corner of the mask to check that you have a clean edge quality and the right intensity of color. Keep the lower edge of the mask in place, so you can just drop it back if you need to rework the color area.

Cut paper edge – close shading

Cut paper edge – hatching

Torn paper edge – shading

Using masking tape

1 Lay down the masking tape evenly, but do not rub too firmly, or you may have trouble lifting it without damaging the paper surface. Shade color over the edges of the tape, as with paper masks. An advantage of masking tape is that you can work over both sides of the tape at once. When complete, peel back the tape carefully.

2 If you are overlaying colors, you can use the same mask or a fresh piece of tape to cover the paper while you lay in the second color.

Using masking film

1 Trace the outline of your drawing on paper. Detach the top edge of the masking film from its backing sheet and smooth it down on the paper, covering the image area with a border of film all around. Gradually pull back the rest of the backing sheet, smoothing the film across the paper as you go.

2 Identify the first shapes you are going to color, and cut around them with a sharp craft knife. Lift one corner of the cut film and peel back the shape. Repeat as necessary.

Apply the colored pencil to each shape, filling it with color up to and over the masked edges.

3 When you have completed all the areas in one color, move on to the next. Cut and lift the mask sections in sequence, then shade in the color.

4 At this stage the coloring is complete, and the uncut masking film is still on the paper, causing the black background to look grayed. The next stage is to remove the remaining masking film completely.

5 Compare the finished effect to step 4. With the mask removed, the edges of the colored areas stand out sharply against the blacks, making each shape clean and distinct.

The many good-quality brands of colored pencils now available offer widely varied properties of color and texture. There are two main advantages to building up a stock of different types of pencils. One is that you can utilize their different qualities of line and massed texture to create interesting variations in the surface qualities of an image. The other is more basic and practical — it is simply that you may find particular colors in one brand that are not available in another.

There is no formal technique governing a combination of pencil types. You need to experiment with the textures of hard or soft pencils, waxy or chalky leads, thin or thick points and pressure variations. The weight, surface texture and color of your paper is also influential. The effects of mixing different types of pencils may be quite subtle and discreet, but this is appropriate since the scale and detail of colored pencil work often requires close attention from the viewer.

1 The reference for this drawing is a photograph with a soft, shadowy mood. The initial layers are laid in with chalky pencils to create broad, grainy lines and gentle shading.

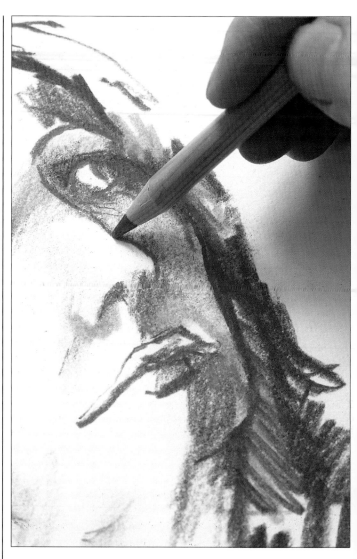

2 The lines and features of the face are sharpened using waxy pencils to create a harder line quality contrasting with the chalky marks.

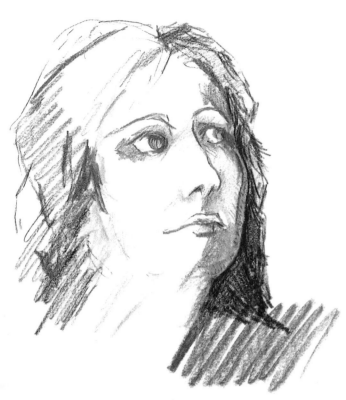

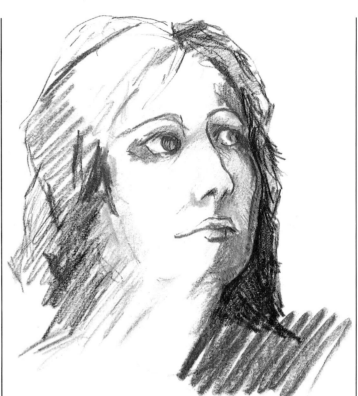

3 Soft-grade waxy pencils are chosen for applying highlighting and shadow to the face and hair. Their texture allows colors to be overlaid cleanly.

4 The linear structure is enhanced with a slightly harder type of moderately waxy pencil, with the same texture used to highlight the face in yellow. The chalk pencils are again applied to soften the drawing in places.

Types of colored pencil
Different pencils have different qualities. Shown from left to right: hard watercolor pencil; chalky pencil; hard pencil; waxy pencil.

The majority of colored pencil renderings depend upon the effects of overlaying colors. In this way you can achieve richness of hue, tonal density and contrast, and effective three-dimensional modeling of forms and surface textures. Because colored pencil marks have a degree of translucency, with the color application reflecting the influence of the paper's grain and surface finish, the process of building up a drawing in layers creates potential for many subtle variations of hue, shade and texture.

There are many different ways of overlaying colors: you can put one layer of SHADING over another to modify colors and produce interesting mixtures and GRADATIONS; you can integrate lines, dashes and dots to develop complex effects of optical mixing; you can enliven areas of flat color by overlaying a linear pattern or broken texture that subtly meshes with the original hue.

Color layering provides greater depth and detail in a composition — for instance, you can achieve active color qualities in highlight areas or dark shadows, which intensify effects of light and atmosphere. In a practical sense, overlaying colors is equivalent to mixing paints in a palette — if you don't have the precise hue that you need, you can create it from a blend of two or more colors.

Building up color shading
1 This portrait drawing begins with the face blocked in lightly with two shades of red-brown.

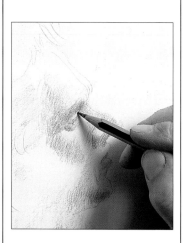

2 To enhance the modeling of the features, a dark brown pencil is used to work over the lighter color around the eyes, nose and chin.

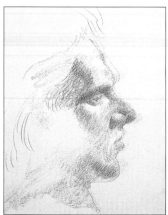

3 Even with this limited palette of colors, the structure of the face is quite clearly defined by the layers of shading.

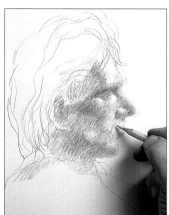

4 Further layers of red-brown build up the contours of the face and increase the contrast of light and shadow. Light yellow is laid over the darker shades around the eyes and mouth to intensify highlighting.

Mixed hues
Overlaid patches of grainy shading produce subtle mixtures and gradations of color. This sample contains four colors – yellow, yellow ocher, green and gray-blue.

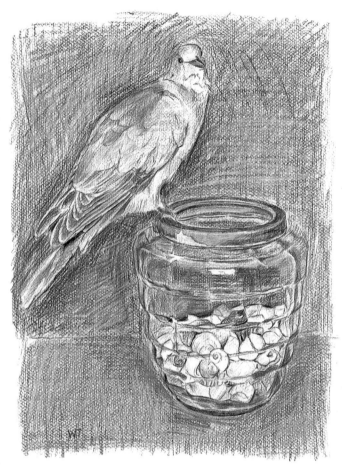

▶ WILL TOPLEY
"Still Life with Bird"
This interesting drawing shows color overlays built up with loose HATCHING and SHADING. The heavy grain of the paper contributes an open, free quality to the color mixes, but the layering of colors makes an attractively descriptive image conveying different kinds of textural detail.

CHRIS CHAPMAN
Untitled
Close shading, with the colors tightly knitted together in successive layers, produces a highly realistic style of rendering with subtle treatment of tonal contrasts and color variations.

PAPER GRAIN EFFECTS

To build up the color density in a colored pencil drawing, you need a surface with sufficient tooth to create some friction with the pencil point — otherwise, the texture of the pencil lead rapidly produces a smooth, compacted finish that resists further applications.

The degree of tooth in a drawing paper depends on the papermaking ingredients and the method of finishing. Cartridge paper, for instance, is relatively smooth, although it has an excellent tooth for pencil drawing. Pastel papers have pronounced grain intended to grip the loose pigment particles laid down by soft pastels. Watercolor papers come in a variety of weights and finishes, the heaviest having a visibly "pitted" surface texture.

The more heavily textured the paper grain, the longer the surface stays open and workable, an important consideration if you are depending on color overlays for your effect. However, on very grainy paper, it is difficult to get a fine, sharp line, because the surface breaks up the pencil mark, and tiny glints of the paper color will show through even densely worked areas of shading. Varying the kind of paper that you use can bring an extra dimension to your work. Try different weights and textures to find out if they are comfortable to work on and produce qualities that suit your own technique and drawing style.

Textured papers
Smooth, laid and heavily textured papers – whatever you choose will affect the quality of your drawing.

Cartridge paper
A relatively smooth surface with a slight tooth, like ordinary cartridge paper, gives a soft grainy quality to light pencil strokes, but as the pressure of the pencil increases, the grain of the paper is likely to be "ironed out" and has less effect.

Pastel paper
Papers made specially for work in pastel have quite a pronounced grain intended to grip the loose color. With colored pencils, the grain shows up as a lightly pitted pattern within the colored strokes.

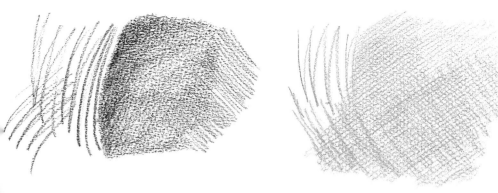

Watercolor papers

Heavy watercolor papers sometimes prove too resistant for colored pencils. The more giving types still have a distinctive grain pattern that leaves white flecks showing through the color. The grain may be heavy (far left), roughening the pencil texture, or it may have a mechanical pattern (left) that breaks the marks into a mesh-like texture.

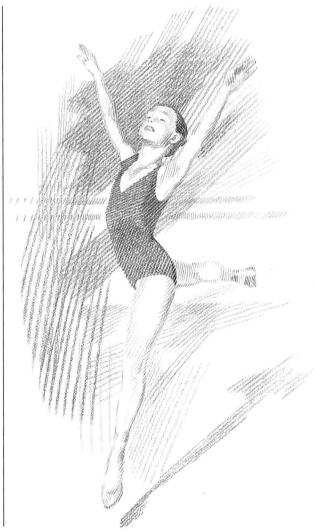

Colored papers

There are many types of colored papers, and the kind that you choose depends on how much you want the paper color to influence the applied pencil colors. The heavier the grain, the more of the paper color shows through. A medium-toothed, fairly even-surfaced paper, like this black sheet, gives the pencil marks a pleasing soft texture, but allows the colors to build up cleanly.

▶ JOHN CHAMBERLAIN "Young Dancer"
The hatched and crosshatched colored lines are cleverly meshed with the deep recesses of the paper grain to create a regular, active texture well suited to the subject. Three-dimensional form emerges from the varying directions of the line work and the white highlighting shot through the color because of the grain pattern.

P A S T E L A N D P E N C I L

Like colored pencils, pastels can be manipulated to exploit their linear qualities or to produce color masses and complex surface textures, so a combination of the two media is generally sympathetic. Another thing that these media have in common is that there are different types of both, caused by variations in the composition of the binder that holds the pigment, and qualities also vary between different brands.

There is no specific recipe for mixed-media work; individual artists develop personalized methods that produce effects suited to their style and subject matter.

The different types of pastels are soft pastels, hard pastels, oil pastels, water-soluble pastels and pastel pencils. All combine readily with colored pencils and contribute varying qualities of color and texture. The greasy texture of oil pastel is more resistant to colored pencil than the dry, powdery finish of soft and hard pastels, but you will find that effects differ according to the properties of the particular brands you are using, the pressure you apply and the density of the color build-up.

1 The drawing is loosely blocked in with soft pastels and pastel pencils to create grainy blocks of color establishing the general shapes of the plant's leaves and stem.

2 Waxy pencil is used to define the contours of the leaves and develop a sharper, more distinct image.

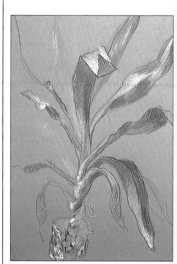

3 Details of the textural qualities of the leaves and stems are enhanced with line work and shading, laid in with waxy and chalky pencils.

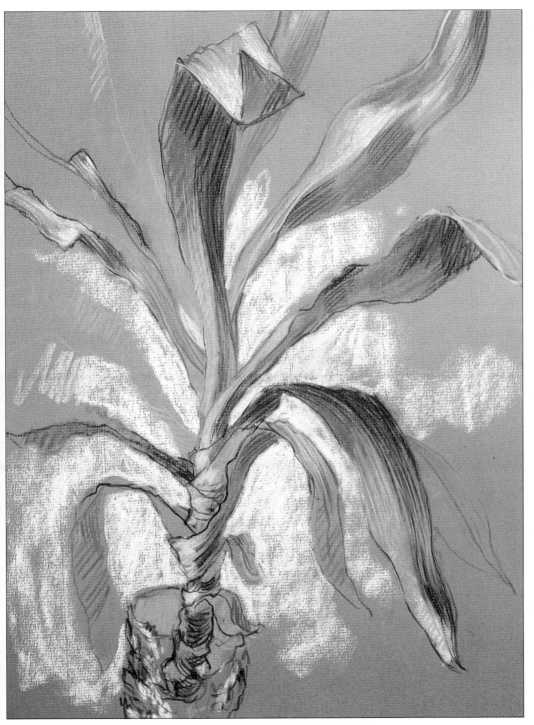

4 With the structure of the plant more clearly defined by the pencil work, soft pastel is again used to introduce highlight areas and block in a pale background. The contrast of hard line and grainy color (see detail, above) gives richness and depth to the rendering.

It can be very frustrating when you have put a lot of work into a colored pencil drawing to find that one area simply does not work, and attempts to correct it make the effect worse rather than better. Repeated overworking may make the surface slippery and resistant, while heavy erasure can ruin the paper.

If one part of the drawing has gone completely wrong, you do not have to abandon the whole thing. You can make a patch correction that sits flush with the rest of the drawing. You create the patch by cutting through a piece of clean paper at the same time as you cut out the error, so it is exactly the right shape. You then insert it in the drawing, secure it with tape on the wrong side, and rework that section of the image.

Although this type of correction can be almost invisible, the fine seam around the new patch may snag the pencil tip, picking up a heavier color application that could draw attention to the outline. The technique works best, therefore, in a drawing that is composed of distinctive shapes. However, by working very carefully toward the edges of the patch, you should be able to integrate the redrawn section quite effectively.

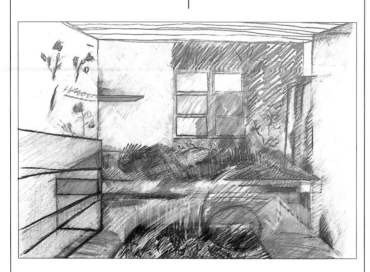

1 In this drawing there is a round shape in the foreground that relates to an element of the composition subsequently deleted. Because the pencil lines are hard, the shape cannot be covered by overlaying color.

2 The area containing the round shape is cut out following, as far as possible, hard edges already established in the drawing. A clean sheet of paper has been laid underneath, and the cut is made through both layers.

3 Both pieces are lifted out after cutting. Working through both layers means that the clean patch is cut to exactly the same shape as the piece being removed.

5 Once firmly in place, the drawing is turned over and the patch is secured with masking tape along all the cut edges.
From the front of the drawing, the patch fits neatly, with no overlap on the edges that would form an awkward ridge to catch the pencil tip.

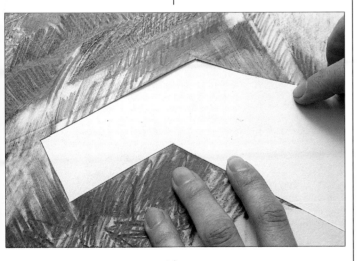

4 The clean patch is inserted in the "hole" in the drawing to check the fit.

6 As the colored pencil drawing is gradually reworked, with pencil strokes crossing the patched section in different directions, the edges of the patch become less noticeable, and the new section can be fully integrated.

The technique of sgraffito involves scratching into a layer of color to reveal the underlying surface. In effect, it is a "negative" drawing process, as you create linear structures and surface textures by removing color, rather than by applying it.

To achieve the effect with colored pencils, you first lay down a solid block of color by SHADING heavily with the tip of the pencil. You then apply a second layer of a different color over the top, again built up solidly so that it covers the lower layer uniformly. The sgraffito drawing can be done with a stylus, or with the point or edge of a craft-knife blade.

An alternative method is to shade pencil color over a thick ground previously applied to the paper. An emulsion primer or gesso base can be applied to paper or cardboard as the ground for the sgraffito. (As this dampens paper and may cause it to buckle, it is advisable to stretch it first.) This technique can be used in a similar way to scraperboard, to etch a white image through a dark color, or you can apply a tinted ground and overlay a contrasting color.

1 Build up the pencil colors quite thickly and freely, using dense shading – the technique works best with soft, waxy pencils on fairly smooth-textured paper. Follow the general lines of your subject and the variations of color and shading.

2 Start "drawing" into the color with a sharp blade. Scratch the color gently, taking care not to dig the blade into the paper surface. Faint lines are scratched back here to suggest the texture of the leek.

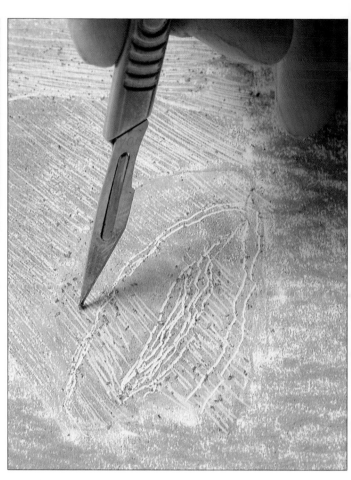

3 To emphasize contour lines and structural elements in the drawing, angle the blade to lift a thicker line of color, revealing more white. You may find it easiest to turn the paper when tracing an irregular contour, rather than to manipulate the blade around awkward curves.

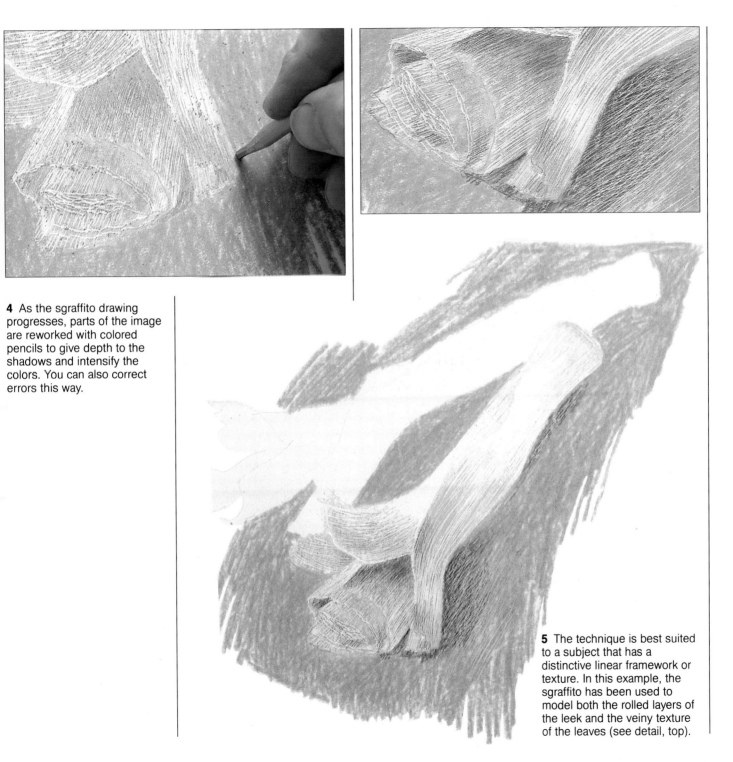

4 As the sgraffito drawing progresses, parts of the image are reworked with colored pencils to give depth to the shadows and intensify the colors. You can also correct errors this way.

5 The technique is best suited to a subject that has a distinctive linear framework or texture. In this example, the sgraffito has been used to model both the rolled layers of the leek and the veiny texture of the leaves (see detail, top).

Shading is the classic method for achieving effects of continuous tone and color. You simply move the pencil point evenly back and forth across the paper, gradually increasing the surface coverage.

Shading typically has a directional "grain," reflecting the movement of your hand and the pencil tip. You can choose to emphasize this linear quality or to eliminate it, depending on the pressure you apply and the angle you work from. Heavy pressure and a consistent angle create directional emphasis. To achieve nondirectional shading, build up the color in lightweight layers and alter the angle of the strokes frequently. An alternative is to keep turning the paper at intervals.

Shading is used both to build up color areas and to model form through GRADATIONS of tone and hue. The strongest color you can obtain is the color of the pencil lead itself; lighter shades of the same hue are formed by easing the pressure on the pencil tip.

To create soft color "glazing," aim to use the side rather than the point of the pencil lead and maintain consistent but gentle pressure.

Lightweight, even shading
Light pressure on the pencil tip enables you to build up shaded color with no linear bias. You can gradually increase the color intensity by reworking the same area.

Heavy, directional shading
When you put a lot of pressure on the pencil tip, the shaded area naturally forms a directional emphasis following the path of the pencil. The color effect is also more intense.

Open shading
A loose movement from the wrist, allowing your whole hand rather than your fingers to guide the pencil, produces an open, scribbled effect comparable to free hatching.

Combining different qualities
When you juxtapose areas of shading of different densities and directional emphasis, the drawing begins to suggest different levels of surface planes, creating space and form.

Shaded gradations

Shading is the classic method of creating smooth gradations of tone and color. It also provides different edge qualities, depending on the direction of the marks and the eventual solidity of the shaded area.

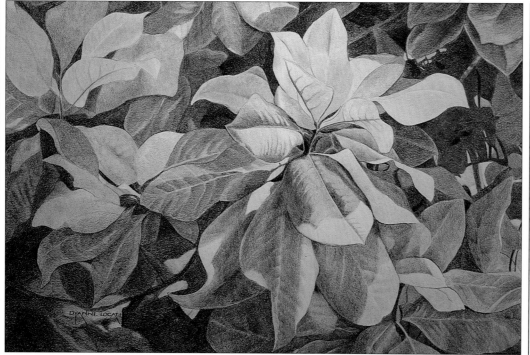

DYANNE LOCATI
"The Azure Jungle"
Controlled shading enables you to build up shapes and forms three-dimensionally by BLENDING and OVERLAYING COLORS. In this example, the artist has handled the variations of shade and color very effectively to describe both light and shadow on the leaves and their local colors and markings.

SKETCHING

Colored pencils are an
excellent medium for sketching
— clean, lightweight, easily
portable and very versatile.
You can work rapidly in line
only to describe individual
shapes and forms (see CONTOUR
DRAWING) or build up color
masses quickly with loose
SHADING and HATCHING.

When it comes to choosing
colors, select at least one pencil
in each of the main colors of
the spectrum (red, blue,
yellow, orange, green and
purple) plus the neutrals
(black, gray and white).
Mixtures of these can be
contrived to cover the
characteristics of any subject
(also remember that you can
add written color notes to
sketchbook drawings for fuller
interpretation back in the
studio).

If you prefer to carry a more
comprehensive range of
shades, choose colors suited to
your subject — for example,
blues, greens and earth colors
for landscape; more of the
bold, bright hues for a subject
such as a fruit market or
flower garden; subtle
variations of gray, brown and
yellow for farm or zoo animals.

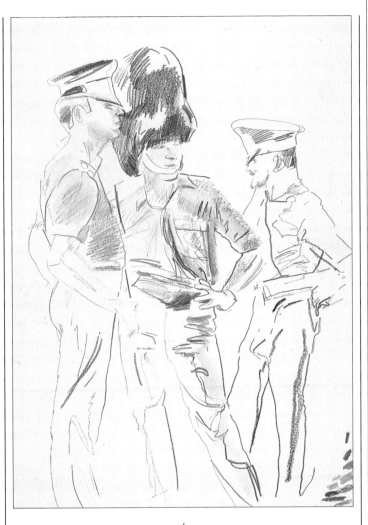

LINDA KITSON
"Soldiers"
Colored pencils are the ideal
medium for this figure sketch,
capturing the poses of the men
and the different aspects of
their military uniforms. The
artist has handled the pencils
quickly and confidently,
recording the telling details of
form and texture.

Sketching
Consider using COLORED PAPERS
for sketching. Pads of tinted
papers in subtle shades are
available; these can help you to
key your range of applied
shades and colors more
efficiently, and may give a more
finished look to a quick
drawing.

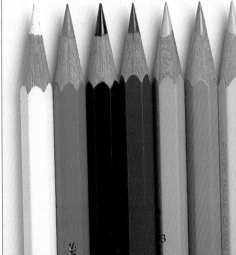

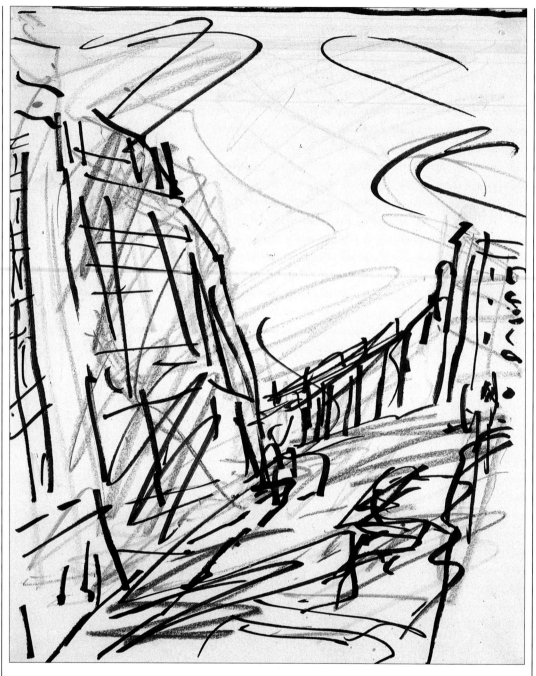

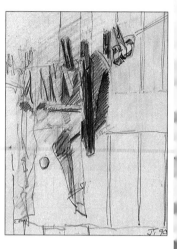

◄ FRANK AUERBACH
"Winter Morning"
The starkness of a winter cityscape is vigorously attacked with INK AND PENCIL, making active use of varied LINE QUALITIES in both media.

▲ JOHN TOWNEND
"Clothes Pegs"
The artist's eye was caught by a view from the kitchen window, with clothes hung out to dry swaying on the washing line. The attractive feature of the colored clothes pins suggested the treatment, using a restrained approach to the surrounding colors and emphasizing the linear pattern in the view, while marking the dancing shapes of the pegs in vibrant hues.

The marks made with some types of colored pencil can be spread and blended with solvents — water, turpentine or the spirit-based medium in a colorless marker blender. Only pencils formulated to be water-soluble will react with water. Spirit solvents may dissolve the colors of pencils intended to be used dry — this has to be a matter of experiment, as it depends on the proportions of pigment and binding materials in the pencil lead, and effects are not wholly predictable.

There are two methods which enable you to take advantage of the more fluid textures produced by solvent techniques. You can either dip the tip of the pencil into the solvent, so that the color becomes softened and spreads as you lay it down; or you can shade or hatch with the dry pencil tip, then work into the color area with solvent using a brush, torchon or cotton bud — or with a marker blender, which is simply a marker pen that contains colorless solvent. You can combine the effects of wet and dry color by allowing the dampened marks to dry, then reworking the area with the pencil points.

To avoid distortion that may occur through the paper buckling when it is wetted by the solvent, stretch the paper beforehand, or work on a pre-stretched paper block or illustration board.

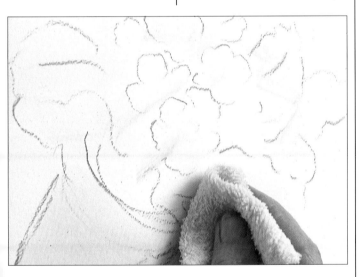

Using spirit solvent
1 The shapes of the flowers are rapidly sketched with a soft waxy pencil line. A rag dampened with turpentine is used to spread the color delicately, indicating the areas of darkest shading.

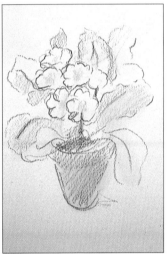

2 The line drawing is strengthened and some broad color areas blocked in with light shading. Notice the heavy grain of the watercolor paper – when applying solvent, you need to use good-quality paper to avoid buckling or tearing.

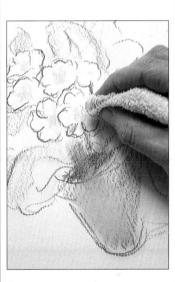

3 A second stage of rubbing with turpentine softens the color and spreads it into the paper grain. The pencil marks are just moistened, not flooded with the solvent.

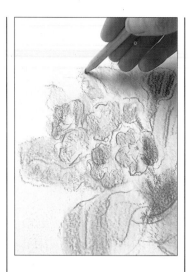

4 To develop the intensity of color, pencils are used again to shade in the solid shapes. The moisture from the underlayers makes the pencil marks smoother and stronger.

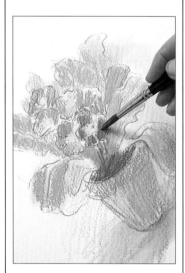

5 Applying solvent with a brush makes the color dissolve and spread more like paint. It is possible to do this selectively, to build up a contrast of different textures.

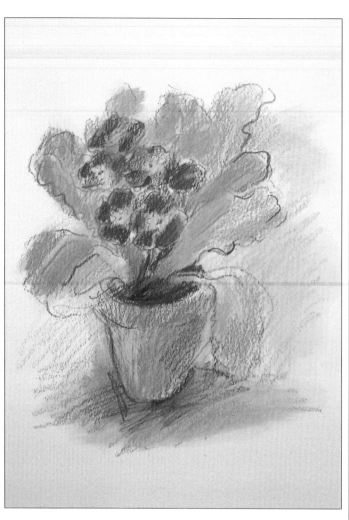

6 In the finished vignette, the brushed color comes up very fresh and intense, contrasting nicely with the more open surface qualities of the pencil shading and line work.

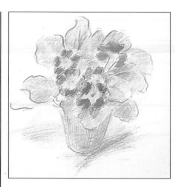

Using water-soluble pencils

This example is worked in much the same way, except that water-soluble pencils have been used for the drawing with clean water as the solvent. The techniques of rubbing and brushing the color apply equally to this medium.

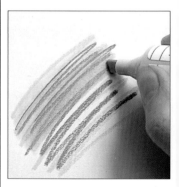

Using a marker blender

The blender is exactly the same tool as a broad-tipped marker, but the fluid content is colorless. To blend pencil colors, rub the tip of the marker firmly over the pencil marks.

SQUARING UP OR DOWN

Many artists work from photographs, not only for the convenience of being able to tackle outdoor subjects without having to work on location, but also because the limitations of photography — the way the camera reads an image selectively — can create dramatic and unusual compositions containing special qualities of light, color and surface texture.

When using either reference photographs or sketches, you may need to enlarge the image, and it can be difficult to scale up accurately if you work freehand. The method of squaring up or down on a grid helps you to locate the various elements of the composition.

First draw a pencil grid over the original image, and then mark up a similar grid on your drawing paper, but with each square proportionately larger or smaller — for instance, one and half or twice the size of the original to enlarge, or half the size to reduce. Now work across the grid square by square, copying the main lines and shapes within each section, and taking careful note of where each element in the photograph intersects a line on the grid. This simple method provides an outline drawing in proportion to the original, but because it is not strictly mechanical, you have scope to adjust elements of the composition if you wish.

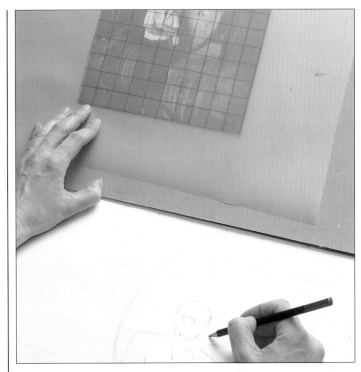

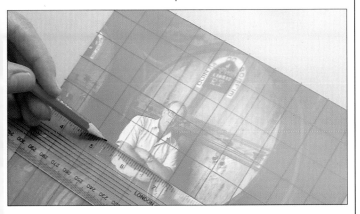

1 You can mark a grid for squaring up on the original photograph or drawing, or on a sheet of tracing paper overlaid on the image, as shown here. Draw the grid with suitable-sized squares, according to the degree of detail in the picture.

2 In this example, the grid squares for the drawing are twice the dimensions of those in the original grid. Start sketching the image near the center of the grid, counting the number of squares sideways and down to locate the points where the main features of the image cross the grid lines.

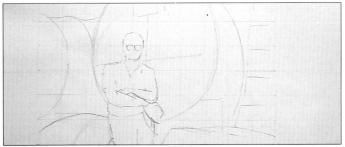

3 Even if you work systematically through the grid, you may misjudge some of the proportions and create "false" lines. But you can easily correct such errors by rechecking the position of particular features of the drawing in different squares.

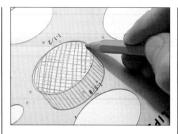

Stencils, cutout shapes which form clearly defined boundaries for color application, are a form of MASKING. The principle is the same as that of stencils used in interior design, where decorative motifs are applied to flat surfaces. In drawing, stenciling has two main functions. One is to allow you to work a color area freely while limiting the color to a specific, hard-edged shape; and the other to create a repeat pattern motif when it is important to have uniformity of size and shape.

There is a wide variety of ready-made plastic stencils and templates that provide a choice of shapes, from basic geometric units such as squares, circles and ellipses to letterforms and diagrammatic symbols. For irregular or unusual shapes relating to your own composition, it is easy enough to make stencils by cutting the required motifs out of thin cardboard, acetate film or stencil paper.

Stenciled hatching
1 A plastic ellipse template of the kind made for technical drawing has been used to establish the upper surface and lower edge of a cylindrical-sectioned shape. The elliptical plane is hatched with fine lines.

2 The vertical sides of the cylinder have also been defined with hatching, and the ellipse template has been used again as a guide for crosshatching the upper surface. The three-dimensional effect is enhanced with light shading, and the contours have been strengthened by using the template to help outline the elliptical curves.

Stenciled shading
1 By using close shading, you can fill a stencil outline with solid, intense color.
To give three-dimensional volume to a simple geometric shape, you can leave highlights within the stenciled area, or vary the tonal gradation.

Regular patterns
Stencils are useful for providing a regular repeated shape corresponding to a particular texture or pattern in your

subject. In this case, a fine ellipse template has been used to create the scaly texture of a fish.

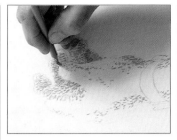

1 The size of the stippled dots and the variations of color need to be related to forms and tones in the subject. You may find it easiest to begin with a light outline drawing.

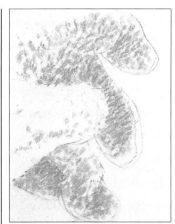

2 The pressure of the pencil that you need to apply a strong color effect means that some dots are rounded, while others are flicked into small dashes. Try to keep the scale of the marks fairly even. Select colors that create shade variation, and build up the marks systematically.

3 The aim of stippling is to model form in the same way as you do with shading, but using active individual marks. This creates free edge qualities, but gradually a sense of solid form emerges.

This is a traditional technique for building up shade and color values, and provides an alternative to linear methods such as SHADING and HATCHING. Stippling consists of a mass of fine dots, closely spaced. Variations in the size and spacing of the dots create modulations of tone and hue. With colored pencil, you can integrate several different colors to produce an optical mixture, and you can achieve very subtle GRADATIONS by controlling the proportion of one color to another in any area of the color mass.

Stippling is time consuming, especially when you use this technique alone to cover large areas of the paper, but it allows great control over the modeling of forms, and the finished effect can be startlingly super-real. Alternatively, you can stipple over blocks of flat or shaded color to enhance effects of three-dimensional form or develop surface texture.

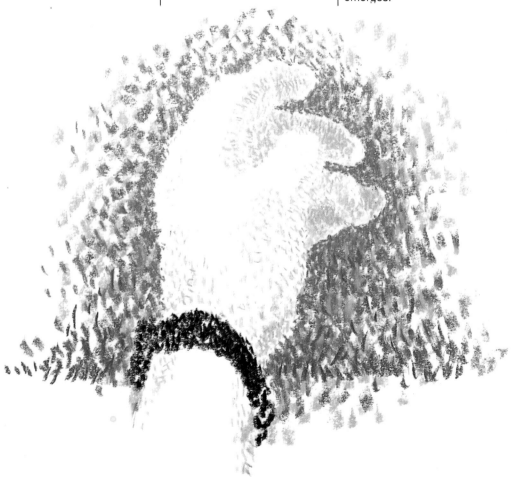

Purpose-made drawing papers provide a wide range of textures (see PAPER GRAIN EFFECTS), but there are many interesting materials you can draw on that provide distinctive surface qualities, giving variety to your colored pencil renderings.

Stationery materials such as brown wrapping paper, large manilla envelopes and cardboard packaging provide rough-textured surfaces with a pleasant, warm medium shade. Abrasive papers such as fine glasspaper and sandpaper have a gritty tooth, and come in colors ranging from charcoal black to natural sandy yellows — but remember that a highly abrasive surface uses up the pencil leads very quickly. For a fine "woven" ground, you can use the prepared canvas boards sold for oil and acrylic painting.

Some artists like to work colored pencil over brushed textures, in which the rhythmic movement of the brush has created fine ridges and hollows that counterpoint the colored pencil strokes. The quality of a painted ground varies from the light texture of a watercolor or gouache wash to the dense opacity of acrylic emulsion or gesso. An extra advantage is that you can choose to apply a white ground or a tint of your own mixing.

Abrasive paper
A fine abrasive sandpaper or glasspaper grips the color very firmly, enabling you to build up rich, vibrant hues and patterns of light and shadow.

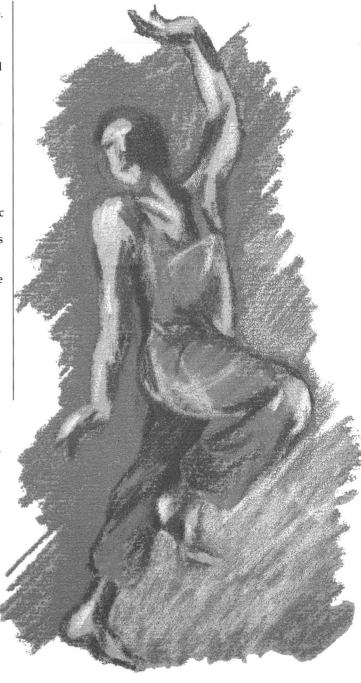

BARBARA SCHOEMMER
"Cape Kiwana II"
The texture of the ground can act as a significant element of your subject. In this drawing, the brushed gesso ground corresponds to the rough surface texture of natural rock.

Cardboard
A section cut from an ordinary cardboard carton has pale brown coloring with a faint striated texture. This acts as a warm middle shade for a monochrome drawing. The thickness of the cardboard provides a soft, giving surface.

Drawing on gesso
1 Apply acrylic gesso ground freely and thickly to drawing paper or board and allow it to dry completely.

2 Brushmarks in the gesso ground affect all kinds of marks that you can make with your pencils. It gives broken linear textures and strong grain patterns in areas of shading.

With some types of colored pencil drawing, it is important to have a clear, accurate guideline. Extensive corrections and erasures can spoil the paper surface before you begin the color work, so to avoid this you may wish to produce a working drawing which can then be transferred cleanly to the final drawing paper with no alterations. Similarly, you may wish to trace the outlines from a photograph as the basis of your composition.

You can do this by the conventional tracing method, drawing around the outlines on tracing paper, scribbling over the back with a graphite pencil or soft pastel, then going over the outlines again to trace the image down on the drawing paper.

Alternatively, you can use transfer papers, available in a variety of colors. These are thin paper sheets coated on one side with a fine, even layer of "crayon-type" color. You simply slip the transfer paper, colored side down, between the tracing and the drawing paper, then go over the outlines again with light pressure, using the point of a graphite or colored pencil.

With either method, be careful not to press too hard when retracing the outlines, or you may leave an impressed line on the paper which cannot be eradicated. (See also COUNTERPROOFING, SQUARING UP OR DOWN.)

2 Turn the tracing over and scribble on the back with the pencil, making sure all the lines of the drawing are backed with shaded tone.

3 Place the tracing on a clean sheet of drawing paper, and go over all the lines with the pencil point. Don't press too hard, or you will make a permanent impression on the drawing paper.

4 Keep the tracing anchored at one corner so you can lift it to check the quality of the traced line, and return it to the right position. Do not remove it completely until you are sure all the required lines show distinctly.

Tracing method
1 Place the tracing paper over your original drawing, and follow the main outlines with a firm pencil line.

Using transfer paper
1 Make the initial tracing by the conventional method. Place the tracing over the drawing paper, with the transfer paper slipped between the two layers, color side down. Retrace the image.

2 Lift one corner to check that a complete guideline is being transferred.

The powdery line is easily covered as you build up the colored pencil work.

Transfer papers
These come in a range of different colors, so you can choose a bold hue or a lighter shade appropriate to the style and subject of your drawing.

The use of a transparent drawing surface such as drafting film or high-quality tracing paper has been widely adopted by illustrators and has become a standard practice in colored pencil drawing. The special characteristic of this method is that you can apply color to both front and back of the transparent support, which increases the potential range and subtlety of color mixing.

Drafting film is a polyester sheet material, highly translucent, although it typically has a slight blue or gray cast which has a minimal influence on the applied colors. It is a very tough and stable medium, but comparatively expensive. You need a type that has a matt surface texture on both sides. If you prefer to use tracing paper, choose a type that is weighty and firm-textured; cheap, thin tracing paper becomes distorted by the pressure of the pencil and may easily tear.

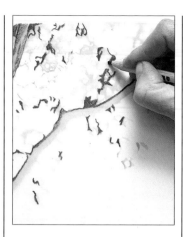

2 The darkest shades in the subject are drawn with a burnt umber pencil. The drawing below is used as a guide, but it is not necessary to copy every detail precisely, as the pencil drawing should have its own character.

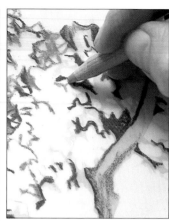

3 The decorative shapes of the tree trunks and leaves are developed using olive green and burnt sienna as well as burnt umber. This produces an effect similar to the original monochrome, but with livelier color interaction.

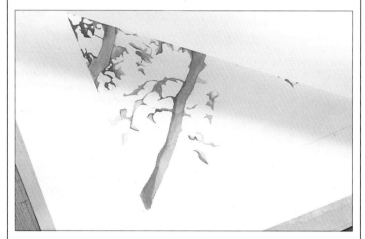

1 This example is drawn on a strong, smooth-grained tracing paper. The colored pencil drawing will be an interpretation of a monochrome watercolor study. The tracing paper is first taped down over the original.

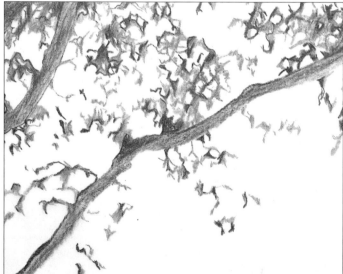

4 This completes the first stage of drawing on the front of the tracing paper. The basic structure of the tree branches is fully established.

5 The lights and colors in the sky background are laid down on the back of the tracing paper. This enables the artist to work freely, without having to shade around the outlines of existing shapes.

7 The drawing is turned over, and some additional sky color is applied to the front of the paper, strengthening the tones and hues and helping to merge the light shades.

6 Gradually the shading on the back of the paper is built up to cover the whole image area with delicate colors.

8 The process of separating the different color ranges, so that pale tints on the back of the paper can be broadly blocked in without picking up color from the darker shades, creates a good effect of bright light behind the trees.

WATERCOLOR AND PENCIL

Watercolor is a translucent paint medium that combines well with the clear hues of colored pencils. The two media can be loosely integrated in free, impressionistic images, or used in a more formal way to create finely structured color drawings.

The clean, crisp LINE QUALITIES that you can achieve with colored pencils form a striking visual contrast with fluid brushstrokes and washes laid in with watercolor. An interesting effect comes from applying water-soluble pencils while the paint layers are still damp; the moisture softens the pencil tip, encouraging broad, brilliantly colored marks. Be careful when working into watercolor with nonsoluble pencil types, however, as the pencil point is likely to tear the wetted paper surface. If you wish to apply detailed line work, wait for the watercolor washes to dry completely.

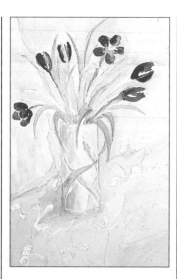

1 You can begin by blocking in direct in watercolor, or you can start with a colored pencil outline and paint into it. Here a faint outline has been drawn to establish the composition, and the basic colors are freely washed in.

2 Successive washes are overlaid to build up the paint colors, with the linear forms of the stems and leaves strengthened with light shading in waxy colored pencils.

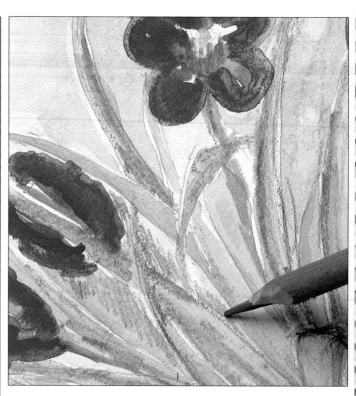

3 Some shading is put in behind the flowers to develop the relationship of shapes against the background. At each stage the technique is quite free, leaving the surface open and workable.

4 The process continues, working back and forth between different shapes to enhance the definition. Avoid drawing over painted areas that are still wet, as the pencil tip could either slide, or tear the paper surface. Allow washes to dry partially before drawing on the color.

5 Where the initial washes have suggested shadow areas, the pencil shading is built up more strongly to heighten the intensity of color and shading.

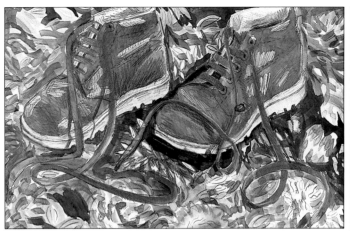

SARA HAYWARD
"Boots"
This drawing shows a very vigorous, confident approach to the combined media. The watercolor is built up in layered washes to develop strong hues, and the pencils are used to overlay pattern and texture.

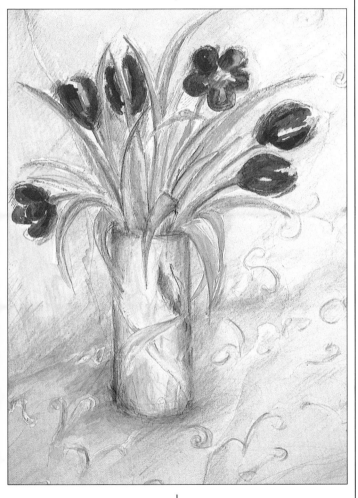

6 The combination of pencil and watercolor allows you to develop a free interpretation. The paint provides the overall impression, and the pencil marks emphasize structure and linear detail.

WHITE LINE

This technique is a formal way of using IMPRESSING to create specific decorative effects in a drawing. You construct a detailed line drawing on tracing paper, then place it on your drawing paper and work

over the lines firmly with a sharp pencil, stylus or ballpoint pen to impress them deeply into the paper. You can then build up the image in color by shading over it with the chosen range of colored pencils.

The method is an excellent way of reproducing particular patterns and textures, such as fine lace in a curtain or tablecloth, or a delicate tracery of leaf veins; or it can be employed to form a "negative" outline drawing, describing forms and volumes that can be filled with applied colors. The impression in the paper surface gives a kind of relief effect to the positive shapes.

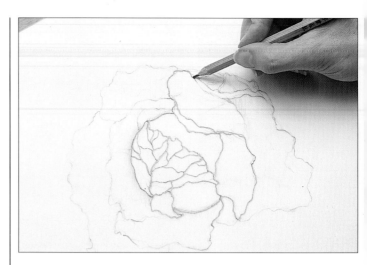

2 Position the keyline drawing over your drawing paper. Go over the outlines again with a pencil, ballpoint pen or scriber, pressing hard to push the lines into the paper. A layer of newspaper underneath helps to provide a "giving" surface.

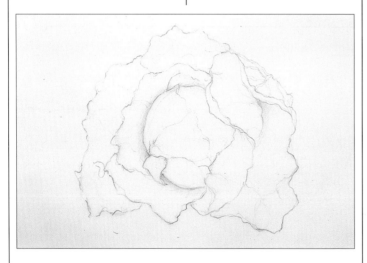

1 Make your initial line drawing in graphite pencil so you can easily make corrections until you have a satisfactory image. Use thin tracing or layout paper.

This drawing shows the contours of the frilly cabbage leaves and the lacy pattern of the veins.

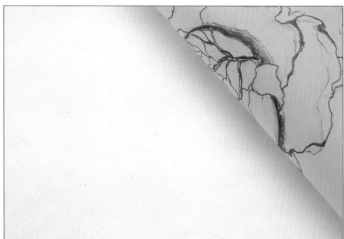

3 Turn back the top sheet to check whether the impression shows clearly on the drawing paper. Keep the keyline drawing accurately in place and retrace lines where necessary.

4 When the impressing is complete, remove the top sheet and start to work in color on the drawing paper. Shade lightly over the impressed lines to allow the image to appear.

5 Gradually work over specific areas of the drawing with different colors, developing the variations of color and tone within the outlined shapes. Keep the layers of shading light, to avoid filling the white lines.

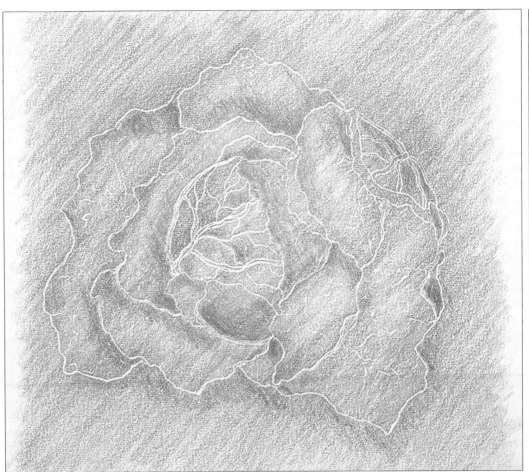

6 The completed drawing shows the structure and texture of the subject, with the folds of the cabbage leaves defined by dark shading. You can plan your drawing to include as much or as little detail as you wish.

PART TWO

THEMES

Only quite recently have colored pencils been fully exploited as a major artists' medium in their own right. Too often, previously, they were treated as secondary tools, useful for sketching and making preparatory drawings for paintings, but not considered suitable for highly finished works. One thing that has radically changed the status of colored pencils is the increasing range of high-quality brands available, with improved handling properties and color qualities. Another important influence on the more creative use of colored pencils has been the variety of exciting and sophisticated work by illustrators appearing in both mass-market publications and more specialized fields such as architectural rendering and technical illustration. Colored pencils are particularly valuable for illustration work, being versatile, quick and clean to use and capable of producing bright, detailed images that reproduce well.

The result of this has been a remarkable exploitation of colored pencil techniques, and the imagery deriving from them continues to develop in new ways. The gallery of drawings assembled in this second section demonstrates how the technical expertise of individual artists is applied to a surprising variety of subjects, some among the classic themes of art, others closely associated with the specifics of this medium. Text and captions give cross-references where appropriate to the techniques previously demonstrated, to enable you to relate the working method to the end result.

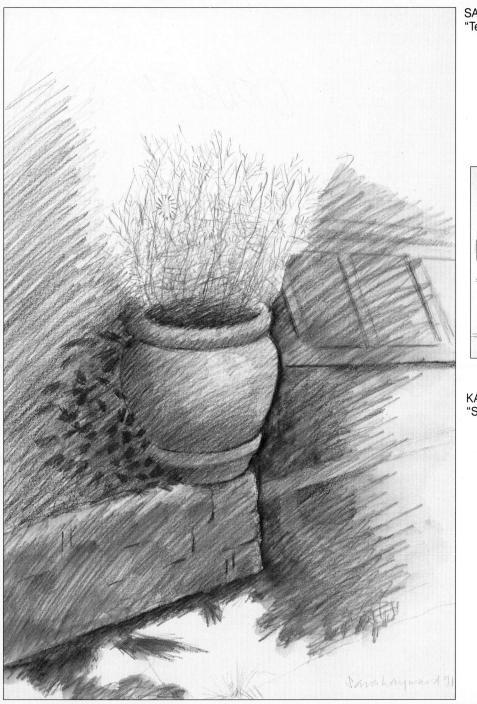

SARA HAYWARD
"Terra Cotta Pot"

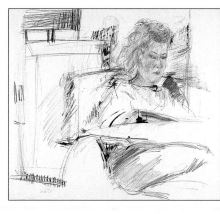

KAYE SONG TEALE
"Seated Figure"

LANDSCAPE AND TOWNSCAPE

Interpreting large-scale subjects with a medium that is essentially fine and linear is a particular technical challenge. If you intend to produce a detailed color study of a landscape view, it can take a great deal of time as you build up the individual marks and color areas into a tightly constructed, cohesive image. For this reason, colored pencils are more frequently used to make sketches and working drawings that will be interpreted in another medium, such as watercolor or oil paint. Such preliminary studies have an interesting character in their own right and provide a good practice ground for exercising the versatility of your techniques. However, you can also see from examples in this section that the labor of producing a highly finished work in colored pencil is often well worth it, resulting in a vibrant, active style of imagery.

Sketching in colored pencils

Very few artists actually complete a landscape or townscape image in front of the subject since the inconveniences of working outdoors make it difficult to concentrate effectively on a detailed approach. The habit of sketching outdoors to produce a body of reference work that can be reinterpreted in the studio is a long-established working method. Colored pencils are an ideal medium for sketching outdoors, being clean and easily portable. All you need is a useful selection of colors — remember to include some brilliant, strong hues as well as the more subtle greens and ochers — and a sketch book of good-quality cartridge or watercolor paper.

Light is an essential element of these themes, and you may be surprised at the way you need to handle your colors in order to capture light effects — you will often find it necessary to create bold contrasts and enhanced color interactions. This is why you should not restrict your color selection to those hues and shades that you can most immediately identify. You need colors that transmit light — such as bright yellows and pinks, and cold, pale blues — and also rich hues such as red and purple to counter-point the earth colors and foliage greens.

JOHN CHAMBERLAIN
"The Tree"

Mixing techniques and media

Using a point medium to express the vast sweep of open landscape often directs the artist's attention to the contours of the land. Directional lines conveying horizontal spread and recession toward the skyline create a framework that can be filled or elaborated using a variety of techniques — SHADING and HATCHING are widely employed. Artists approaching landscape or townscape views in terms of color masses often prefer to block in general shapes with paint before working in the detail with colored pencils: WATERCOLOR AND PENCIL is an effective mixed-media technique for this subject. You should also consider using COLORED PAPERS and COLLAGE that immediately establish broad color areas over which you can apply a complex network of pencil marks.

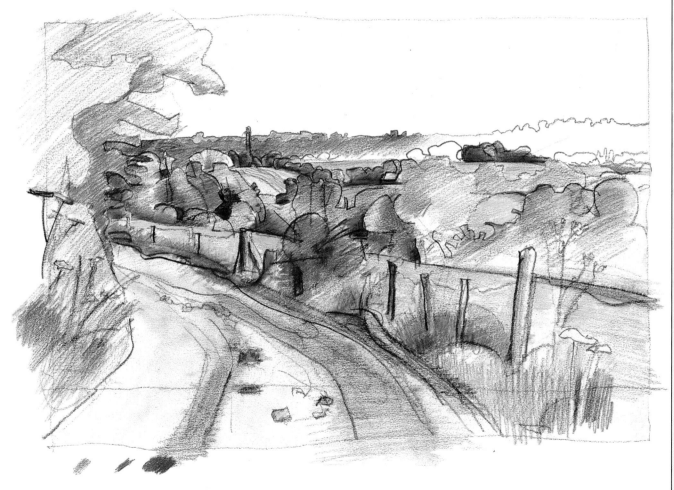

JOHN TOWNEND
"A View Near Biggin Hill"

The pictorial space of a landscape is defined by your viewpoint, your position as spectator setting the level of the horizon line. The proportion of sky to land is significant in creating space and the elements of landscape need to be carefully orchestrated to define spatial recession toward the horizon.

A relatively small area of the paper may represent a vast area of land, and you must achieve an accurate sense of scale, assessing the relationships of interlocking shapes and the way colors and textures are layered within the compressed space. Because colored pencils are linear, careful judgment of the scale and direction of the marks you make is crucial to a convincing impression of space and distance.

Framing of the image is an important factor. A horizontal format in itself helps to express the breadth of landscape and is more commonly used than a picture format with vertical emphasis. The overall shape of the image also affects the sense of space — the picture area need not be strictly rectangular — as does the extent of the view that you choose to include.

▲ JOHN TOWNEND
"Copping Hall"
The sweeping space of the landscape is achieved by locating the focal point of the building on the horizon line and emphasizing the curve in the foreground. Layers of loose shading create a rich impression of fall colors.
● *Overlaying colors*

JEFFREY CAMP
"Clifftop"
Simplified shapes and gentle colors produce a charming effect. The grainy pencil marks are wetted and spread in brief touches. The odd sense of floating above the scene is achieved by the absence of a true ground level in the perspective.
● *Solvents*

MARK HUDSON
"Mountain Landscape"
Light washes of paint form the ground of the landscape and are complemented by the soft quality of the pencil drawing. Rough shading and hatching contribute to the atmospherics of the sky, while slashing and trailing lines in the foreground suggest the textures of grass and stony ground. The colors chosen are natural hues, reflecting the subject and create a harmonious mood.

● *Drawing into paint*
● *Linear marks*
● *Watercolor and pencil*

COLOR STUDIES

The subtle variations of color in landscape are a challenge to the artist working in colored pencils. Rather than trying to match the individual colors that you see in nature, you need to develop the skills of analyzing color relationships and finding satisfactory equivalents by manipulating the qualities of hue, shade and intensity in your pencil colors. Important factors to consider include the extent of one color against another, whether mixed color effects are best achieved by interweaving or juxtaposing the pencil marks, and the selection of hues and shades that interact to create the right nuances.

Qualities of light and shadow should be achieved with vibrant mixes to keep the picture surface alive; using the neutrals — black and white — to strengthen tonal contrasts can deaden the image. Dark shadows can be shot through with red-brown, indigo or purple; highlight areas can be intensified with touches of bright pink or yellow.

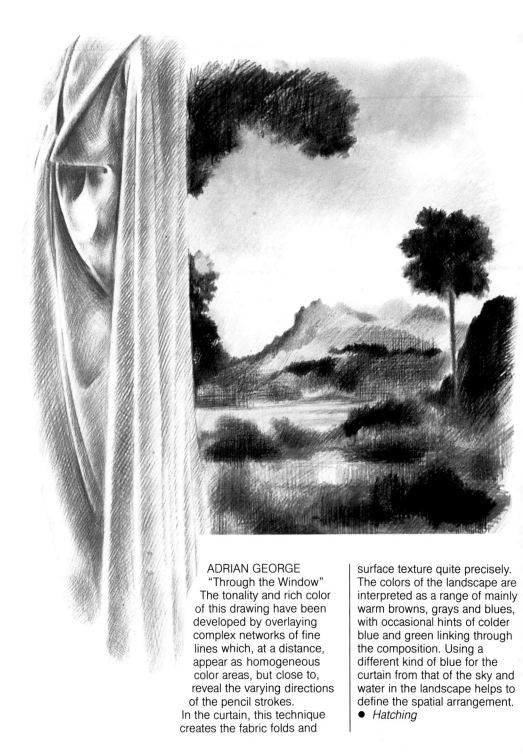

ADRIAN GEORGE
"Through the Window"
The tonality and rich color of this drawing have been developed by overlaying complex networks of fine lines which, at a distance, appear as homogeneous color areas, but close to, reveal the varying directions of the pencil strokes.
In the curtain, this technique creates the fabric folds and surface texture quite precisely. The colors of the landscape are interpreted as a range of mainly warm browns, grays and blues, with occasional hints of colder blue and green linking through the composition. Using a different kind of blue for the curtain from that of the sky and water in the landscape helps to define the spatial arrangement.
● Hatching

STEVE RUSSELL
"Cala Honda, Spanish
Landscape"
Soft-leaded waxy pencils are
combined with chalky pastel
pencils to provide the bright
color scheme of this sunlit view.
The shapes are simplified to
emphasize the rhythms and
patterns of the landscape and
buildings. Using broadly
shaded patches of bold color
gives an exotic impression,
enlivened by formal pattern
elements in the foreground.
● *Linear marks*
● *Mixing pencils*
● *Shading*

▼ DAVID HOLMES
"Landscape"
In an abstract interpretation,
mere hints of color can be
selected and emphasized to
provide a dramatic contrast.
The boldness of the red-blue
opposition matches the vigor of
the gestural mark-making in
broad-leaded, waxy pencils and
watercolor.
● *Hatching*
● *Linear marks*
● *Watercolor and pencil*

▶ JO DENNIS
"English Countryside"
The gentle contours of the land
are framed in a way that creates
a classic pastoral scene,
described in naturalistic colors.
Solid shading is varied in
density to bring colors up more
intensely in the foreground than
in the distant parts of the view,
and emphatic line drawing is
overlaid to enhance the detail.
● *Line qualities*
● *Overlaying colors*
● *Shading*

SHAPES AND TEXTURES

Landscape is composed of shapes within shapes, from the broad levels of the land to dominant features such as rocks and trees to the delicate details of foliage and flowers. Form and texture in a landscape image are developed out of concentration on the relative scale and complexity of these different elements.

However detailed your drawing, it is inevitably an approximation of what you actually see — no one draws every leaf or every blade of grass, and even the major forms acquire some modification as you translate them into a two-dimensional representation. The choices made in selecting particular aspects of the subject and working out ways of interpreting them technically are the ingredients of an artist's personal style.

This selective process means that it is important to find those things that most effectively describe the character of the subject and convey your special interest in it, whether they are generalized forms or specific textures. Because colored pencils allow you to work up an image slowly, you can make continuous adjustments and focus quite precisely on the elements of the landscape that you wish to bring out.

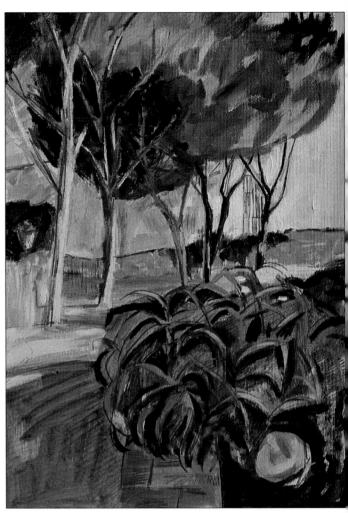

◀ JO DENNIS
"Stone Wall"
The wall forms a curving line, leading the viewer right through the space of the picture and effectively cutting the composition into two parts. The focus on the large stones in the foreground startlingly enhances the perspective. These interlocked shapes contain an interesting pattern of smaller shapes within.
● *Gradations*

HELENA GREENE
"Tree-lined Road"
Loosely brushed acrylic paint on a canvas-board ground is the main medium for blocking in the shapes and textures of the foliage and tree trunks. Colored pencil drawing is added to sharpen the edge qualities and enhance the lights and shadows, redefining the play of natural forms.
● *Drawing into paint*

▲ JOHN TOWNEND
"Haymaking"
Each different element of the
landscape is interpreted as
contributing to an overall
schematic rhythm, with
individual forms defined by
bold contour lines. The texture
of the free shading is varied, as
well as the colors, to help
differentiate the hayfield from
the trees flanking the far side.
● *Contour drawing*
● *Hatching*
● *Shading*

◄ CARL MELEGARI
"Sydney Harbour Bridge"
Although he has used an
active, all-over texture of
vigorous line drawing, the artist
has contrived the colors in a
way that allows distinctive
forms to emerge from the busy
surface. The texture of the
image itself is as important as
the structures it portrays.
● *Linear marks*

LIGHT AND ATMOSPHERE

If you are working in colored pencils only, qualities of light and atmospheric impressions can be difficult to handle. Whereas with paint or pastel you can rely on overworking with pale tints to retrieve the lights and modify blends and color mixes, with colored pencils your means of adjusting the high-key tones are restricted if you have laid in colors too heavily or broadly. You need to have an organized sense of the composition from the start, especially if you rely on using the white of the paper to make the highlights.

Degrees of tonal contrast sometimes have to be exaggerated to achieve a vibrant impression of light effects. Colored pencil drawing allows you plenty of time to build up contrasts; if you find the drawing looks flat, don't be afraid to attempt radical measures, introducing a darker color or more vivid hue.

You may wish to work very quickly and spontaneously to develop the mood of a landscape deriving from the quality of light or particular weather conditions. Mixed media approaches are frequently successful for landscape work.

MIKE PEASE
"Forest Light"
The effect of strong light is created with tonal contrast, similar to the counterpointing of shading used in the adjacent image. Here, though, there is a misty, fragile quality to the rendering – due to the muted background colors and smaller, more intricate shapes – that describes a very different atmosphere.
● Gradations
● Shading

▲ LAURA DUIS
"A Corner of Green"
When describing brilliant
sunlight, it is most effective to
show a very strong contrast
between the lights and
shadows. The large, hard-
edged cast shadow in this
picture lifts the pale yellow-
greens to create singing tones.
These register strongly even
though the brightest highlight
area is the white front of the
bench.
● *Highlights*

DAVID HOLMES
"Cornfield"
A dramatic image can be
achieved by reducing a subject
to its bare essentials. The artist
here has chosen the basic
abstract qualities of the scene –
broad shapes, directional lines,
tonal contrast – to form the
composition. These underlying
elements are present even in
the most representational
imagery.
● *Line and wash*
● *Linear marks*

The shape and structure of an individual building may evoke a particular sense of place, or it may draw associations with a personal "narrative" relating to its own function and a suggestion of the lifestyle of people living or working there. You can use the colors and textures of colored pencil marks to convey mood and atmosphere in a drawing, and you can use them to create basic structures.

In terms of formal composition, a building is an arrangement of broad planes and volumes intercut with more detailed frameworks, such as windows and doors, roof coverings and architectural ornament. You need not always try to include all the information that you see. Use a selective eye to search out those details that are both descriptive and decorative.

The geometry and perspective of the view need not be strictly accurate, unless the real space of the building is your primary interest. Often a slightly quirky or exaggerated angle of view adds to the impression of how a well-ordered architectural structure acquires a distinctive character through its age and style.

▲ JEAN ANN O'NEILL
"Bangkok"
This drawing looks for decorative qualities, but builds them solidly with free shading and distinctly drawn shapes.
● *Filling in*
● *Shading*

◄ KAY SONG TEALE
"Pavilion"
A quirky interpretation of the perspective enhances the decorative complexity of the architecture, giving charming character to the artist's impression. The linear qualities of the pencil marks have been given free reign.
● *Graphite and pencil*
● *Linear marks*

▲ HELENA GREENE
"Castle"
The low viewpoint contributes a grand and sinister mood to the imposing castle. The mixed media approach combines oil pastel in the building, watercolor in the surrounding landscape, and colored pencil drawing over both.
● *Pastel and pencil*
● *Watercolor and pencil*

◄ SARA HAYWARD
"Courtyard"
Loose shading puts a pale glaze of yellow over the courtyard walls, giving the whole drawing a warm, sunny tone. The structures of the building are economically described with line and the actively scribbled and hatched color overlays.
● *Linear marks*

FAÇADES

Concentrating on the façade of a building is like drawing its portrait. The three-dimensional depth and interior space become irrelevant; you focus on the details of the architecture that give the essence of the building's style and make it recognizable and memorable. You have to work out which details contribute to a true likeness of the building as you see it.

Since a direct, frontal viewpoint eliminates many elements of perspective, it simplifies your task in terms of identifying basic structures — but because there is no surrounding detail to distract the eye, the elements of the façade that you wish to portray need to be well chosen and accurately rendered. The accuracy lies not in reproducing shape and proportion correctly as if from an architect's blueprint, but in defining the relationships of shape, form, color and texture — the ways they interact and how each element functions within the whole. As can be seen from the examples here, this can be dealt with as an apparently detailed, naturalistic image or as a "portrait sketch" homing in on the bare essentials.

◀ MICHAEL BISHOP
"L'Escargot"
Many clever touches contribute to the detailed impression of this imposing façade. For example, in the brickwork, a few faint lines serve to convey the overall texture and the cast shadows on the flat surfaces emphasize the detail of the architecture. The quality of the pencil marks is varied to suggest different textures and the organization of color strongly underlines the structural framework.
● *Dashes and dots*
● *Linear marks*
● *Shading*

▶ RAY EVANS
"Naval College, Leningrad"
A complex architectural structure is described in line, with soft washes of color forming coherent surface planes within the framework. This treatment makes the most of the soft textures that can be achieved with water-soluble pencils.
● *Line and wash*
● *Solvents*

CHLOË CHEESE
"Café de Lyonne"
Focusing on the simple cutout shape of the café façade eliminates all distracting detail. The artist's technique and interpretation can therefore be at its most economical, but, at the same time, highly effective in drawing a charming portrait of the continental café.
● *Sketching*
● *Watercolor and pencil*

TOWNSCAPES

The massed structures that form a townscape are inviting to the artist, containing many interesting juxtapositions of shape and form. Both the viewpoint that you take and the degree of detail that you include are important factors in developing the character of the scene.

To record the "layered" architecture of a small, picturesque town, a high-level viewpoint is often favored; it typically reveals a sense of order in the arrangement of streets and buildings that you do not appreciate in the view from ground level. A normal eye level, however, has the advantage of leading the viewer into the townscape and focusing on familiar territory. In this case, the drawing techniques may be employed in a way that expresses something beyond the simple appearances of things.

There is a useful discipline to be gained in choosing a familiar location as the subject of your drawing; it is a challenge to see it with a fresh, objective eye and devise a suitable technical interpretation. But it is often the charm of an unfamiliar place that appeals, such as in places you visit on vacation.

FRANK AUERBACH
"Street"
A streetscape can be harsh, busy, even threatening in mood. The vigor and intensity of the marks you make can express an idea or feeling about the place as well as its formal structure. The calligraphic qualities of pen-drawn and colored pencil lines are combined to strong effect in this abstract study.
● *Ink and pencil*
● *Line qualities*

RAY EVANS
"Lucca from Torre Guinigi"
There is enduring visual fascination in the pattern of interlocking planes, the slanted roofs and staring walls that compose a townscape. The high viewpoint here provides an overview of the structural logic. Two different kinds of soft-leaded pencils have been used to build up the color areas with gentle but emphatic strokes.
● *Hatching*
● *Shading*
● *Sketching*

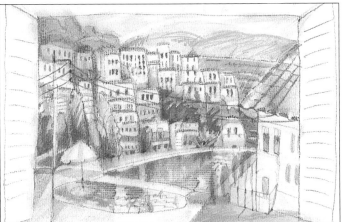

◄ LUC VAN DER KROOY
"Waterside"
The stepped arrangement of the buildings provides a charming framework over which to drape the Mediterranean colors. The detail is minimal and loosely described, but still achieves a sense of character intrinsic to the location. The faintest hints of reflection on the water are enough to separate its glassy surface from the opaque textures surrounding it.
● *Watercolor and pencil*

LANDSCAPE: SPACE AND LIGHT

JOHN TOWNEND

Any landscape view provides a wealth of visual information — space, light, form, texture, color — so you need to focus clearly on selected features of your subject and ways of interpreting them effectively with colored pencils. Otherwise, it is difficult to know how or where to start. Techniques such as shading and hatching enable you to build color blocks quite rapidly, while the linear qualities of your pencils can be used to develop form and texture within the broader shapes.

In this demonstration, John Townend works toward achieving the particular sense of space and light inherent in his subject. The road leads into the distance, flanked by the solid shapes of trees, bushes and fences, and the unusual quality of light, reflecting from the damp surface of the road, creates unusual colors and shades in the sky at the central horizon.

1 The artist begins by drawing in the main guidelines of the landscape view with a soft pencil. These lines have a sketchy quality, creating the basic forms and rhythms of the composition.

2 Light SHADING is used to lay in broad areas of color. In this initial stage of BLOCKING IN, varying intensities of yellow indicate the high tones, overlaid with a medium olive green to give depth.

3 The whole drawing is lightly covered with free, open shading and HATCHING to "knock back" the luminosity of the white paper and activate the drawing surface.

4 Color variations are developed gradually by OVERLAYING areas of shading and hatching. The artist begins to pick up some of the smaller and more detailed shapes and work into them.

5 This step completes the basic stages of blocking in, establishing a definite structure to the composition and suggestions of individual forms and textures.

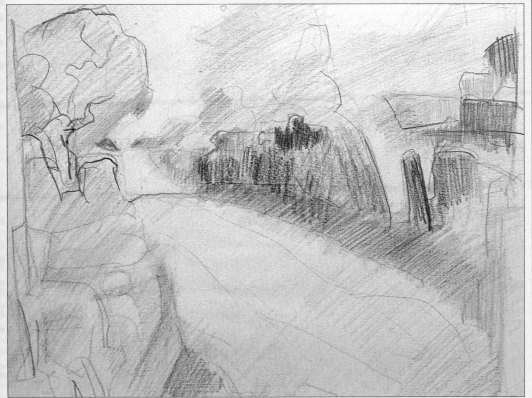

6 The drawing develops depth and texture through the overlaying of different colors and shades, but, as this detail shows, the pencil marks are still kept loose and open to avoid filling in the paper grain.

7 The definition of the overall composition is enhanced by laying in areas of non-naturalistic color, but the hues and shades are chosen to create a harmonious palette of colors equivalent to the effects seen in the features of the landscape.

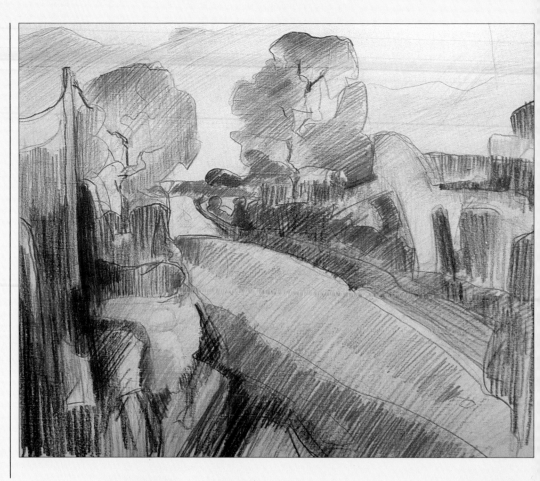

8 The artist here holds the pencil by the underhand grip (see HANDLING PENCILS) to give emphasis to the LINEAR MARKS that create the rhythms and directions of the landscape.

9 The surface sheen of the wet road needs to be represented by distinctive tonal variations. Color BLENDING and tonal GRADATION are built up with overlaid blocks of hatching in strong colors.

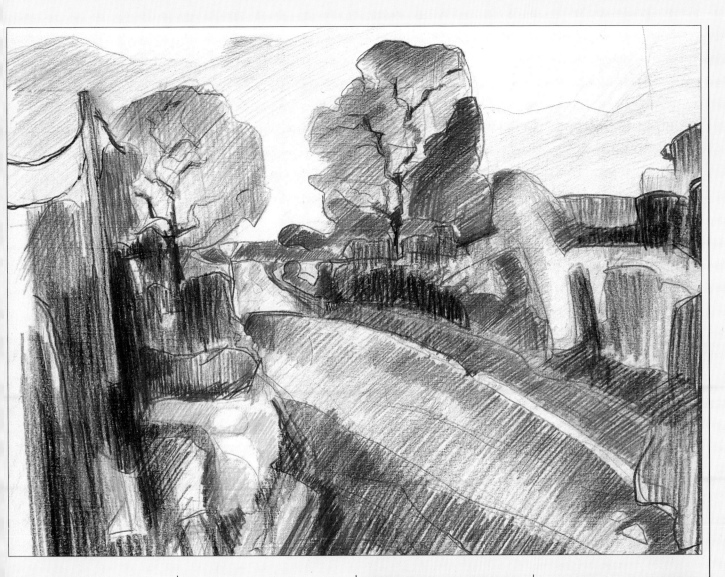

JOHN TOWNEND
"Autumn Road"
In the final image, the artist has achieved the sense of space and receding forms and surfaces characteristic of this view, while attending to the abstract properties of shape and color that give the drawing techniques an active presence in forming the image. In the final stages, he has used graphite pencil mixed in with the colors to strengthen the dark shades (right) and redefine individual structures such as the tree trunks and branches (far right).

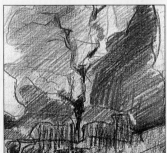

OBJECTS

INDIVIDUAL OBJECTS make truly exciting images, particularly well suited to the scale and detailed textures of colored pencil drawing. The range of this theme is extensive; many of the objects shown in this section are readily available items, typically part of your day-to-day life. It is possible to buy others inexpensively, and you can start to make a collection of simple but attractive things to include in your drawings.

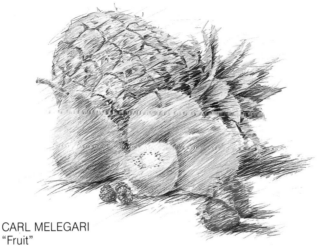

CARL MELEGARI
"Fruit"

of learning your craft, there are two different and equally useful forms of approach. You can select one item, or a group of objects, and make several studies, trying out alternative techniques individually and studying particular aspects of the subject one at a time — devoting one study to distinct individual shapes, for example, another to surface effects or an impression of color and light. Alternatively, you can make one finished drawing incorporating as much detail as possible and combining different techniques to indicate different elements — CONTOUR DRAWING or solid SHADING to construct the forms, for example, with LINEAR MARKS overlaid to show pattern, texture and other surface detail. Selective use of techniques such as FROTTAGE, IMPRESSING and SGRAFFITO can also be employed to obtain textured effects. Then, when you are satisfied that the interpretation is complete, you can change the still-life set-up or select other kinds of objects for a new composition.

Selecting your subject and technique

If you are learning to work with colored pencils and developing your control of technique and color mixing, studies of objects are an ideally practical way to train your hand and eye. You can set up a single object or a group on a drawing board or tabletop out of the way of your daily routine, and it can remain there for as long as it takes to complete the drawing, so you can work in stages with frequent interruptions if necessary. You can start with very simple forms and gradually work though to increasingly more complex images and compositions.

If you treat this category of subject matter as a way

While it is useful to set yourself exercises of this kind, do choose objects that particularly interest and attract you, so that you have no trouble keeping your

concentration over an extended period of study. Every item has specific qualities that challenge your technical skills — you can find different ways of manipulating your drawing tools to reproduce such effects as the reflective surface of glass, the fineness of lacy or sheer fabrics, the irregular pattern of wood grain, or the soft downy skin of a peach.

In addition to these technical problems, you have also to deal with the representation of three-dimensional form, the dynamics of a group, the spaces around and between the objects and the shapes created by overlapping forms. Using relatively small-scale subjects to investigate these formal elements of composition and technique also provides you with valuable experience for tackling more complex or ambitious themes.

JOHN DAVIS
"Drinks"

HOUSEHOLD OBJECTS

There is a great deal of material for detailed study in everyday objects found all around your home. Furniture and clothing, which have been chosen originally for the interest and attractiveness of their shapes, patterns and textures, make excellent subjects for colored pencil drawings. A chair, a rug, a coat hanging up, or a pair or shoes sitting on the floor — such apparently simple, familiar items contain a wealth of detail and teach you how to analyze basic shapes and forms, as well as specific surface qualities. Household objects are of suitable scale for representation through controlled drawing techniques such as HATCHING, SHADING and STIPPLING.

Many smaller items can be found that contribute to colorful still-life groups, enabling you to make close-up studies of form and texture. As shown here, simple items from a sewing basket make a fascinating image; other good possibilities are kitchen implements, cosmetics and toiletries, ornaments on a shelf, or the materials and equipment found on a desk or studio table.

▲ SARA HAYWARD
"Slippers"
The interplay of line and color in the patterned fabrics suggests the combination of shading and hatching.
● *Hatching*

◀ SARA HAYWARD
"Chair"
Paint and pencil marks are actively drawn, contributing rhythm and energy to an otherwise static subject.
● *Watercolor and pencil*

▶ JEAN ANN O'NEILL
"Pencils"
The image forms a witty reference to the medium and is attractively interpreted with shading and erased highlights.
● *Eraser techniques*

CARL MELEGARI
"Sewing Materials"
The jewel-bright colors of the spools of thread make a vivid contrast to the restrained pattern of the striped fabric. The bright hues are nicely echoed in the reflections on the scissors and pins. The artist's characteristic style of vigorously woven pencil marks is cleverly adapted to the scale of the objects, even encompassing detail as graphic and precise as the numbers on the measuring tape.
● *Hatching*
● *Linear marks*

Many functional objects owe their visual appeal to the colors and patterns applied to them. They are simple forms, made more interesting by the imposition of decorative surface elements — fabric and ceramic items are typical examples.

For the artist, there is a more complex visual challenge underlying the surface color. A pattern is molded to the shape of an object and reflects the contours and volumes of its form. A patterned scarf, for example, is rarely seen as a flat rectangle, and when it is draped or folded, the logic of the pattern is broken up, so the relationships of color and shape within the pattern itself become more complicated. In the same way, patterns on cups, pitchers and bowls follow the curves and hollows of the object's shape.

Identifying the ways that the surface elements respond to the underlying form is an interesting problem. An additional factor is the way that light models volume and contour, at the same time modifying surface color and subtly disrupting the uniformity of an imposed pattern. Thus decorative objects designed to be immediately attractive reveal many layers of visual information that you need to take into account in your drawing.

Pattern qualities
Some foodstuffs have interesting pattern qualities relating to their own structure or surface detail — the scales and markings of a fish, for example, or the segmented interiors of certain fruits. In a still-life group, patterns are also created by the repetition of similar shapes. These decorative elements can be brought out and enhanced by colored pencil drawing, using the technical variety of LINEAR MARKS, HATCHING and SHADING to develop the internal rhythms of the composition.

One way of achieving a particularly bright and busy image is to play off the natural colors and shapes of the chosen foods against the formal, imposed patterns of printed fabrics and decorated dishes. This creates an interesting challenge in how to deal with the interactions of flat patterns and three-dimensional forms. One solution successfully employed in the examples shown here is to use a watercolor underpainting to establish a sense of solid form, over which the colored pencil drawing develops the surface activity, elaborating the intricate detail of color and texture.

HELENA GREENE
"Gift Packages"
Controlled shading produces a variable tonal range that conveys the surface sheen of the decorative papers as well as the printed patterns and colors. The artist has been careful to follow the way pattern shapes are wrapped around the underlying volumes.
● *Gradations*

TESS STONE
"Sewing Kit"
An interesting combination of techniques describes the varied textural qualities of this image. The fabric patterns are silkscreened, real labels have been collaged onto the threads, and the pin box is painted with watercolor and detailed with pencil.
● *Collage*

JEANNE LACHANCE
"The Empty Woman"
The intricate control that you can maintain when drawing with the points of colored pencils is admirably demonstrated in the details of lace, buttons and ties. The overall silky texture, and slight translucence of the white fabrics, is achieved by careful gradation of tones.

● *Gradations*
● *Shading*

▶ JANE HUGHES
"Flowered Scarf"
The vibrance of pencil and watercolor in combination is adapted to both the broad pattern of the scarf and the jewel-like shapes in the necklace and earrings. The folds in the scarf are described only by exact observation of the pattern shapes and the way these are broken by folds. They are treated as whole colored shapes, not dictated by linear contours.

● *Drawing into paint*
● *Watercolor and pencil*

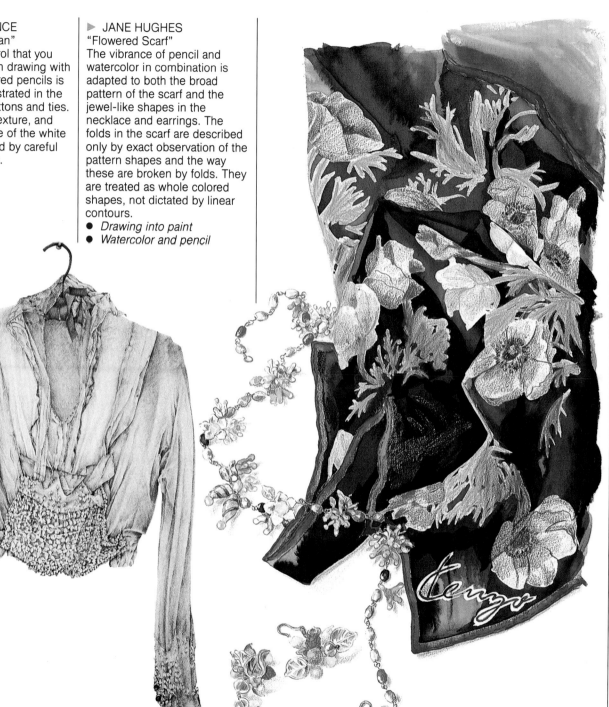

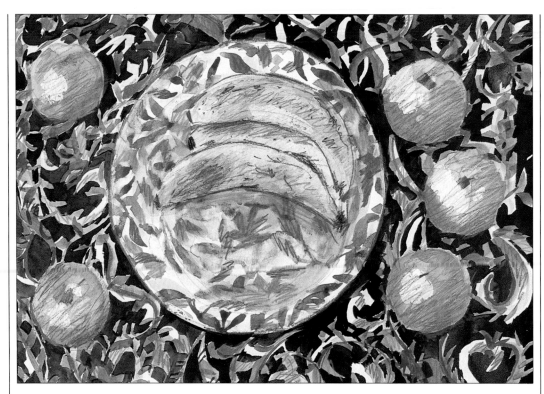

SARA HAYWARD
"Bananas"
The very strong black is an important element in bringing up the brilliance of the pure hues, and it has a crisp, solid presence because it is painted in watercolor rather than shaded in pencil. The same applies to the vivid highlights on the oranges, established by a distinct tonal contrast in the watercolor underpainting. Colored pencil drawing is used to develop the surface interest of the rendering, relating it to texture and pattern rather than form and volume.
● *Linear marks*
● *Watercolor and pencil*

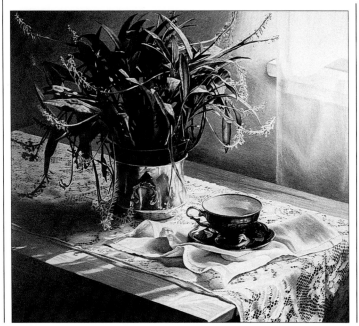

◄ BARBARA EDIDIN
"The Blue Cup"
This is a virtuoso demonstration of achieving richness and variety in a colored pencil rendering through patient and consistent technique. Most important are the artist's skills of observation, which enable her to analyze very precisely the shapes, colors and surface qualities that identify the different elements of her subject. She weaves a pattern of light and shadow across the formal patterns of china and lace, capturing, too, the exact tonal values of the reflective metal container and the complex foliage arrangement.
● *Gradations*

▲ CARL MELEGARI
"Table Still Life"
The freely scribbled technique
is an unusual way to achieve
subtle gradations of shading
and color, but it works very well
in modeling the forms and
surface detail of the objects. A
mixture of different qualities of
colored pencil, including water-
soluble types, enables the artist
to keep the colors brilliant and
fresh.
● *Gradations*
● *Mixing pencils*

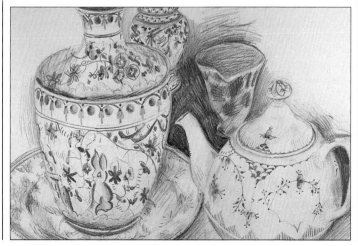

◄ SARA HAYWARD
"Blue and White China"
The objects are chosen for their
interesting individual shapes
and related, but not uniform,
surface patterns. The
distribution of the pattern is the
main vehicle for modeling the
curves of the teapot and vase,
with a little light shading
emphasizing the shadow areas.
● *Linear marks*
● *Shading*

TOYS AND EPHEMERA

The variety of colored pencil drawing found in advertising and magazine illustration has introduced a range of subject matter well outside the traditional focus of fine art themes. Toys, games and candy bars, typically designed with wacky shapes and colors intended to give them market appeal, are not the most obvious items for detailed study in a drawing. But they are ordinary and accessible elements of our daily life in the way that more austere still-life subjects have always been, and they make colorful, busy images that are fun to work out technically.

An illustration is put in context in a way that a one-off drawing is not; but as the examples on these pages show, there are similar formal considerations that need to be resolved to create a striking and effective composition. Because the basic shapes and surface colors and textures may be quirky and specific, it is all the more important to analyze them accurately and adapt your drawing techniques effectively to portray individual aspects of the subject.

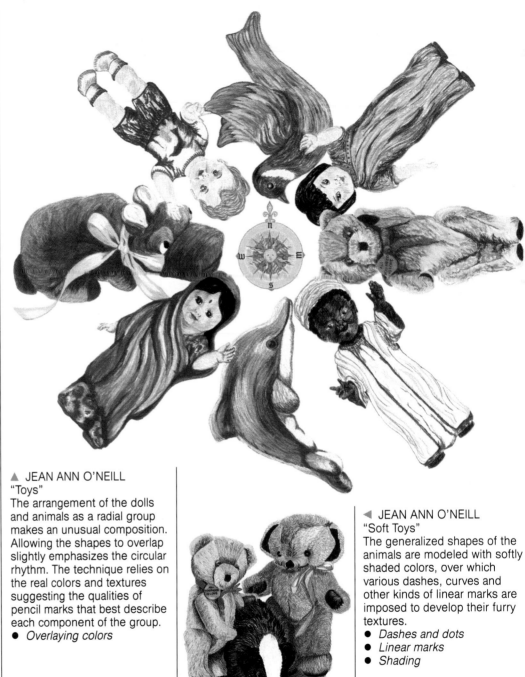

▲ JEAN ANN O'NEILL
"Toys"
The arrangement of the dolls and animals as a radial group makes an unusual composition. Allowing the shapes to overlap slightly emphasizes the circular rhythm. The technique relies on the real colors and textures suggesting the qualities of pencil marks that best describe each component of the group.
● *Overlaying colors*

◄ JEAN ANN O'NEILL
"Soft Toys"
The generalized shapes of the animals are modeled with softly shaded colors, over which various dashes, curves and other kinds of linear marks are imposed to develop their furry textures.
● *Dashes and dots*
● *Linear marks*
● *Shading*

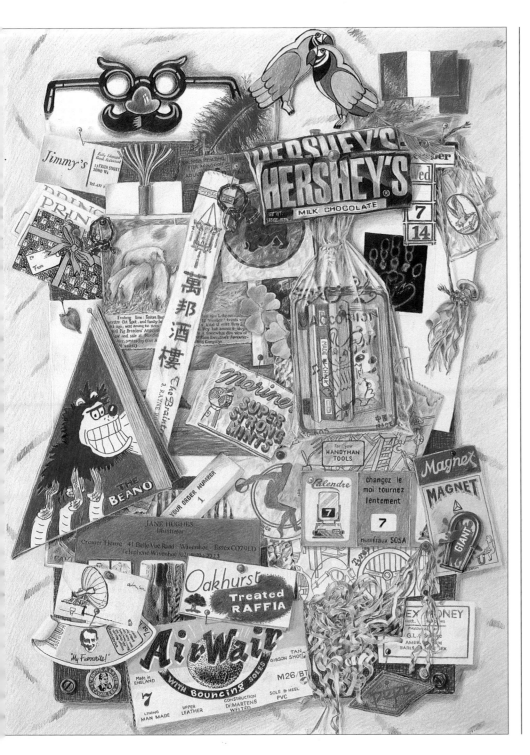

JANE HUGHES
"Cards and Wrappers"
This self-promotional work includes all manner of ephemeral items, providing a range of bright colors and varied textures that demonstrate the artist's skills in applying her medium. The apparently random selection of objects is arranged to form a strong interplay of shapes and directions. Within this framework, various techniques have been used to build up particular impressions, from the vivid opacity of printed colors to the subtle shadowing and reflection on transparent wrappers. Through careful observation, the artist has achieved an effective rendering of the differences between flat, graphic items and three-dimensional objects.
● *Blending*
● *Eraser techniques*
● *Filling in*

GROUPS

Grouped objects present you with a number of decisions on how to treat the composition of the group, as well as suitable techniques for interpreting particular forms and surface effects. What angle of view will you take? What are the spaces between the objects, and how much visual interest do they contain? How do you deal with background elements in relation to featured objects? Is your drawing purely a formal still-life study, or does it reflect a mood?

If you are dealing with a number of disparate objects — perhaps using a "found" grouping rather than one you have set up yourself — you need to decide whether your techniques will emphasize the differences of form and texture or have the effect of bringing them together visually. With colored pencil drawing, there is a great deal of scope for BLOCKING IN the overall composition in a way that gives it a cohesive structure, then using varied techniques to develop the detail and enhance the character of each item.

Foodstuffs
Foodstuffs have often been important components of traditional still-life groupings. They provide a common theme which unifies a composition, whether the individual items are similar or selected from a varied range. A simple loaf of bread is in itself a fascinating study of specific textures; readily available foods such as fruits, vegetables and fish all offer great variety of form, color and surface detail that lends itself to the intimate scale of colored pencil drawing. Packaged foods introduce an interesting modern variation on traditional still-life themes, mixing bold interactions of shape and form with graphic surface detail.

Setting up a group of objects for a drawing needs careful thought. A highly formal arrangement in which each component is clearly visible can look too "posed" and unnatural, but a random grouping may present undesirable combinations of shape and color. Think about the format of your drawing, the way you will handle the color detail, and the modeling of light and shadow that brings out characteristic forms. Focus in your own mind the points of main interest in the groupings, and adjust the components as often as you like.

◀ HELENA GREENE
"Still Life"
Free washes of watercolor and lively brush drawing establish basic shapes and forms, and a balance of color and shade. Over the painted ground, colored pencils add sharpness and detail.
● *Watercolor and pencil*

▲ RITA D. LUDDEN
"Summer Still Life"
The gradations of color have been so subtly contrived in this picture that it has the smoothness and delicacy of a watercolor, but it has been worked completely in pencils.
● *Gradations*
● *Shading*

▲ HELENA GREENE
"Vegetables"
The painting which forms the basis of this image is boldly modeled with color and shadings, but the individual details of texture and light and shadow on the vegetables benefit from discreet touches of colored pencil line and shading.
● *Drawing into paint*

◀ JANE STROTHER
"Summer Plate"
The attractive sunlit mood of a simple still life is captured with the combination of watercolor and pencil. The slight translucence typical of pencil colors helps to lift the tonal density, but the line work and shading are strong, with a punchy descriptive quality.
● *Linear marks*
● *Watercolor and pencil*

CHLOË CHEESE
"Heart"
Creating an interesting grouping of objects does not mean composing a conventional still life. The emphasis in this composition is mainly on flat shapes and patterns, with occasional reminders of the three-dimensional aspect in, for example, the edge qualities of the note, card and snapshot. The artist's use of line and shaded color weaves the visual links and connections. The brown wrapping paper ground provides a uniform underlying texture and a warm base for the color work that makes the blues and yellows look particularly vibrant.

● *Filling in*
● *Line qualities*
● *Overlaying colors*

JO DENNIS
"Sargent's Tools"
The success of a highly realistic style of rendering in colored pencils relies on developing consistency in the technique and using the pencil marks discreetly to interpret specific aspects of the subject. The conventional method of close shading is used here to model the forms and textures tonally, paying careful attention to the highlights that enliven the restricted color range. Some delicate line work emphasizes the woodgrain patterns.
● *Gradations*
● *Highlights*

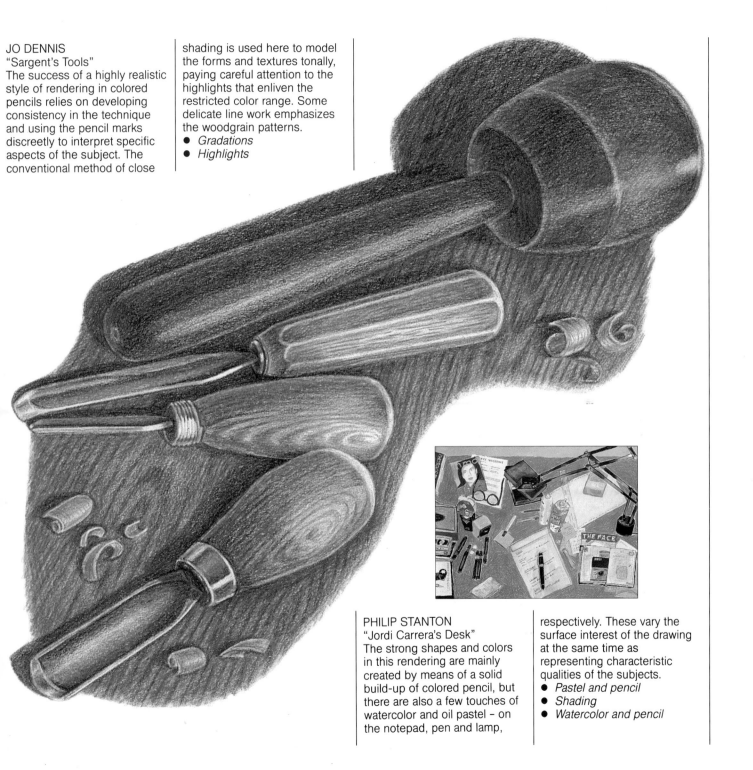

PHILIP STANTON
"Jordi Carrera's Desk"
The strong shapes and colors in this rendering are mainly created by means of a solid build-up of colored pencil, but there are also a few touches of watercolor and oil pastel - on the notepad, pen and lamp, respectively. These vary the surface interest of the drawing at the same time as representing characteristic qualities of the subjects.
● *Pastel and pencil*
● *Shading*
● *Watercolor and pencil*

TESS STONE
"Tea Table"
All the objects in this group in reality have cleanly defined shapes and even textures, so the free pencil technique and quirky contours provide an interesting reinterpretation which expresses the artist's own style and energy. The individual colors are mostly quite low-key and muted, but the particular combination of hues creates a colorful impression.

● *Contour drawing*
● *Filling in*

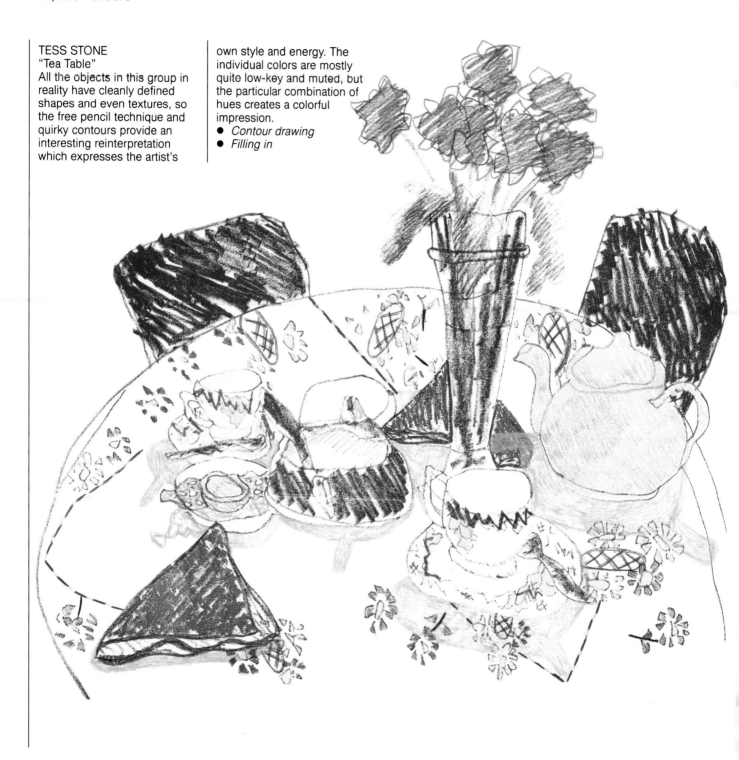

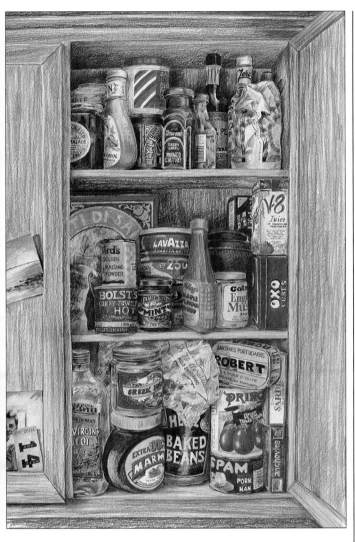

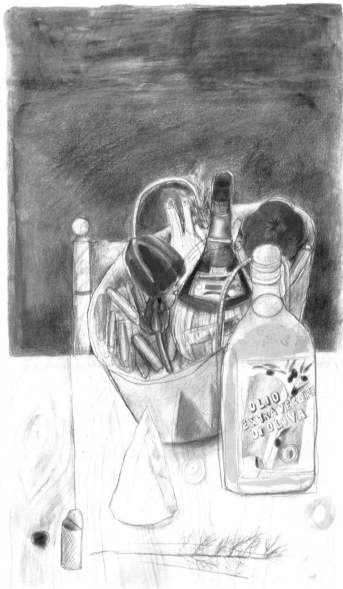

JANE HUGHES
"Store Cupboard"
This drawing represents the kind of found subject that can be overlooked as material for the artist because the components are everyday things. However, this picture shows how the various types of food packaging can create a fascinating composition full of variation, in the same way as more conventional forms of still life. The inclusion of the postcard and photograph tucked into the frame of the left-hand door adds a personal touch.
● *Linear marks*
● *Shading*
● *Watercolor and pencil*

CHLOË CHEESE
"Shopping Bag"
Small patches of colored ink on the red pepper and oil bottle provide a glowing base for the pencil color, but the overall impression of the drawing and the build-up of detail depend mainly on the pencil work. This contrasts open areas of linear pattern with solid color and subtle shading, to good effect.
● *Line qualities*
● *Overlaying colors*

All kinds of fruits make ideal subjects for colored pencil drawing. The shapes are distinct and self-contained, the colors bright and appealing, and the variable textures suggest interesting ideas for visual interpretation. Individual items are easily available and mostly inexpensive, and fruits last well if you need to leave a still life in place so that you can complete a drawing over a period of days.

The variety of marks you can make with colored pencils allows you to deal with broad shapes and color areas and with intricate details of color and texture. The sense of solid form may be achieved by using the classic technique of close SHADING, building up the colors in cohesive blocks before surface detail is overlaid, or you can exploit directional LINEAR MARKS to create an active image area, orchestrating variations of color and shade to portray the subject descriptively.

These simple, natural forms are excellent vehicles for learning and practicing colored pencil techniques — you can find a great deal to study in just one or two common fruits, such as apples or oranges. To create greater complexity in the image as your confidence builds, you can construct a more ambitious still-life group, perhaps adding fabrics, ceramics or glass items — such as a bowl in which to hold the fruit — to extend the variety of form and texture.

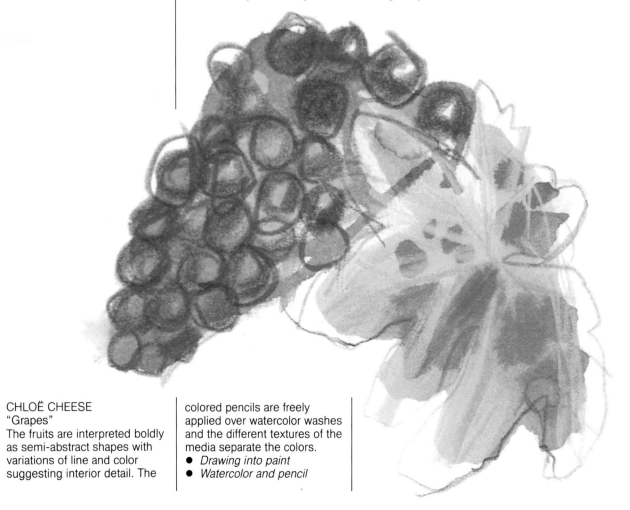

CHLOË CHEESE
"Grapes"
The fruits are interpreted boldly as semi-abstract shapes with variations of line and color suggesting interior detail. The colored pencils are freely applied over watercolor washes and the different textures of the media separate the colors.
● *Drawing into paint*
● *Watercolor and pencil*

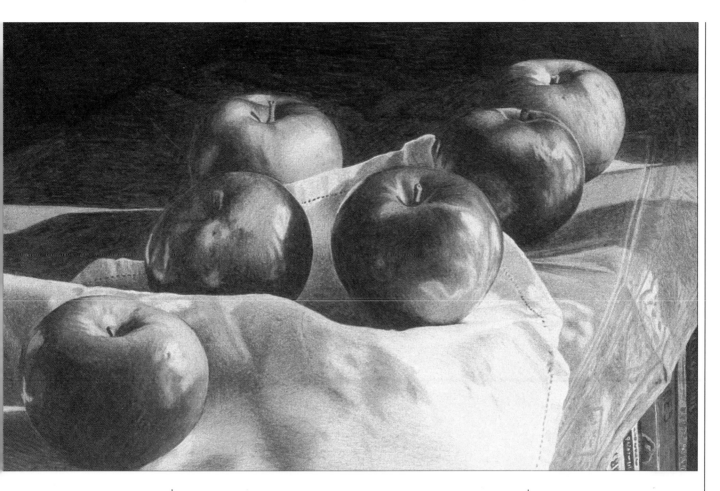

▲ BARBARA EDIDIN
"Vicki"
Part of the effectiveness of this composition lies in confining the still life aspect to the simple, similar shapes of the apples, rather than selecting very different fruits. The artist concentrates on reproducing their colors and textures very precisely and applies the same sharp vision to the qualities of the fabrics.
● *Blending*
● *Shading*

◀ SARA HAYWARD
"Fruit Bowl"
This unpretentiously attractive subject is interpreted with a vigorous approach to the drawing technique. The combination of hatched and shaded color creates an open surface texture that allows the colors to sing out clearly. Notice that the heavy shadow areas are also treated colorfully.
● *Hatching*
● *Linear marks*

A striking image is often obtained by surprisingly simple means — sometimes what you leave out is as important as what you include, and going for a bold, simplified or stylized interpretation produces an arresting or dramatic composition. Reducing a subject to its bare essentials has a powerful effect; for example, by eliminating detail both within and around the form, you encourage the viewer actively to participate in the drawing, using imagination to "complete" the image. Remember also that a drawing need not have a conventional rectangular frame, and that often the way the subject is positioned within the picture space can create visual tensions that underline the mood or message of the drawing.

Alternatively, you can represent your subject in a way that enhances its characteristic qualities or provides a particular context. The drawing of a honeycomb dripping honey into a spoon expresses very precisely the material properties of the subject, but both the technique and composition convey much more than the simple facts. This kind of approach can be applied to other themes and subjects — many examples in this book show unusual viewpoints, for instance, or an inventive arrangement of forms matched by ambitious technique. Even in the most ordinary subject, it is worth looking for a visual impression that really tests your skills.

▲ RITA D. LUDDEN
"Study in Light"
This is an unusual subject in
itself, made exceptional by the
beautiful shape of the shadow.
Controlled shading builds the
shapes and textures with great
accuracy, relying on the realities
of the still life to make the
visual impact.
● *Highlights*
● *Overlaying colors*

▶ JANE STROTHER
"Honey"
The luscious subject is
matched by an especially rich
and inventive drawing
technique. A mottled texture is
created by spattering colored
inks from the bristles of a
toothbrush onto flat washes of
color. The ink is used like
watercolor, to establish a
ground of bright, translucent
color. Details of form, light and
shadow are drawn over the top
with colored pencils.
● *Watercolor and pencil*

◀ CHLOË CHEESE
"Pie"
The free outline of the
composition is a decisive factor,
focusing interest on the shapes
and textures of the pie.
● *Blending*
● *Linear marks*

One of the pleasures of eating and entertaining is the visual appeal of a table decoratively laid with a variety of foods, dishes and silverware, bottles and glasses. Not surprisingly, this element features largely in illustrations for magazines and cookbooks. But the production of such a drawing can be an end in itself, whereas an illustration is typically an accompaniment to other kinds of information being conveyed. The inspiration of an attractive table setting is something that any artist can exploit.

It is a subject that can be treated quite straight-forwardly, as a form of traditional still life, or it can be the starting point for an investigation into particular points of technique, style and composition. The examples shown on these pages include detailed, representational images with a casual naturalness, and also unusual viewpoints and stylized, highly organized compositions.

An important technical factor to be considered here is the scale of your drawing and the ways in which the marks you make will correspond to individual elements of the setting. You may be incorporating quite a large overall area, and at the same time examining quite small, intricate objects. Spend some time planning your approach and relating it to the image area of your drawing — it is worthwhile BLOCKING IN the composition carefully, to make sure that you include all the required elements within the drawing's outer frame and that the arrangement of objects creates a balanced, interesting composition.

JOHN DAVIS
"Blue Bar, Cannes"
Unusually, the grouping of objects on the table leaves each individual item separate from the next, so the blue tablecloth needs to form a strong background-shape and color. This organization of the objects is partly due to the high viewpoint which, as it is different from our everyday experience of ordinary settings, also creates a distinctive mood.
● *Overlaying colors*

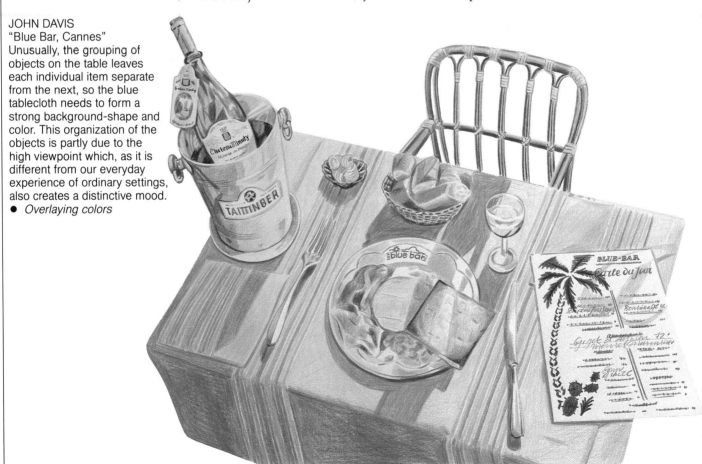

▶ PHILIP STANTON
"Sunday Breakfast"
As in the picture opposite, the objects are laid out on the table as separate items, but this time the device represents a deliberately formal styling that gives ordinary, recognizable objects a kind of abstract presence. The impression of even, flat color adds to the effect, although there is plenty of detail to be discovered.
● *Hatching*
● *Shading*

▲ HELENA GREENE
"Summer Lunch"
Colored pencil is used here to supplement the detailed work in watercolor, adding mainly linear touches that sharpen the shapes and textures, together with stronger emphasis in the shadows.
● *Drawing into paint*
● *Hatching*
● *Line qualities*

◀ JANE STROTHER
"Pizzas"
The ingredients of a simple, tasty meal make a vibrant still life full of color and texture. The variations of form and surface detail are matched by the varied methods of applying watercolor and pencil. In places the color is washed in broadly; elsewhere, water-soluble pencils have been laid over a damp ground to make thick, rich, linear detail that contrasts with the finer pencil work.
● *Solvents*
● *Watercolor and pencil*

OBJECTS: FORM AND SURFACE DETAIL

STUART ROBINSON

When you choose objects to arrange a still life for color drawing, think as you do so which techniques will most aptly describe their shapes, textures and patterns and how these will work with each other in the finished picture. In this demonstration sequence, the objects are made of polished and naturally reflective materials — glass, wood and metal. This creates quite a lot of intricate detail in the surface qualities, which is interwoven with the intricacies of form.

The way the still life is lit and the movements of your head when you are drawing, can also cause the reflected colors and shades to change. This apparent variation helps to increase the richness of your image, but you don't have to record every tiny nuance. Select what seem to you to be the most important elements of form and surface texture. Stuart Robinson uses a tightly controlled shading technique which allows him to develop plenty of descriptive detail and build the density of color and tone.

1 As the still life is a detailed, quite intricate subject, the artist begins by making a precise outline drawing of light graphite pencil lines.

2 Specific areas of the image are chosen for tonal interpretation, enabling the artist to key the high and low tones. The base of the fan is described with controlled SHADING and GRADATIONS in burnt umber.

3 A similar technique is used to describe the candlestick, glass and dish, using colors appropriate to the dominant colors of the objects.

4 The color range is gradually made more complex, but the artist continues to work with even shading and OVERLAYING COLORS, building up mixed hues and tones.

5 Where the shapes become finer and more intricate, the artist follows the forms carefully. Notice how the different layers of the composition are preserved, where shapes seen through the glass are combined with reflected colors.

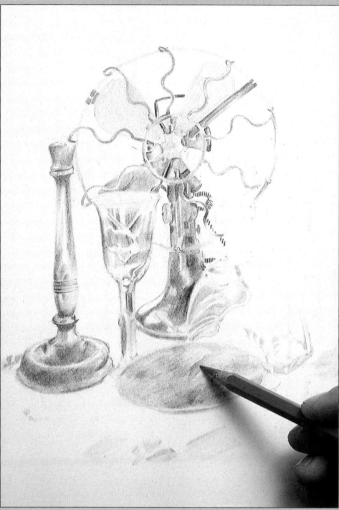

6 The overall impression of the objects is now well defined, so the artist begins to develop the color values, introducing stronger hues to enliven the tonal treatment.

9 To obtain the shiny texture of the metal fan blades, parts of the yellow shading are erased to make HIGHLIGHTS and the darker shades are strengthened with color overlays.

7 Colors are gently blended and overlaid using a range of bright hues chosen to match the pattern of the fabric on which the still life is arranged.

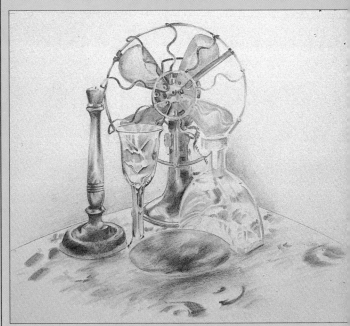

8 To sharpen the outlines of the objects, they are redrawn using a plastic stencil to guide the graphite pencil around the curves.

10 Similar techniques are applied to bring up the surface qualities of the glass and wood. Soft shadows shaded in behind the objects add depth to the composition.

11 The strongest highlights on the glass are brightened with opaque white gouache, delicately painted in with a pointed sable brush.

12 Finally, a vinyl eraser is used for BURNISHING the color on the glossy and reflective surfaces to enhance the smoothness of the tonal and color gradation.

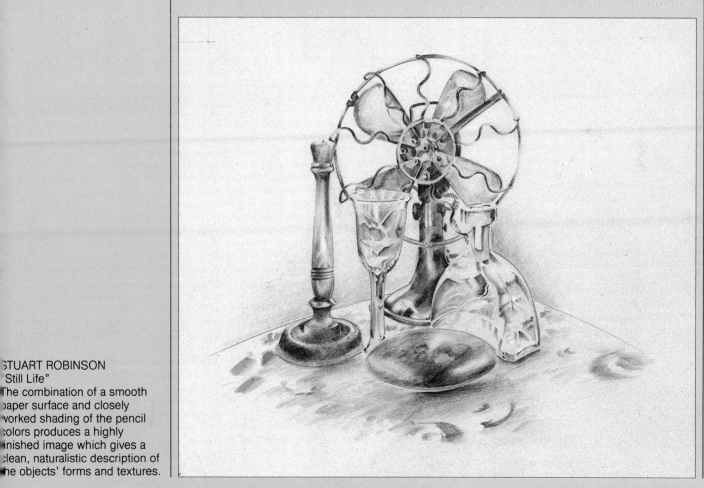

STUART ROBINSON
"Still Life"
The combination of a smooth paper surface and closely worked shading of the pencil colors produces a highly finished image which gives a clean, naturalistic description of the objects' forms and textures.

NATURE

THE VARIETY OF NATURE subjects provides a wealth of interest for the artist, from the brilliant colors of garden flowers to the elaborate foliage forms of tropical plants; from the well-loved elegance of the family cat to the impressive physical presence of a wild beast. For colored pencil drawing, there is a particular fascination in the range of natural colors and textures in plants and animals. Quite ordinary subjects can be interpreted very creatively with pencil drawing techniques, while more exotic imagery challenges your inventiveness in matching the incidental brilliance of nature's forms and colors with your own deliberate technical skill.

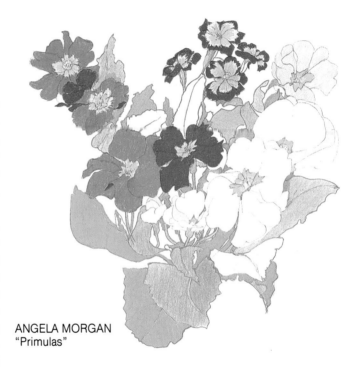

ANGELA MORGAN
"Primulas"

displays are a wonderful source of colorful and often unusual plant arrangements. Just about everyone has an immediate response to the natural beauty of plants, which adds to the pleasure of drawing them. Their range of colors enables you to exploit to the full the wonderful potential of your "palette" of colored pencils. Shapes and textures ranging from the most delicate to the most bold and dramatic exercise the accuracy of your observation.

Sources of imagery
Cut flowers and growing plants are accessible subjects. You can buy flowers specially for drawing, cut them from your garden or study them in the wild. You can find your subjects in a public park or specialized botanical garden — large greenhouse

The animal kingdom is obviously a less accessible resource, although the variety, from tiny jeweled insects to huge creatures such as big cats and other larger mammals, certainly means that the animal theme contains something for everyone. It is extremely difficult to study any kind of animal in the wild, so photography is an important reference medium. But there are other sources of detailed information. Household pets are rarely obliging about posing, but because you spend a lot of time around them, there are plenty of opportunities to draw.

Likewise, farm and zoo animals are useful live models for the larger species. Zoos also feature interesting insects and colorful birds; small-scale creatures can alternatively be observed as museum exhibits, which enable you to study anatomy and surface detail at close quarters, although many people find it somewhat distasteful to work from dead specimens.

There is a long tradition of natural history illustration in which the forms of botanical and zoological subjects are studied for their own sake. Animal subjects are also interesting for their symbolic associations, and these are sometimes brought out by using stylized or imaginative treatments. This section looks at different ways of presenting natural forms, as well as different technical approaches to the renderings.

JULIA COBBOLD
"Buddleia and Red Admirals"

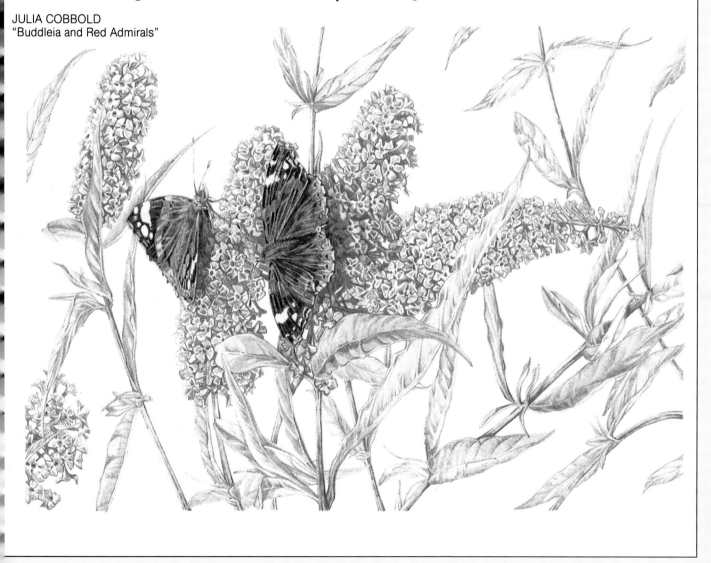

FLOWERS AND FOLIAGE

Probably the ideal subject for the beginner learning to work with colored pencils, flowers have such brilliance and variety in their shapes, colors and textures that they remain a most popular subject even among highly experienced artists. They are well suited to studies in any painting or drawing medium, but perhaps especially to colored pencils because their complex forms and rich color variations are contained at a scale that enables them to be observed in close detail.

However, because many flowers have precise and intricate structures, this does not mean that a drawing must be equally elaborate. A free, bold interpretation can be just as successful as a detailed nature study. Flowers provide a vehicle for experimentation with technique, which you can adapt to reveal different impressions of similar subjects, or to investigate the vast natural variety of flower types. You can choose to work with cut flowers, potted plants or garden flowers, according to convenience, and many subjects will be long-lasting enough to provide hours of work from a single selection.

Foliage

Leaves are just as various and appealing as flowers, although at first sight their color properties may seem less rich in scope. However, part of the skill of working in colored pencils is learning to control subtle nuances of color and to form complex color blends and mixtures by building up and overlaying your range of individual hues. The subtle changes of hue and shade within the range of foliage greens provide an excellent means of developing and testing your skills in this direction: HATCHING, SHADING and STIPPLING are all potentially valuable techniques, and in studying the intriguing shapes and textures of different kinds of leaves, you can learn to exploit the full range of your pencils' LINE QUALITIES.

Indoor plants are ideal subject matter, especially as many foliage houseplants are tropical and sub-tropical species with strong, fluid shapes. The colors of variegated leaves also add to the variety of your resources. Outdoor locations — the yard, parks or the open countryside — provide plenty of inspiration. When working outdoors, position yourself close to the subject so you can study the detail; if you wish to bring specimens home to work from, make sure there are no local restrictions on gathering plant material from the wild.

TRACY THOMPSON
"Summer Flowers"
Thick, grainy pencil color and a bold approach to forming shapes and patterns in the flowers and fabric background give this composition a strikingly decorative feel, yet the technique is free and expressive. Touches of opaque watercolor paint intensify color contrasts. The white flowers are drawn with a brush, so the artist has not had to leave their shapes completely open while applying the pencil color.
● *Drawing into paint*
● *Overlaying colors*

▲ MICHELE BROKAW
"Tao Arch and Hollyhocks"
A delicate, painstaking approach to building up form and texture pays off in the attractive detail of the finished image. The artist has cleverly varied the tonal qualities and textures to capture the characteristics of the different flowers and the solid frame of the arch.
● *Gradations*
● *Shading*

◄ HELENA GREENE
"Bouquet"
Transparent materials are a special challenge to the artist's rendering skills. The combination of shaded and hatched colors and free line work is well used to convey the layered effect of spiky flower forms and stems within the cellophane wrapper.
● *Hatching*
● *Linear marks*
● *Shading*

► STEVE TAYLOR
"Eucalyptus"
The leaf shapes are simple forms, and so a controlled tonal balance is essential to the complexity of the rendering. The gentle watercolor hues are strengthened with light pencil shading. Where veins and stems show white against the color, the paper is left bare or very lightly painted. A clear guideline is needed, which can be drawn direct or may be transferred from an existing drawing or photograph.
● *Counterproofing*
● *Tracing*

▲ STEVE TAYLOR
"Autumn Leaves"
The interest here lies in the clarity of shape and color. Both are described with a clean, crisp technique appropriate to the subject. Watercolor washes allow you to block in smooth texture over which pencil detail can be laid.
● *Watercolor and pencil*

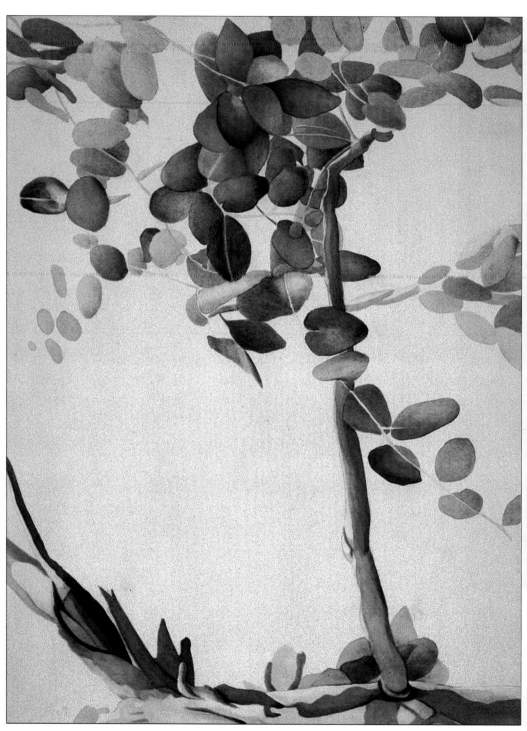

DYANNE LOCATI
"The Palm Jungle"
The effectiveness of an image with strong graphic qualities like this relies as much on close observation and accurate drawing as on the techniques of applying pencil color. Even shading has been carefully built up to fill the shapes and form subtle tonal and color gradations. The grainy texture of the paper allows the applied colors to "breathe," adding sparkle to the rendering.

● *Gradations*
● *Paper grain effects*
● *Overlaying colors*

GARY GREENE
"Pansies"

The color clarity that pencils provide is well exploited in this drawing of vivid pansies covered with jewel-like dewdrops. The three-dimensional realism of the shapes and textures is due to careful gradations of color and shade that model the petals, leaves and drops of water very precisely. The pinpoint white highlights are crucial to the effect of glistening dew.
● *Gradations*
● *Highlights*

ANGELA MORGAN
"Sweet Williams"

With the shapes of the flowers required to stand out cleanly on a white ground, the exactness of the rendering is important, and it has been established with a light outline in graphite pencil, into which the colors are delicately introduced. The pinks and reds in the flowers are shaded quite boldly, to obtain the intensity of the hues, while the shading on leaves and stems is more subtle to capture the detail of light and shadow, as well as local color variations.
● *Filling in*
● *Graphite and pencil*
● *Overlaying colors*

ANGELA MORGAN
"Tulips"
The blazing colors of the
orange tulips are a vibrant
blend of yellow, orange and red
pencils. The more delicate
pinks are similarly described
with varying tones of the basic
hue. The complex arrangement
of petals and leaves that forms
the composition has been
keyed with a faint pencil outline,
and although the overall effect
is light and fresh, the pencil
colors have been laid in with a
confident, free technique.
● *Blending*
● *Gradations*

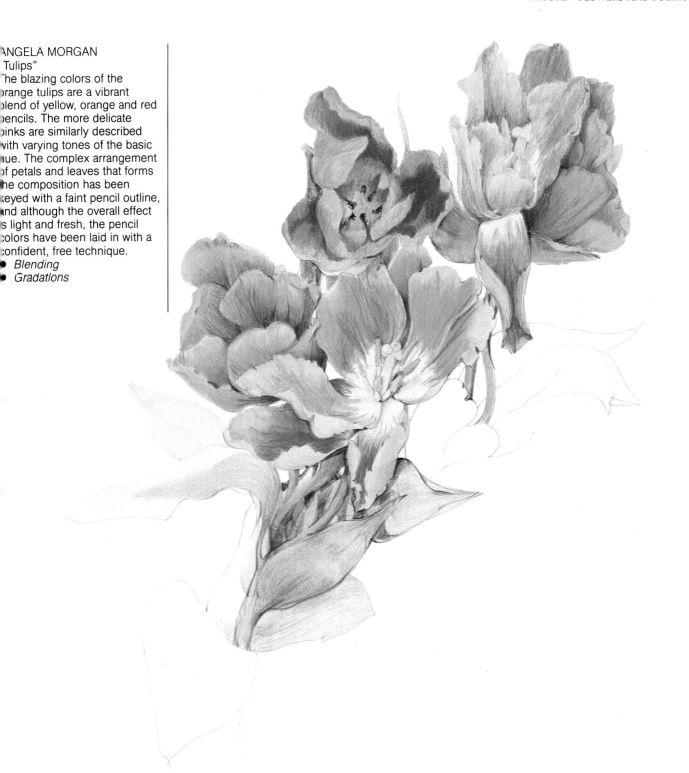

C O N T A I N E R P L A N T S

Plants grown in containers are cultivated for their ornamental qualities, so you should have no trouble in finding an attractive composition, whether from a single specimen or a group of plants. As the leaves and flowers are growing, rather than cut materials, the shapes and forms are unlikely to change at all within the time you need to complete a drawing.

The background to a container plant will form an important aspect of your composition, unless you are making the kind of detailed botanical study usually drawn on a flat, untreated background. Consider the colors and textures that surround the plant and its container, if necessary moving the plant or placing something underneath it, to provide a sympathetic complement to its form and detail. Natural textures such as wood, canework or stone provide interesting surface qualities that do not compete visually with the plant. Alternatively, however, you could choose to make a colorful, semi-abstract composition by including patterned fabrics and containers that create a busy background.

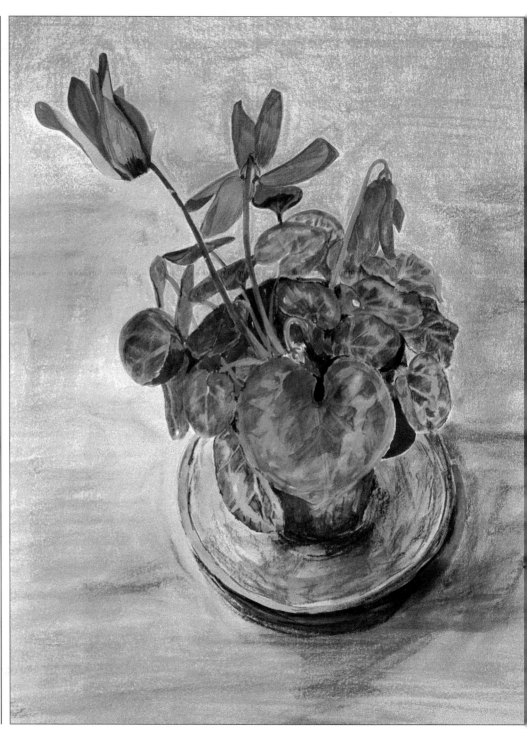

◀ HELENA GREENE
"Cyclamen"
Paint and pencil are a valuable combination for interpreting plants and flowers, giving a wide range of textural qualities that can be matched to aspects of the individual subject. The background is treated simply to focus the eye on the detail of the plant.
● *Drawing into paint*
● *Line and wash*

▲ JANE STROTHER
"Garden, Chengdu"
The brilliance of translucent watercolor is used to set the tonal key of the sunlit garden. Textural detail, loosely hatched and shaded in pencil, is applied over the painted ground.
● *Watercolor and pencil*

HELENA GREENE
"Hyacinths"
The pencil lines have a strong presence in creating the framework of this drawing. They provide distinctive contours and hatched shadings, with the watercolor washes forming a subtle complement.
Line qualities

ANIMAL STUDIES

Animals are not natural models, and many artists find it difficult to deal with them because of their constant movement. But they have considerable appeal as drawing subjects, both through the associations we make with images of different kinds of animals and because of their variety of forms, colors and textures that we can study as purely visual problems to be solved by applying particular skills and techniques.

It takes patience to complete useful "life studies" of animals; frequently a pose lasts only seconds, and anyone who sets out to draw an animal will become familiar with the frustration of having to abandon a drawing at a promising stage because the model has changed the pose or wandered away. For this reason, photographic reference is commonly used; ideally, this can be combined with direct observation, so that the elements of form that appear imprecise in a photograph can be adjusted from real knowledge of the subject.

This is easy enough if you are drawing domestic animals; more difficult with wild subjects, when photographs are essential sources. It is useful to collect a library of images, even if you base your drawing on one particular shot, as you will then have alternative reference for details that may not be clearly seen in a single photo.

Technical studies, as in the tradition of natural history illustration, need not include a portrayal of the animal's environment. However, if you do choose to give your subject a realistic location, pay as much attention to its detail as you do to the animal itself; otherwise, the image may appear unconvincing.

PATTI McQUILLIN
"Loons and Puffins"
This unusual, somewhat stylized study graphically explains the forms and patterns of the birds. By flattening the shapes and working within clear outlines, using an economical amount of tonal modeling, the artist combines detailed observation with a personalized descriptive sense.
● *Filling in*
● *Gradations*

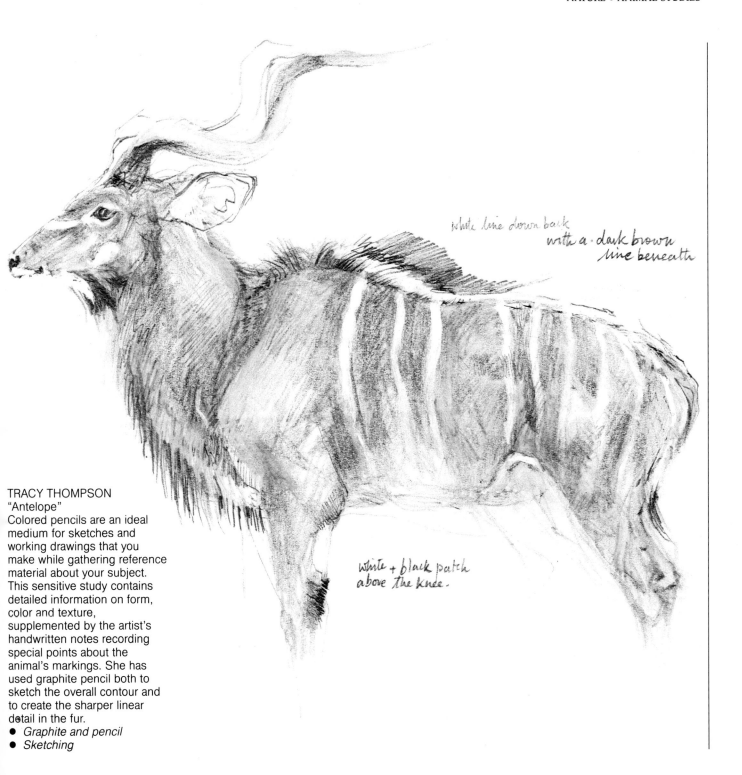

white line down back with a dark brown line beneath

white + black patch above the knee.

TRACY THOMPSON
"Antelope"
Colored pencils are an ideal
medium for sketches and
working drawings that you
make while gathering reference
material about your subject.
This sensitive study contains
detailed information on form,
color and texture,
supplemented by the artist's
handwritten notes recording
special points about the
animal's markings. She has
used graphite pencil both to
sketch the overall contour and
to create the sharper linear
detail in the fur.
● *Graphite and pencil*
● *Sketching*

▲ LAURA DUIS
"Warming Up"
Controlled shading is used throughout this image to build up the color values over the heavy paper grain. The technique appears very consistent, producing a unified surface, but there are subtle variations in the directions of the pencil strokes that model form and texture. The color changes are beautifully orchestrated to create the warm summer light.
● *Blending*
● *Overlaying colors*

◄ DON PEARSON
"Coyote and Quail"
This is a classic presentation of an animal in its environment, using the natural camouflage of the coyote's colors to key the overall palette. The shades and textures are carefully managed to make sure that the animal stands out from its surroundings. By contrast, the quail is drawn half-hidden in the grass, but its pattern is a means of identification.
● *Linear marks*
● *Shading*

KEES DE KIEFTE
"Leopard"
Soft shading builds up the
curving volumes in the heavy
body of the leopard, developing
naturalistic modeling and rich
color qualities. Small checks
and dashes made with a
sharpened pencil tip elaborate
the coarser textures. The
whiskers and clean white
patches around the eyes and
muzzle, and the bright fur on
the tail, have been crisply
painted with opaque white.
● *Dashes and dots*
● *Highlighting*
● *Shading*

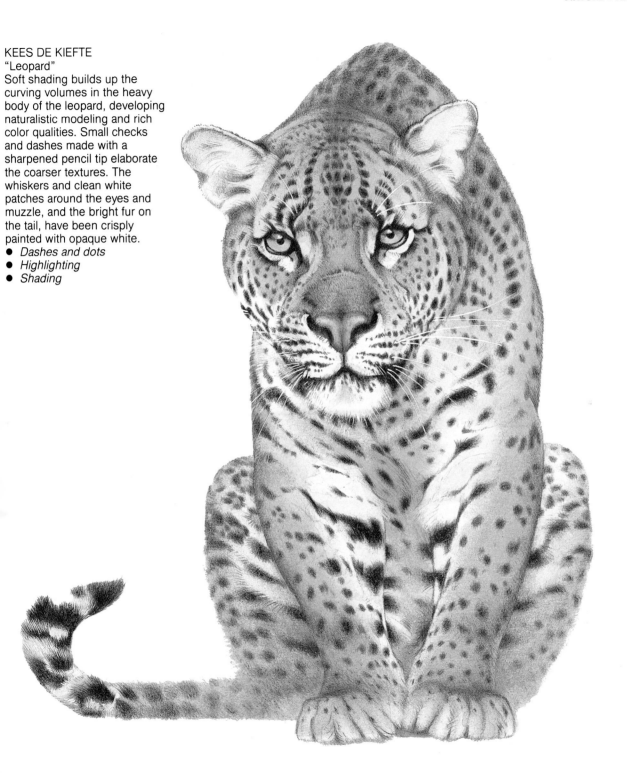

PATTERN AND TEXTURE

Sometimes it is the overall impression of a particular animal that suggests its suitability as a drawing subject — the grandeur of an elephant or lion, for example; sometimes the personal association, as with a family pet — but in pure visual terms, the variety of patterns, textures and colors that different types of creatures display also makes them fascinating as a resource for detailed study.

Small-scale creatures such as butterflies, insects and fish, which carry intricate, bright-colored patterns, lend themselves particularly well to the delicacy that you can achieve working in colored pencils. Fine LINEAR MARKS and subtle HATCHING and SHADING can be closely controlled to elaborate the detail. In larger creatures, often the colors and markings are more muted and subtle, but again the linearity

of colored pencils aids the depiction of such features as fur or bristles and folded or wrinkled hides.

Don't lose sight of the fact that these patterns and textures also reflect the underlying forms of the animals. You need to be responsive to small shifts of color and tone that trace an animal's structure and contour at the same time as describing its surface feel.

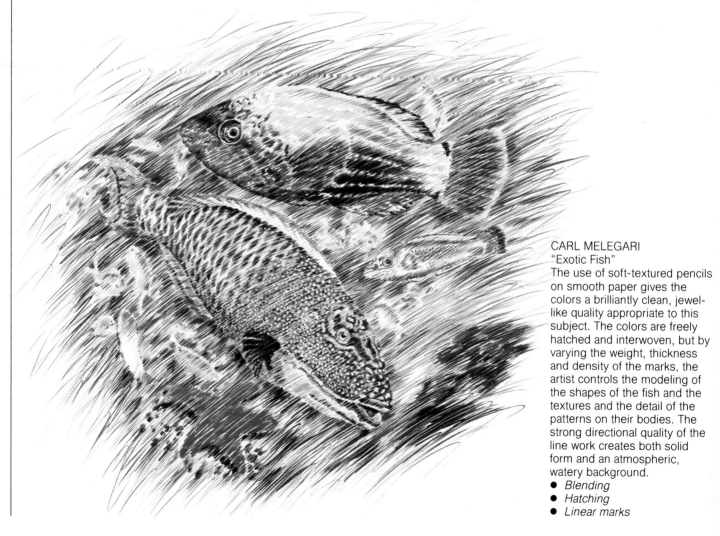

CARL MELEGARI
"Exotic Fish"
The use of soft-textured pencils on smooth paper gives the colors a brilliantly clean, jewel-like quality appropriate to this subject. The colors are freely hatched and interwoven, but by varying the weight, thickness and density of the marks, the artist controls the modeling of the shapes of the fish and the textures and the detail of the patterns on their bodies. The strong directional quality of the line work creates both solid form and an atmospheric, watery background.
● *Blending*
● *Hatching*
● *Linear marks*

CAROLYN ROCHELLE
"Barnaby"
Shading is an extremely versatile technique and, using it, the artist has here conveyed the glossy surface of the dog's coat, the rougher fur on the head and legs and the variations of color and tone.
● *Gradations*
● *Shading*

▼ MICHELE BROKAW
"The Rogue"
At 40×28in. (100×70cm), this is a relatively large format for a colored pencil drawing. The size has enabled the artist to give bold treatment to the rugged trunk and rippling ears by means of layering of color overlays and blends.
● *Blending*
● *Overlaying colors*

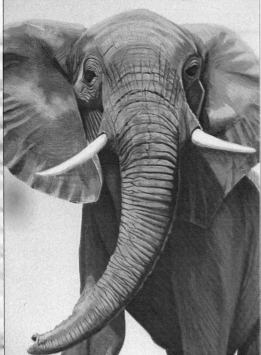

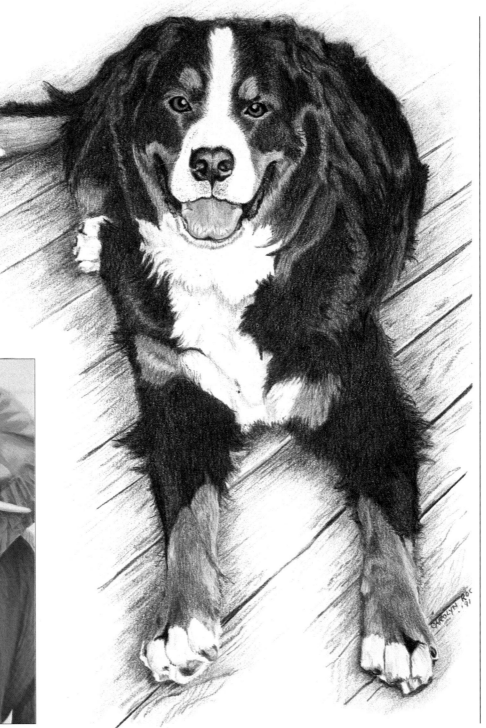

There are different ways of conveying a sense of movement two-dimensionally, in animal or human subjects.

One way depends on the composition of the image — you choose a "snapshot" pose that conveys the essence of a movement sequence, creating a characteristic contour with internal rhythms and tensions. Another way has more to do with technique — you use the marks of your pencils very actively, to create a network of lines and color areas from which the moving form emerges; in this case, the viewer does not necessarily see the whole creature in focus, but still gains an impression of its solid form. Another suitable technique in this context is LINE AND WASH, which effectively conveys both form and movement.

You can produce very interesting drawings by observing a moving animal directly and tracing the lines and shapes that you see on paper. You need to develop a quick response and be unconcerned about creating a "realistic" portrait.

If you prefer a more methodical approach toward a detailed image, you will need to use photographic reference to "freeze" the image. Many magazines and books contain excellent wildlife photography that does the job for you — but be careful not to become stuck in the mode of merely reproducing someone else's image; use your skill in pencil techniques to interpret, rather than copy, the picture. With some subjects, you can take the photographs yourself; this has the advantage that at the same time you can directly observe the animal's typical patterns of movement, perhaps also making sketches to use as reference for full-scale finished works.

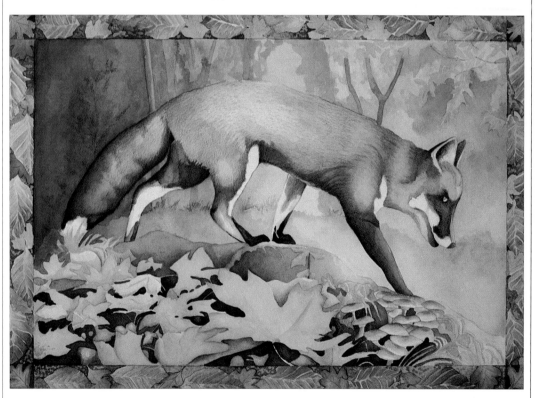

STEVE TAYLOR
"Fox in Autumn"
Most of the modeling and atmospheric description is created here with watercolor, subtly modified with water-soluble colored pencils. The movement is expressed by the fluid lines of the fox – the angle of its body and the downward thrust of the head, as well as the more obvious motion of its legs and paws. This artist frequently uses decorative borders as a way of edging and enhancing the main image. The leaf shapes in the border relate to, but do not copy, the similar detail within the frame.
● *Solvents*
● *Watercolor and pencil*

FRANK DE BROUWER
"Horse and Rider"
The gestures of the artist's hand and arm can be seen from the rhythms of this drawing, giving it a sense of physical movement additional to that implied by the subject. The variations of line – emphatic black colored pencil over more tentative, shifting graphite pencil marks – enhance the vitality. The non-naturalistic primary colors that provide the medium shades between black and white are also enlivening.
● *Contour drawing*
● *Graphite and pencil*
● *Linear marks*
● *Line qualities*

NATURE:
THE FRESH BEAUTY
OF FLOWERS

JANE STROTHER

One of the most pleasurable aspects of drawing flowers and foliage is their fresh color and textural variation which enables you to make the most of your colored-pencil "palette" and the versatile mark-making capacities of this medium. Jane Strother's demonstration is drawn on a relatively large scale so that each item in the massed flower group can be freely described. Her pencil initially fluidly travels the contours of the subjects, then she uses solvent to spread and rub the dark shades and, finally, combines drawing and painting techniques to build up richness and texture. This is not a precise portrait of the potted plants and garden tools, as the shapes are loosely realized rather than exactly drawn. Tight shading and subtle gradations of tone and color would produce a very different, probably no less striking, result.

1 The outlines of the composition are first lightly sketched in red, using a soft-leaded water-soluble pencil to create a gentle, grainy line.

2 A purple pencil is used to block in the areas of darkest tone, including cast shadows. The color is rubbed with a rag dampened with turpentine to make loosely scrubbed washes.

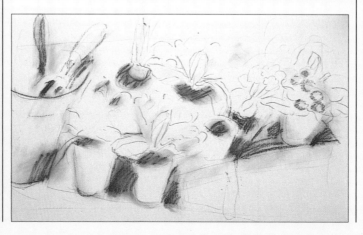

3 The same treatment is applied right across the paper to give the line drawing depth and tone. Further line work is drawn over the top, putting in leaf and flower shapes.

4 The artist gradually builds up the color detail, using green, yellow and red pencils to shape and color the flowers.

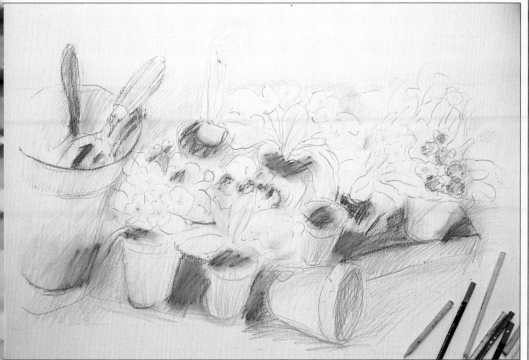

5 Middle shades are roughly blocked in with free shading and hatching, using terracotta and yellow ocher pencils. Lighter shades are added – pink and yellow.

6 A soft sable brush wetted with clean water is passed over the drawing within some of the solid shapes, to dissolve and spread the color until it resembles a watercolor wash.

7 The intensity of tone and color is gradually developed by overlaying hatched lines, taking care to avoid the areas that must remain highlighted.

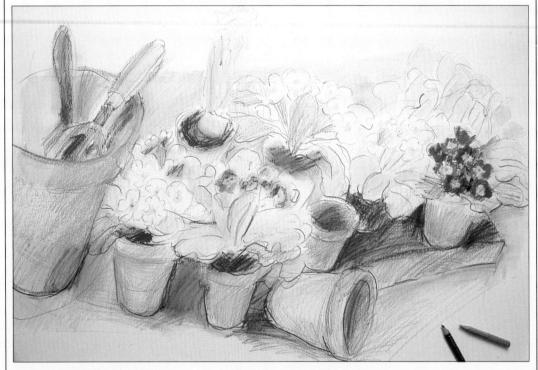

8 The process of working back and forth into different parts of the image produces a richer, more detailed effect overall.

9 The flowers that have not yet been fully described are colored more strongly; then the wetted brush is used again to merge some of the pencil marks.

10 Pale shading on the garden tools enhances the modeling of the shapes. This color on the handle is heavily hatched with broad lines.

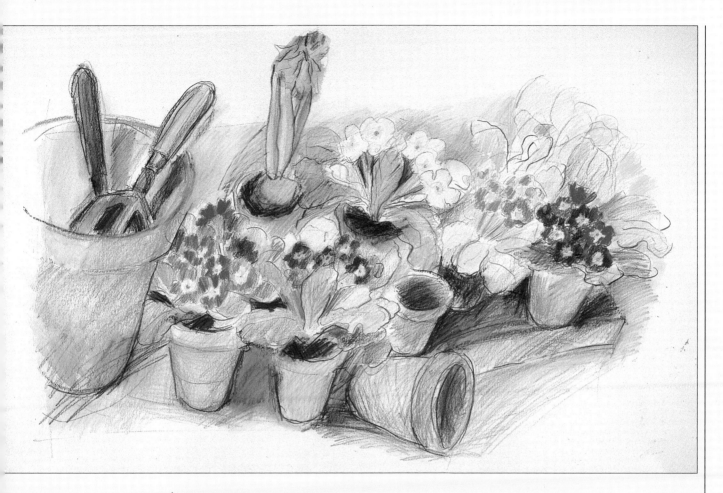

JANE STROTHER
"Primulas"
In the finished rendering, the active pencil lines give the image vitality, and they contrast effectively with the smoother, all-over textures of the rubbed and brushed colors. The detail (right) shows the degree of surface interest that has evolved through the layering of the mixed techniques.

PEOPLE
AND PORTRAITS

THE HUMAN FIGURE is considered by many artists to be the most important and enduring of the major themes in art. There can be no doubt that figure compositions have provided a great wealth of interpretive material, from traditional life studies and formally posed portraits to images of incidental human activity in a wide variety of situations and contexts. Other people are continually fascinating as a subject for drawing and painting; associative and narrative elements are always implied in imagery that includes figures, but there are also many interesting visual considerations — the variety of human shapes and forms, the subtle coloring of skin and hair, the colorful detail of clothing and accessories.

JOHN CHAMBERLAIN
"Children's Portraits"

newspapers, showing different poses and activities, styles of clothing and different backgrounds. Individual elements from different photographs can be combined to create a single composition. Other artists tend to collect more personally selective reference material by taking their own photographs of likely subjects.

If you work from live subjects, you need to develop a facility for quick sketching and a keen eye for essential details. One of the advantages of developing your skills of drawing with colored pencils is that the same medium can be used for your sketches and for more finished works. Therefore you will gradually acquire useful experience in deciding what aspects of your subject should be recorded in sketch drawings and devising suitable technical approaches.

Composition and technique

Figure studies range from the life-class nude to quick sketches of individuals to detailed and elaborate renderings of figure groups, sometimes requiring equally detailed attention to the background setting. Photographic reference plays an important part if your subjects are drawn from daily life; some artists collect a library of pictures, from magazines and

Setting up a portrait

The way you pose and light your model depends on the mood and character you wish to give to the portrait, and the degree of elaboration involved in your technique. If you are making a linear, sketchy drawing, there is no point in spending a lot of time on

dramatic light effects. But if you want to study the tonal modeling of the face, you need a strong directional light that emphasizes curves and hollows, though without heavy cast shadows that can cause distortion. Colored pencil is a subtle medium, however, and lighting is perhaps not as important as an expressive or characteristic pose.

PAMELA VENUS
"Kurdish Shepherd
on Mountain"

LINDA KITSON
"C/Sgt Burton"

The sense of an individual is not necessarily conveyed by a distinct likeness, as in a portrait, but by what seems to be a convincing, characteristic pose or gesture. The viewer does not know who the subject is, but can recognize a particular reality in the representation.

Colored pencil has an excellent range for figure drawing of all kinds. Depending on whether you decide to create quick reference sketches, to work in detail from life or to interpret photographic reference, you can use a form of rapid linear notation or more elaborate methods of building up detail. The techniques of pencil drawing provide considerable versatility in the surface qualities that you can employ — as well as varying your technical approach, consider the surface values you can obtain by combining different types of pencil textures.

JEFFREY CAMP
"Sleeping Figure"
The sense of an individual does not necessarily come from the face – posture, body shape and characteristic features such as hair color and texture help to build the impression. These elements are very telling in this unusual figure study.
● *Contour drawing*
● *Hatching*

▶ LINDA KITSON
"Drummers"
The robust drawing technique exploits both the descriptive features of the subjects and the strong lines and colors of their dress uniforms. A mixture of pencil textures with acrylic and oil pastel grooved with a knife produces a striking effect.
● *Drawing into paint*
● *Linear marks*
● *Mixing pencils*

MAX TEN BOSCH
"Couple"
Sensitive contour drawing underpins a bold use of linear techniques and rapid color shading. These techniques create a drawing of exciting texture and convey the appearance and mood of its subjects. Overall, the gestural qualities of the pencil marks are freely laid in, but the right kind of precision just where it is needed builds a sympathetic portrait. The dark lines and shades gain subtle variation from the interplay of graphite pencil with black and gray colored leads.

- *Contour drawing*
- *Linear marks*
- *Line qualities*
- *Shading*

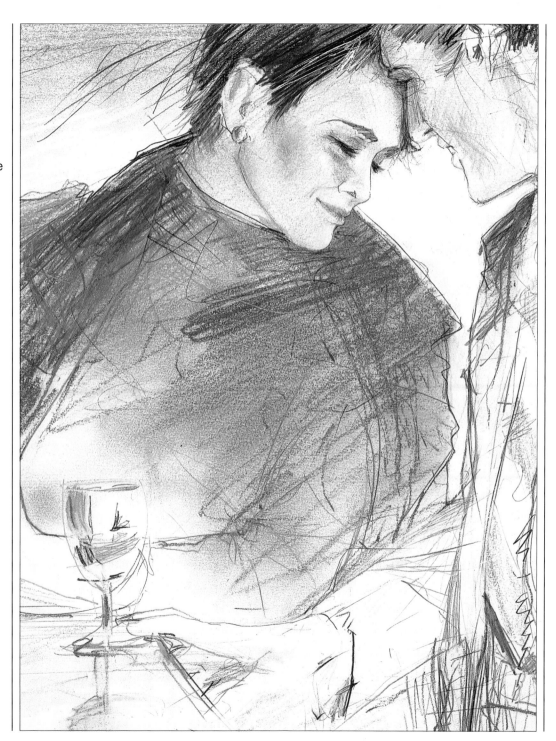

GROUPS

Any figure group, small or large, creates an interestingly dynamic image. There are complex rhythms and tensions in the way forms are interwoven and juxtaposed, caused by actual and implied movements in the figures. The elements of pattern and texture can be varied and detailed — hair, clothing, accessories, background features. And in addition to describing the physical facts of a group of people, you may also wish to convey a narrative context — a sense of the personal relationships between them, the common purpose or activity of the group.

The examples on these pages show small and large figure groups in a range of contexts, with widely different approaches to composition and technical interpretation. The sections on Movement (pages 172-175) and Environment (pages 176-177) demonstrate further solutions to the problems of conveying interactive relationships between figures and their surroundings.

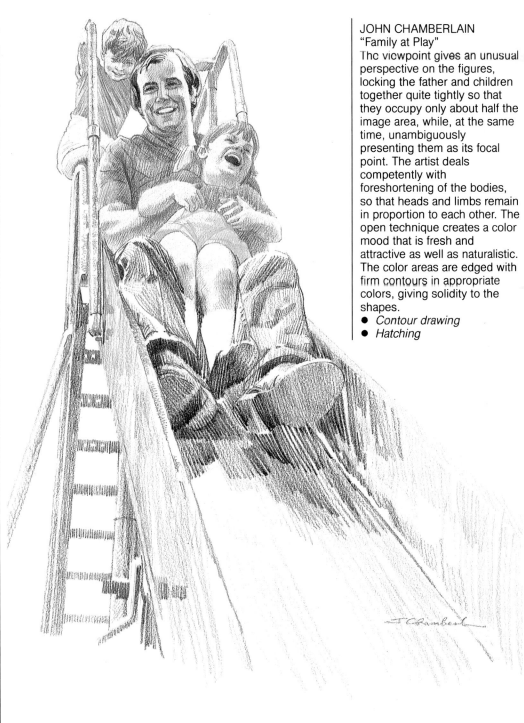

JOHN CHAMBERLAIN
"Family at Play"
The viewpoint gives an unusual perspective on the figures, locking the father and children together quite tightly so that they occupy only about half the image area, while, at the same time, unambiguously presenting them as its focal point. The artist deals competently with foreshortening of the bodies, so that heads and limbs remain in proportion to each other. The open technique creates a color mood that is fresh and attractive as well as naturalistic. The color areas are edged with firm contours in appropriate colors, giving solidity to the shapes.
● *Contour drawing*
● *Hatching*

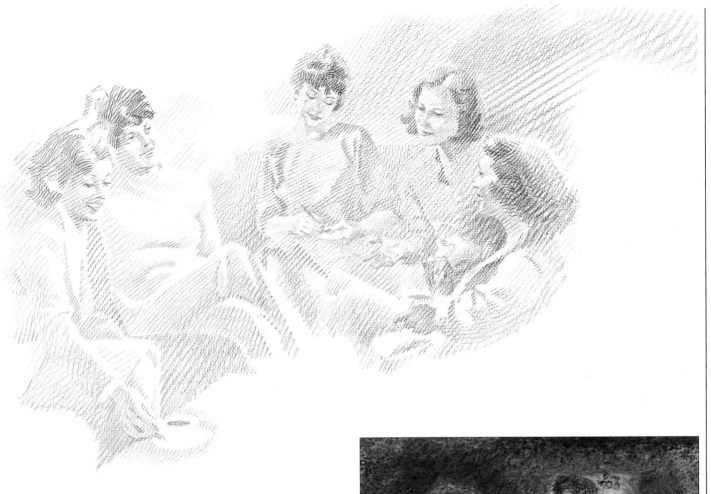

JOHN CHAMBERLAIN
"Women Talking"
The woven texture created by crosshatching is broken up still more by the heavy paper grain, so that the image seems filled with illumination from the white of the paper shining through the delicately blended colors. The free outline shape emphasizes the flow of rhythmic shapes formed by the particular attitudes of bodies and heads.
● *Hatching*
● *Paper grain effects*

▶ **JEFFREY CAMP**
"Figure Group"
A textured ground washed with painted color breaks through soft pencil marks to produce a grainy, atmospheric surface effect. The intimacy of the scene is enhanced by bringing the viewpoint in close to the group, leaving the left-hand figure cut off in profile at the edge of the frame.
● *Drawing into paint*
● *Textured grounds*

◄ VERA CURNOW
"Class of '44:
The Cheerleaders"
The figures are affectionately caricatured in this stylized composition. The heavy shapes of the bodies are expressed with equally solid color applications, but, because the paper has a pronounced, pitted grain, the dark colors are relieved by tiny pinpoints of white. The artist employs this effect to help in modeling the tonal gradations, by varying the pressure of the pencil shading. Clean white line detail in the hair and clothing have been created by shading over impressed lines.

● *Gradations*
● *Impressing*
● *Overlaying colors*

▶ DAVID HUGGINS
"Dance"
A strong thread of narrative runs through this composition, with the figures in the grouping mostly sorted into pairs, their attitudes suggesting different "stories" about their individual relationships and common enjoyment of the dancehall atmosphere. The artist has used simple shading to fill every shape with color and has added many interesting details of pattern and texture using a range of pencil marks.

● *Filling in*
● *Linear marks*
● *Shading*

Young children have distinctive characteristics that need to be observed and rendered carefully, to give the subjects of your drawings a childlike quality. The facial features of children, smaller and less boldly formed than in adults, also occupy a smaller proportion of the head; typically, the brow is high and cheeks and chin rounded; skin texture and coloring are relatively smooth and uniform. The head is quite large in relation to overall body height, as compared to the proportions of an adult figure.

These are physical characteristics common to children in early stages of development, but there are plenty of signs of individuality in both appearance and behavior. The eyes are often a striking and expressive feature; clothing and hairstyle also reflect personality; the activities children engage in and the accessories they introduce into work and play provide a variety of visual material for constructing a composition.

It can be difficult to work from life with a child model, as all untrained models find it difficult to hold a pose, and a child, especially, will soon find it boring and uncomfortable. If you are making a study of a particular subject, you can sketch unobtrusively while the child is occupied with his or her own concerns; but it is unlikely you will get time to complete a whole, detailed composition. Photography is often a vital resource for the artist working with children, and ideally you should take your own snapshots rather than using other people's.

DAVID MELLING
"Drawing"
Both the pose of the child and the quality of the softly blended and graded colors contribute to a tranquil mood appropriate to the subject. Although the gradations are gentle, there is quite a strong contrast of shades that gives depth and impact to the composition.
● *Blending*
● *Gradations*
● *Highlights*

◄ JEAN ANN O'NEILL
"Modeling"
This drawing describes different stages of an activity. In each stage, the child's total concentration on the task is caught through his gestures and poses. The schematic arrangement of color helps to lead the eye across the image.
● *Overlaying colors*
● *Shading*

ERIK VAN HOUTEN
"Child Study"
A direct frontal pose typically
has a confrontational mood, but
here this is made ambiguous
by the child's posture, which
seems to draw back slightly
from the viewer, and the cuddly
toy she clutches, as if in need
of a friend. Her face, though, is
strongly drawn, with decision
and clarity in those features
which form the important focal
points of a portrait – the eyes
and mouth. Varied strands of
color in the hair and skin
enliven what is essentially a
monochromatic rendering of
the child subject, to which the
unreal, bright colors of the toy
form a striking contrast.
● *Linear marks*
● *Shading*

EUAN UGLOW
"Life Drawing"
Color is not always a decorative
or naturalistically descriptive
element in drawing. It often has
a structural function, helping to
define space and form. In this
study, color is systematically
applied to the contours of the
figure, chair and interior space,
to indicate particular elements
of the compositional
framework: blue represents the
edges between the most
distant parts of the subject;
green defines butting forms
and shadows; on the figure, the
deep red stands for distant
forms curving away – the
medium red defines the middle
distance and orange the nearer
elements; yellow lines show
slight but significant changes of
contour within the form.
● *Contour drawing*

This traditional element of art
training has been adapted to
all manner of styles and
techniques in drawing and
painting. The nude figure is
used as a vehicle for objective
study of form and proportion;
yet the tendency for both artist
and viewer to identify with a
human subject means that it is
difficult to maintain a strictly
objective response.

If you attend a life class, you
may find that you are asked to
focus on a different aspect of
form and technique in each
session: for instance, using line
only to trace the contours of
the figure; employing a
restricted palette of neutral
shades to model form with
light and shadow; using color
as a method of "coding"
various kinds of information
about the figure. This helps
you to acquire a discipline of
visual analysis, and the same
kind of systematic examination
of a subject can be applied to
other themes — a still-life
group or vase of flowers, for
example — if you haven't a
human model to work from.
The "live" element of life

drawing is important; there is
little value in working from
photographs, which tend to
flatten and distort the forms.

If you cannot get someone
to pose for you formally, you
might try sketching figures on
the beach or at a swimming
pool where, first, you can see
details of bodies and limbs
and, second, you may find
people adopting fairly still
poses for some length of time -
– while sunbathing, for
example. Be careful not to be
intrusive when selecting and
studying your subjects.

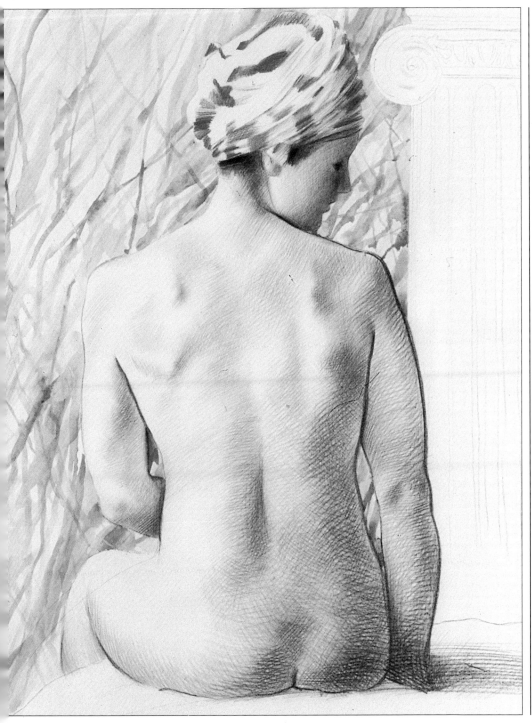

◄ ADRIAN GEORGE
"Turbaned Nude"
There is a direct visual reference here to the classical painting of a turbaned bather by the French artist Ingres (1780-1867). The pose and setting have been adapted, but there is the same emphasis on the smooth contour in both the linear outlining of the figure and the modeled curves and hollows of the body. The marbled background consists of light trails of watercolor.
● *Hatching*
● *Line qualities*

▲ PHILIP SUTTON
"Seated Nude"
Arguably this drawing has an imprecise quality, especially compared to the clear definition to be found in the other life studies on these pages, but the free combination of line and shaded color here provides an expressive interpretation of the pose.
● *Shading*

A sense of movement is inherent in many figure poses and can be underplayed or emphasized by the artist's choice of technique and method of arranging the composition. The drawing can be treated as a "still picture" of a person engaged in a particular activity or sequence of motion, so that it becomes a cleanly focused and detailed description of a split-second event. Or the active qualities of the pencil marks can be contrived to enhance the sense of movement, and the background can be treated in a way that also suggests the figure's motion through the surrounding space.

Pictorial devices that suggest movement include fluid or repetitive LINE QUALITIES, vigorous HATCHING, and subtle soft-focus BLENDING of shades and hues. In addition to studying the ways artists have expressed various kinds of activity and movement in the examples on these pages, look for different approaches throughout this section on figure drawing and also at the feature on Animal Movement on page 154.

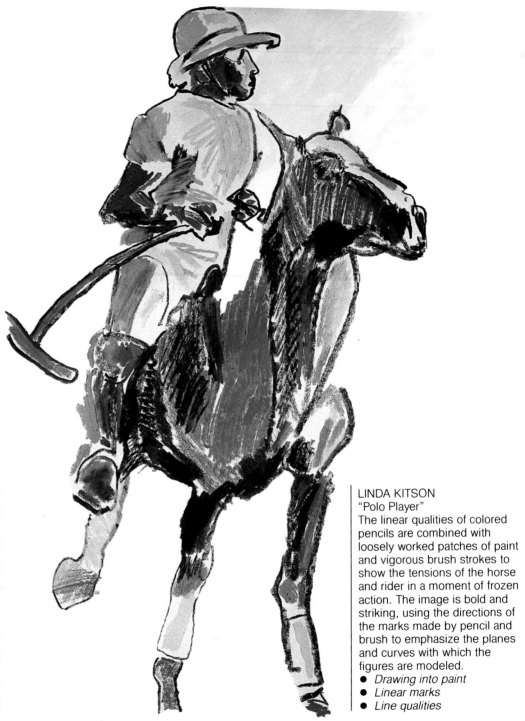

LINDA KITSON
"Polo Player"
The linear qualities of colored pencils are combined with loosely worked patches of paint and vigorous brush strokes to show the tensions of the horse and rider in a moment of frozen action. The image is bold and striking, using the directions of the marks made by pencil and brush to emphasize the planes and curves with which the figures are modeled.
● *Drawing into paint*
● *Linear marks*
● *Line qualities*

JO DENNIS
"Juggler"
This is an interesting example of the way a movement sequence can be fused into a single image. The figure is defined each time by its contour and filled out with colors. There is a schematic quality to the drawing that is nicely offset by the naturalistic approach to describing the figure. The areas of overlap between the successive parts of the pose are subtly handled by varying the degree of detail shown and the depth of shading with which the rapid movements are described.
● *Contour drawing*
● *Line qualities*
● *Shading*

CHRIS CHAPMAN
"Skateboarder"
The sense of movement is cleverly suggested here by blurring the background, but making the figure very sharp and well defined. An important aspect of conveying motion is the visible contrast between movement and stillness, but here the real relationship has been reversed. Close shading and complex color overlays are used to create a heightened realism.
● *Blending*
● *Gradations*
● *Shading*

JOHN CHAMBERLAIN
"Young Dancers"
The strong directional lines of the pencil hatching echo the restrained forward motion of the dancers and the lines of their extended legs and pointing feet. The subtle contrast of warm, cold and neutral colors gives depth to the image.
● *Hatching*
● *Paper grain effects*

CARL MELEGARI
"Golfer"
The active drawing technique enhances the swing and rhythm of the golfer's action and gives the pose a forceful sense of direction. The selection of bright colors creates an effect that is both naturalistic and atmospheric. Some of the most brilliant hues come from the color intensity of water-soluble pencils.
● *Overlaying colors*
● *Solvents*

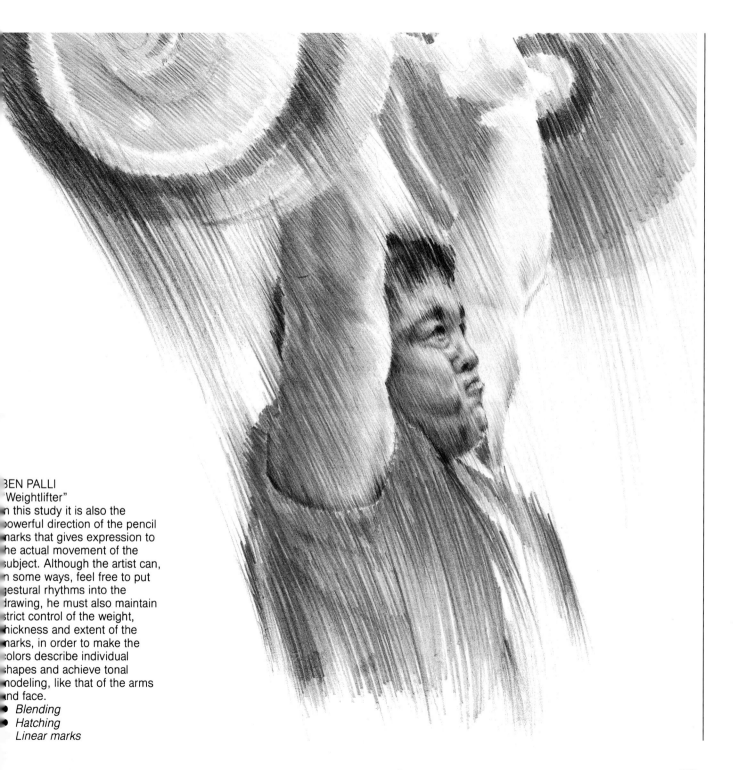

BEN PALLI
"Weightlifter"
In this study it is also the
powerful direction of the pencil
marks that gives expression to
the actual movement of the
subject. Although the artist can,
in some ways, feel free to put
gestural rhythms into the
drawing, he must also maintain
strict control of the weight,
thickness and extent of the
marks, in order to make the
colors describe individual
shapes and achieve tonal
modeling, like that of the arms
and face.
● Blending
● Hatching
　Linear marks

The location of an individual person or group of people is often an important aspect of a figure composition, giving logic to the poses and sometimes suggesting an ambience that gives the artist a cue for selecting a particular technique or style of rendering. It is not always necessary to include the background elements in great detail, but it is frequently appropriate to indicate the nature of the setting, to add to the descriptive or narrative effect of the image.

The way you render the space that a figure occupies can also imply a mood. A crowded interior space, for example, can be made to seem enclosing by selecting a viewpoint that draws in the perspective and by using a technique that conveys particular qualities of light and atmosphere. However, it is also possible to construct an impression of space, volume and relative distances with economical means. A few lines properly judged can indicate the shape of a room or the open space of an outdoor setting.

▲ SHERI LYNN GOYER DOTY
"Salt Lake International Airport"
This sensitive study pulls together the different elements of the subject by means of a consistent, controlled drawing technique. The heavy grain of the paper creates surface interest, helping to define the individual textures, from fabrics to concrete.
● Shading
● Paper grain effects

ANDREW TIFFEN
"Waiting Room"
The bold, sketchy quality of the pencil marks and open contour of the image give vitality to this everyday subject. The strong colors are allowed to stand out clearly, defining separate shapes without overlays or blending.
● Hatching
● Sketching

STEVE RUSSELL
"Nightlife"
Solid color blocks are activated by means of loosely hatched and scribbled marks, both techniques being used to define form and contour. The colors are overlaid to produce loose blends and gradations that create the atmospheric lighting effect. The composition is well thought out, using the mirror image to create a balance. By pushing the figures toward the edges of the picture area, the artist has given them a shadowy, oblique presence, even though they are the main subject.
● *Blending*
● *Hatching*
● *Overlaying colors*

EXPRESSIVE PORTRAITS

Ideally, a portrait expresses something about the sitter as well as making a visual record of the individual. There are various ways of endowing a portrait with expressive character, deriving from both the composition of the drawing and the techniques you apply.

In selecting a pose, you need to decide on the angle of view — showing a person full-face tends to create a confrontational aspect, while a slightly turned pose can seem mysterious or mischievous. You can focus on face and head only, or include part or all of the body, so that the subject's physical shape and posture contribute to the mood of the image.

Different approaches to shading and color can vary the expressive qualities of the rendering. A tonal study gives emphasis to the modeling of form and features. Colors need not be strictly realistic; to enhance the impact of the portrait, you can play up faint nuances, such as warm lights and cool shadows in skin tones, or exaggerate the contrasts of hue and tone to construct a more colorful interpretation.

The kinds of marks you make also contribute to an individualistic portrait; soft SHADING and subtle GRADATIONS can be organized in ways that create a photographically realistic effect; or you can use more vigorous techniques such as HATCHING and LINEAR MARKS to emphasize both structural and surface characteristics.

DAVID MELLING
"Woman"
The gesture and facial expression of the model are the true subjects of this portrait. All attention is drawn to them by the almost monochromatic tonal treatment, but there are subtle hints of color in the blended shading, which ranges from a dark, neutral sepia to warm red-brown. Athough the color areas are cohesive, the direction of strokes and paper texture give a distinct grain pattern to the shading.
● Blending
● Paper grain effects

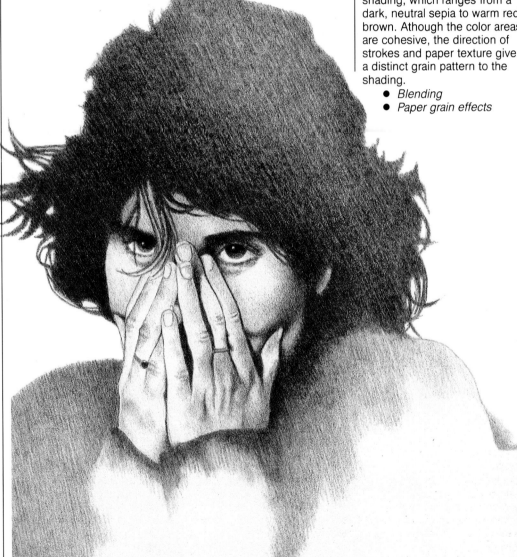

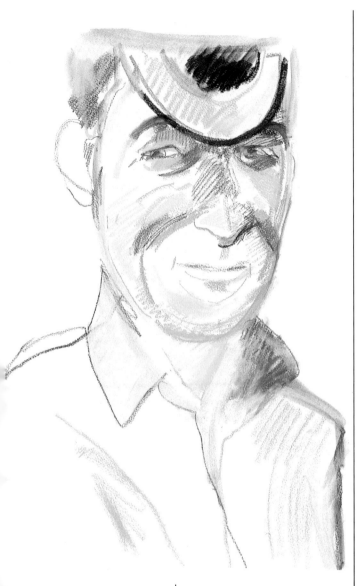

LINDA KITSON
"Soldier"
Both the colors and the surface qualities of the drawing contribute to a good-natured portrait, capturing the particular shapes of the face and individual features in an expressive manner. The grainy lines of soft, waxy pencils are contrasted with solid areas of chalky color and brief patches of watercolor wash.
● *Hatching*
● *Mixing pencils*

JOHN TOWNEND
"Self-portrait"
The strong contrast of black and red, further enlivened by the complementary contrast of green shadow areas, presents a powerful, almost aggressive study of the face. The mood of the portrait is emphasized by the busy activity of the pencil marks, weaving over and around each other to describe form and texture.
● *Linear marks*
● *Overlaying colors*

CHARACTER STUDIES

A descriptive sense of character in a portrait is conveyed in the way you select and handle specific details. This does not mean that the style of your drawing has to be detailed and realistic — you can capture the essence of a person with a very simple contour, if it is precisely seen and sensitively drawn. The character of the subject is expressed not only in the face but in particular poses or gestures, and you may choose to feature such aspects in your drawing. You can also use clothing and props that explain something about the person's lifestyle or occupation.

The subject's age is an important aspect of a character study, and there are various physical elements you can identify that suggest different stages of life, such as the angle of head and shoulders, the structure of the face and positioning of the features, and the colors and textures of skin and hair (see also Children, page 168-169).

JEFFREY CAMP
"Reader"
The artist uses economical means to describe his subject, reducing the face to a few essential contour lines and adding the descriptive detail of the hat, sweater and book as a way of enhancing the viewer's impression of the subject. The background color of the paper gives the portrait a warm, sympathetic cast.
● Colored grounds
● Line qualities

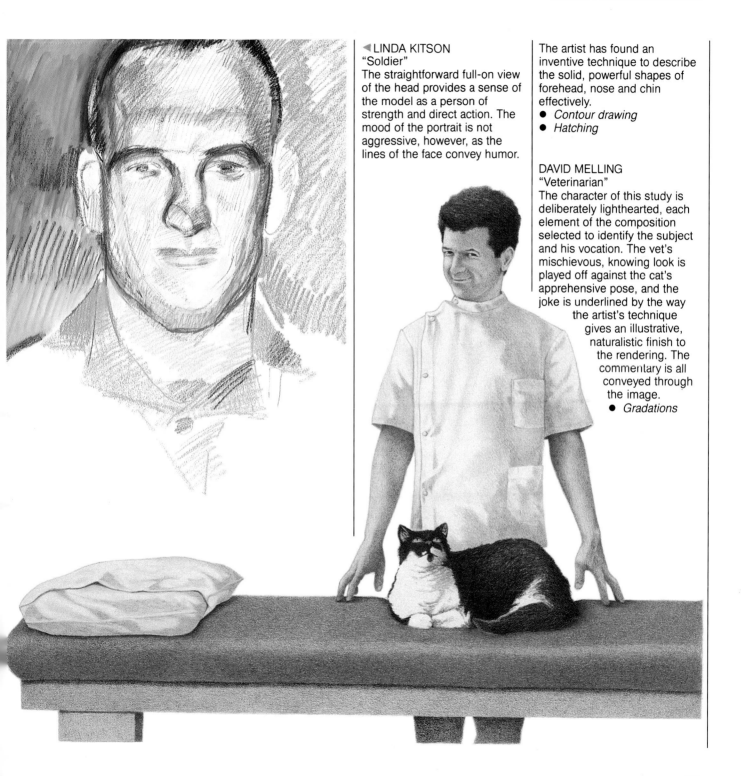

◄ LINDA KITSON
"Soldier"
The straightforward full-on view of the head provides a sense of the model as a person of strength and direct action. The mood of the portrait is not aggressive, however, as the lines of the face convey humor.

The artist has found an inventive technique to describe the solid, powerful shapes of forehead, nose and chin effectively.
● *Contour drawing*
● *Hatching*

DAVID MELLING
"Veterinarian"
The character of this study is deliberately lighthearted, each element of the composition selected to identify the subject and his vocation. The vet's mischievous, knowing look is played off against the cat's apprehensive pose, and the joke is underlined by the way the artist's technique gives an illustrative, naturalistic finish to the rendering. The commentary is all conveyed through the image.
● *Gradations*

F·U·L·L-L·E·N·G·T·H

PORTRAITS

In a full-length portrait, the subject's body and clothing provide certain kinds of descriptive detail that reduce the emphasis on facial characteristics as a means of creating a likeness. Typically, however, the head and face remain the most closely focused element of the image, whereas in other kinds of figure studies the model may be portrayed in an impersonal and anonymous way.

When you compose a full-length portrait, consider how your viewpoint can help to construct the mood of the image. Generally, you expect to be roughly at a level with another person, so a high or low viewpoint creates an unusual tension between subject and viewer.

The most commonly used angle of the head in portraiture is a three-quarter view; in the full-length portrait this can be echoed or counterpointed by the posture of the body.

On the other hand, you can choose a more dramatic frontal pose or a clear-cut profile. It is not necessary to include a full background; as in the examples shown here, you can briefly suggest the surroundings to give the figure a context and balance the pose.

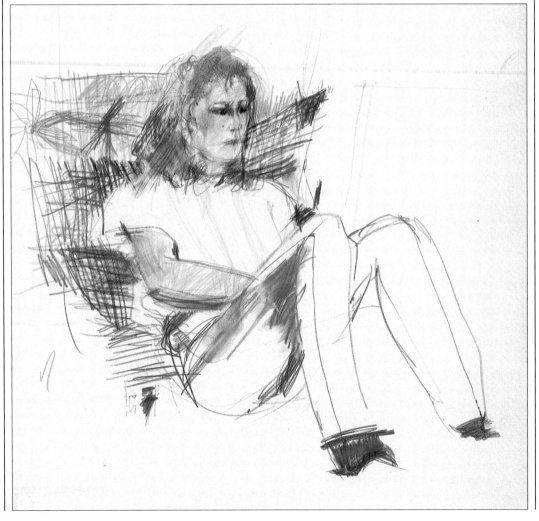

▲ ADRIAN GEORGE
"Standing figure"
There is a coolness to this drawing that is conveyed in all aspects of the composition – the restrained colors and controlled technique, as well as the pose itself and inclusion of the classical column.
● *Hatching*

◄ KAY SONG TEALE
"Girl in Blue Jeans"
Both the pose of the figure and the facial expression suggest a rather downbeat mood, but the pencil marks and colors are, by contrast, extremely lively.
● *Contour drawing*
● *Linear marks*

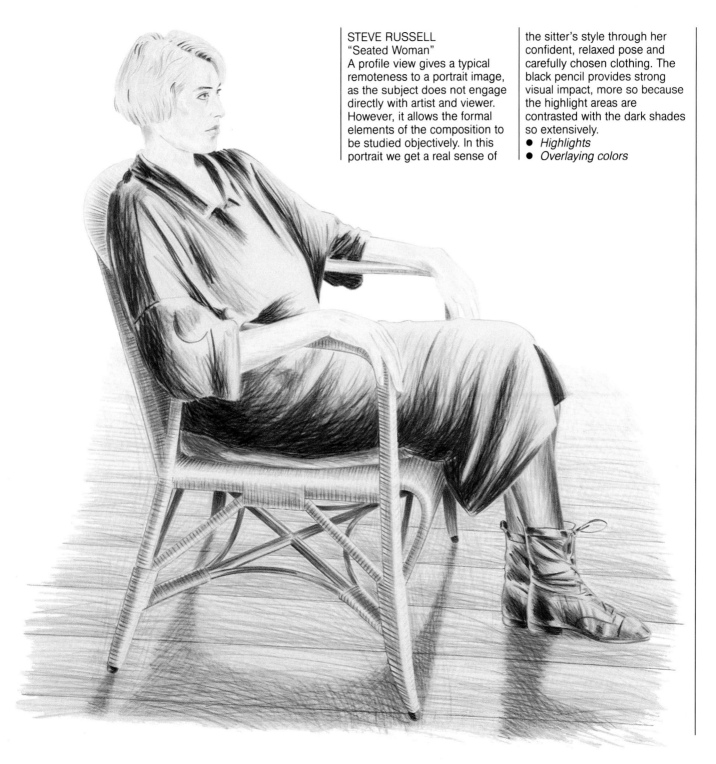

STEVE RUSSELL
"Seated Woman"
A profile view gives a typical remoteness to a portrait image, as the subject does not engage directly with artist and viewer. However, it allows the formal elements of the composition to be studied objectively. In this portrait we get a real sense of the sitter's style through her confident, relaxed pose and carefully chosen clothing. The black pencil provides strong visual impact, more so because the highlight areas are contrasted with the dark shades so extensively.
● *Highlights*
● *Overlaying colors*

PEOPLE:
TWO APPROACHES TO THE SAME SUBJECT
TRACY THOMPSON

This demonstration shows two versions of the portrait drawing that illustrate very different ways of using the medium. The artist was commissioned to create the work using only water-soluble colored pencils. She developed techniques that enabled her to use the pencil color inventively — drawing with the pencil leads both dry and wet, brushing the color into washes on the paper surface, and softening the sharpened pencil leads in a palette to turn their pigments into a kind of gouache-like "paint."

The first version of the colored pencil drawing is worked in a very free way so that the image has the spontaneity and movement of a rapid sketch, even though the composition was carefully worked out beforehand. In the second version, drawn on heavy watercolor paper, the artist has emphasized the strong graphic qualities of the subject, but has also devised techniques that give a vibrant, painterly finish to the color work.

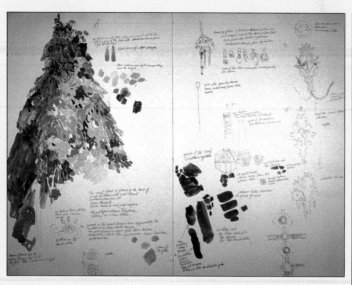

Sketchbook drawings
The detail of the bride's headdress was originally recorded in the artist's sketchbook, using watercolor and pencil to make a color study and notation of individual elements in the elaborate decoration.

Free color drawing
1 The basis of the portrait is roughly blocked in with line and light shading in appropriate colors. The artist begins to work into the detail of the headdress, initially establishing the larger shapes within the pattern.

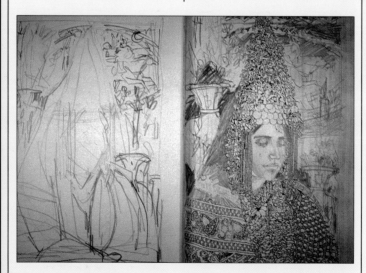

Working drawings
Before beginning the colored pencil studies, a rough pencil sketch was made to plan the composition (left), followed by a more intricate working of the actual shapes and patterns (right).

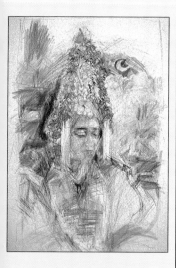

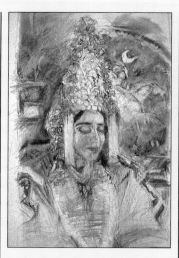

2 Gradually the colors are freely introduced all over the image area to develop the general impression of the figure. In places, the water-soluble pencils have been brushed over to create loose washes.

4 In the final stage of blocking in, all the color areas are broadly defined, and the linear pencil marks create a loose indication of the image's complexity.

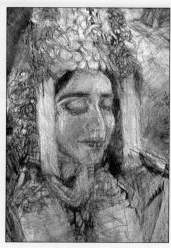

3 This detail shows the variety of marks already achieved by using the pencils wet and dry, and incorporating light brushstrokes into the rhythms of the drawing.

5 The color overlays and pencil textures provide rich surface qualities, and tonal values are used more strongly to model the face and hair.

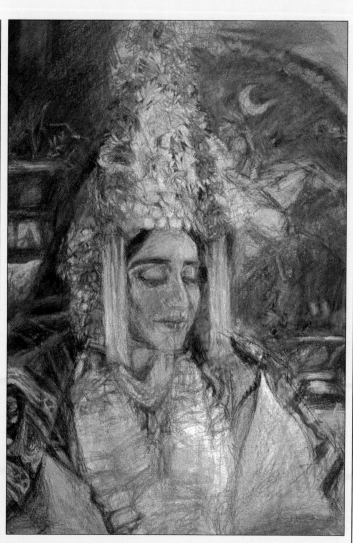

6 The artist increases the variety of shades and colors to add depth to the background. Although the interest focuses on the figure, all areas of the drawing are very active and expressive due to the dense combination of shading, linear marks and brushed color.

Final version

1 The detailed study is intended to have a more graphic, elaborate effect, with areas of flat color contained within strong outlines and contours. The initial drawing is made in line only, at first drawn faintly, then strengthened with crisp, dark tones.

2 The colored outlines are varied according to the colors with which the shapes will be filled. Contrasting colors are often used, such as purple for the shapes of the orange flowers and green lines for the rose-petal garland, which will be colored pink.

3 Although the keylines strictly define the color areas, the artist introduces gradations of each color within the shapes to create a rich interpretation of the textures and patterns.

4 The detail shows more clearly how certain colors have been graded in tone and intensity to create depth. The blue patterned fabric is lit up with many touches of other colors – greens, purples and pinks.

5 Gradually the intricacy of the image is developed. The artist varies the pencil techniques, using the color wet and dry so that the elaboration of the drawing's surface matches the complexity of the subject.

6 The face is modeled with light washes of color, spreading the pigment from the pencil leads with a dampened brush. Gentle shading increases the depth of tone, then, over the washed areas, the linear detail is drawn precisely with sharpened pencil tips.

TRACY THOMPSON
"Yemeni Bride"
The drawing that initially was constructed as a flat, graphic pattern is alive with variable colors and lights, all worked delicately into the detailed patterning. Additional highlighting has been achieved by two methods: wetting and lifting the color with a brush or softening the pencil leads with water to obtain an opaque color "paste," painted onto the surface.

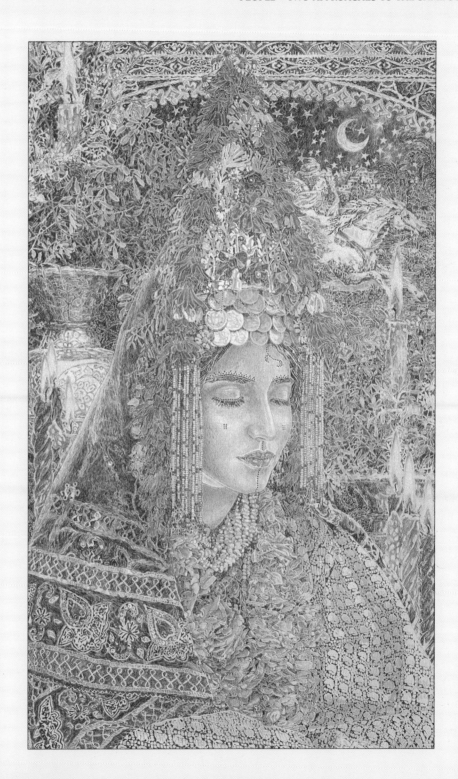

CREDITS

The author and Quarto would like to thank the following for their help with this publication and for permission to reproduce copyright material.

Title verso Chloë Cheese; **p7** Neville Graham; **p13** Mathilde Duffey, CPSA; **p23** (*above right*) Leslie Taylor, Eikon; **p27** Kaye Song Teale; **p35** Bill Nelson, CPSA; **p37** (*right*) Philip Stanton; **p41** (*below*) John Chamberlain; **p43** (*right*) Jo Dennis; **p61** (*above right*) Will Topley, (*below right*) Chris Chapman; **p63** John Chamberlain, Courtesy of The Royal Academy of Dance; **pp72/73** (*left*) Dyanne Locati, CPSA, (*right*) Linda Kitson; **p74** (*left*) Frank Auerbach, (*right*) John Townend; **p81** (*above right*) Barbara Schwemmer, CPSA; **p87** (*above right*) Sara Hayward; **p91** (*top*) Sara Hayward, (*below*) Kaye Song Teale; **p92** John Chamberlain; **p93** John Townend; **pp94/95** (*above left*) John Townend, (*below left*) Jeffrey Camp, (*right*) Mark Hudson; **pp96/97** (*left*) Adrian George, Francis Kyle Gallery, (*above right*) Steve Russell, (*below right*) Jo Dennis, David Holmes; **pp98/99** (*below left*) Jo Dennis, (*above left*) Helena Greene, (*above right*) John Townend, (*below right*) Carl Melegari; **pp100/101** (*left*) Mike Pease, CPSA, (*above right*) Laura Duis, CPSA, (*below right*) David Holmes; **pp102/103** (*far left*) Kay Song Teale, (*left*) Jean Ann O'Neill, (*above right*) Helena Greene, (*below right*) Sara Hayward; **pp104/105** (*left*) Michael Bishop, Folio, (*above right*) Ray Evans from *Learn to Paint Buildings* HarperCollins 1987, (*below right*) Chloë Cheese; **pp106/107** (*left*) Frank Auerbach, (*above right*) Ray Evans from *Sketching with Ray Evans* HarperCollins 1989, (*below right*) Luc van der Kooij, Artbox Amsterdam; **pp108-111** (*Demonstration*) John Townend; **p112** Carl Melegari; **p113** John Davis; **pp114/115** (*above left*) Sara Hayward, (*far left*) Sara Hayward, (*left*) Jean Ann O'Neill, (*right*) Carl Melegari; **pp116/117** (*above left*) Helena Greene, (*below left*) Tess Stone, (*above right*) Jane Hughes, (*below right*) Jeanne Lachance, CPSA; **pp118/119** (*above left*) Sara Hayward, (*below left*) Barbara Edidin, CPSA, (*above right*) Carl Melegari, (*below right*) Sara Hayward; **pp120/121** (*above left*) Jean Ann O'Neill, (*below left*) Jean Ann O'Neill, (*right*) Jane Hughes; **pp122/123** (*far left*) Helena Greene, (*left*) Rita D. Ludden, CPSA, (*above right*) Helena Greene, (*below right*) Jane Strother; **pp124/125** (*left*) Chloë Cheese, (*right*) Jo Dennis, (*far right*) Philip Stanton; **pp126/127** (*left*) Tess Stone, (*right*) Jane Hughes, (*far right*) Chloë Cheese; **pp128/129** (*left*) Chloë Cheese, (*above right*) Barbara Edidin, CPSA, (*below right*) Sara Hayward; **p130** (*left*) Chloë Cheese, (*right*) Rita D. Ludden, CPSA, (*far right*) Jane Strother; **pp132/133** (*left*) John Davis, Folio, (*above right*) Philip Stanton, (*right*) Helena Greene, (*below right*) Jane Strother; **p137** (*Demonstration*) Stuart Robinson; **p138** Angela Morgan; **p139** Julia Cobbold; **pp140/141** (*left*) Tracy Thompson, (*above right*) Michele Brokaw, CPSA, (*below right*) Helena Greene; **pp142/143** (*far left*) Steve Taylor, (*left*) Steve Taylor, (*right*) Dyanne Locati, CPSA; **pp144/145** (*far left*) Gary Greene, CPSA, (*left*) Angela Morgan, (*right*) Angela Morgan; **pp146/147** (*left*) Helena Greene, (*right*) Jane Strother, (*far right*) Helena Greene; **pp148/149** (*left*) Patti McQuillan, CPSA, (*right*) Tracy Thompson; **pp150/151** (*above left*) Laura Duis, CPSA, (*below left*) Don Pearson, CPSA, (*right*) Kees de Kiefte, Artbox Amsterdam; **pp152/153** (*left*) Carl Melegari, (*right*) Michele Brokaw, CPSA, (*far right*) Carolyn Rochelle, CPSA; **pp154/155** (*left*) Steve Taylor, (*right*) Frank de Brouwer, Artbox Amsterdam; **pp156-159** (*Demonstration*) Jane Stother; **p160** John Chamberlain; **p161** (*left*) Pamela Venus, (*right*) Linda Kitson; **pp162/163** (*far left*) Jeffrey Camp, (*left*) Linda Kitson, (*right*) Max Ten Bosch, Artbox Amsterdam; **pp164/165** (*left*) John Chamberlain, (*above right*) John Chamberlain, (*below right*) Jeffrey Camp; **pp166/167** (*left*) Vera Curnow, CPSA, (*right*) David Huggins; **pp168/169** (*above left*) David Melling, (*below left*) Jean Ann O'Neill, (*right*) Erik van Houten, Artbox Amsterdam; **pp170/171** (*left*) Euan Uglow, (*right*) Adrian George, Francis Kyle Gallery, (*far right*) Phillip Sutton; **pp172/173** (*left*) Linda Kitson, (*above right*) Jo Dennis, (*below right*) Chris Chapman; **pp174/175** (*far left*) John Chamberlain, Courtesy of The Royal Academy of Dance, (*left*) Carl Melegari, (*right*) Ben Palli, Artbox Amsterdam; **pp176/177** (*above left*) Sheri Lynn Doty, CPSA, (*below left*) Andrew Tiffen, (*right*) Steve Russell; **pp178/179** (*left*) David Melling, (*right*) Linda Kitson, (*far right*) John Townend; **pp180/181** (*left*) Jeffrey Camp, (*right*) Linda Kitson, (*far right*) David Melling; **pp182/183** (*far left*) Kaye Song Teale, (*left*) Adrian George, Francis Kyle Gallery, (*right*) Steve Russell; **pp184-187** (*Demonstration*) Tracy Thompson, Faber-Castell/R.C.A

Special thanks to the artists who did demonstrations: Judy Martin, George Cayford, Marianne Padiña, Jane Strother, John Townend, Tracy Thompson and Stuart Robinson.

Every effort has been made to trace and acknowledge all copyright holders. Quarto would like to apologize if any omissions have been made.